THE
TAO
IS
SILENT

道是靜的

THE
TAO
IS
SILENT

Raymond M. Smullyan

HARPER & ROW, PUBLISHERS
NEW YORK, HAGERSTOWN,
SAN FRANCISCO,
LONDON

FIRST EDITION

Library of Congress Cataloging in Publication Data

Smullyan, Raymond M
 The tao is silent.

 Bibliography: p.
 1. Tao. I. Title.
B127.T3S65 1977 170'.202 76–62939
ISBN 0–06–067469–5

 85 86 10 9 8 7

CONTENTS

THE TAO IS A SILENT FLOWER

The Tao is a silent flower which blooms
 through the night,
But the night through which it blooms
 is the flower itself.
No Tao, no flower, no bloomer, no night.
 And for this reason, it blooms.

PREFACE

When I first came across the Taoist writings, I was infinitely delighted. I did not feel that I was reading something strange or exotic, but that I was reading the very thoughts I have had all my life, only expressed far better than I have ever been able to express them. To me, Taoism means a state of inner serenity combined with an intense aesthetic awareness. Neither alone is adequate; a purely passive serenity is kind of dull, and an anxiety–ridden awareness is not very appealing. A Chinese friend of mine (of the modern school) recently criticized Taoism as a philosophy of "having one's cake and eating it too." I replied, "What could be better?" He responded, "But one *can't* have one's cake and eat it too!" This is precisely where we disagree! All my life I have believed that one *can* have one's cake and eat it too. Hence I am a Taoist.

Actually, I came to Taoism first through Zen–Buddhism. It took me quite a while to realize to what extent Zen has combined Taoism and Buddhism, and that it was primarily the Taoistic elements which appealed to me. The curious thing about Zen is that it first makes one's mouth water for this thing called *Satori* (enlightenment) and then straightaway informs us that our desire for *Satori* is the very thing which is preventing us from getting it! By contrast, the Taoist strikes me as one who is not so much in search of something he hasn't, but who is enjoying what he has.

This is more than a book *on* Chinese philosophy; it consists

of a series of ideas *inspired* by Chinese philosophy. Though the Taoist viewpoint may be central, this book as a whole treats of a wide variety of subjects—it is really a book on life in general. It is dedicated to my wife, my brother and sister, my puppies, my students, my friends, my readers, and everyone else.

Elka Park, New York RAYMOND M. SMULLYAN
January 17, 1977

PART I

WHAT IS THE TAO?

1.

CHINESE PHILOSOPHY
IN A NUTSHELL

A mathematician friend of mine recently told me of a mathematician friend of his who everyday "takes a nap". Now, I never take naps. But I often fall asleep while reading—which is very different from deliberately taking a nap! I am far more like my dogs Peekaboo, Peekatoo and Trixie than like my mathematician friend once removed. These dogs *never* take naps; they merely fall asleep. They fall asleep wherever and whenever they choose (which, incidentally is most of the time!). Thus these dogs are true Sages.

I think this is all that Chinese philosophy is really about; the rest is mere elaboration! If you can learn to fall asleep without taking a nap, then you too will become a Sage. But if you can't, you will find it not as easy as you might think. It takes *discipline!* But discipline in the Eastern, not Western style. Eastern discipline enables you to fall asleep rather than take a nap; Western discipline has you do the reverse. Eastern discipline trains you to "allow yourself" to sleep when you are sleepy; Western discipline teaches you to *force* yourself to sleep whether you are sleepy or not. Had I been Laotse, I would have added the following maxim—which I think is the quintessence of Taoist philosophy:

> The Sage falls asleep not
> because he ought to
> Nor even because he wants to
> But because he is sleepy.

2.

THE TAO

There is something blurred and indistinct
Antedating Heaven and Earth.
How Indistinct! How Blurred!
Yet within it are forms.
How dim! How confused!
Quiet, though ever functioning.
It does nothing, yet through it all things are done.
To its accomplishment it lays no credit.
It loves and nourishes all things, but does not lord
 it over them.
I do not know its name,
I call it the Tao.[1]

Thus writes Laotse some twenty-five hundred years ago. I think this is as good an introductory description of the Tao as can be desired. It raises many interesting questions: Just what is the Tao? How should one define the Tao, or does the Tao elude any possible definition? If it exists, what is it like? What are its properties?

Before turning to these matters, let me tell you the story of a Zen-Master who was asked by a student, "What is the Tao?" He replied, "I will tell you after you have drunk up the waters of the West River in one gulp." The student countered," I have already drunk up the waters of the West River in one gulp." To which the Master replied," Then I have already answered your question."

4

3.

DOES THE TAO EXIST?

The Tao is above existence
 and non-existence.
Existence is for men who
 use words
But the Tao does not use
 words.
It is as silent as a flower.
Words come from the Tao—
 the Tao *produces* words,
But it does not use them.

In the trial scene in Alice in Wonderland, the White Rabbit read an obscure verse which was apparently quite irrelevant to the case. The King triumphantly exclaimed "That's the most important piece of evidence we've heard yet". Alice flatly contradicted him and said, "I don't believe there's an atom of meaning in it". The King then said, "If there's no meaning in it, that saves a world of trouble, you know, as we needn't try to find any".

I might make a similar comment about the Taoists. Since the Taoists make no claim that the Tao exists, it saves them a world of trouble in trying to prove that the Tao exists. This is really Chinese common sense at its highest!

Just compare the situation with the history of Western religions thought! Good heavens, the amount of debates, battles, bloodshed and torture over the question of whether God

5

does or does not exist! It has seemed to be even more than a life and death issue. At all costs, the Christian must convince the heathen and the atheist that God exists, in order to save his soul. At all costs, the atheist must convince the Christian that the belief in God is but a childish and primitive superstition, doing enormous harm to the cause of true social progress. And so they battle and storm and bang away at each other. Meanwhile, the Taoist Sage sits quietly by the stream, perhaps with a book of poems, a cup of wine, and some painting materials, enjoying the Tao to his hearts content, without ever worrying whether or not the Tao exists. The Sage has no need to affirm the Tao; he is far too busy enjoying it!

4.

YES, BUT DOES THE TAO EXIST?

My, my, how persistent you are! Well now, let me say a little more about this.

The Taoist is not like the Western agnostic who grants that either God exists or he doesn't, but doesn't know which. The Western agnostic will say, "By simple Aristotelian logic, we know that either God exists or he doesn't, but we do not have confirming evidence one way or the other. Hence our only rational recourse is to suspend judgment on the matter until further evidence becomes available." Now, the Taoist sees the matter quite differently. He does not "suspend judgement" as to whether or not there is a Tao; the question of the existence or nonexistence of the Tao simply does not occur to him, or if someone presents it to him, he regards it as vague, meaningless, somehow irrelevant and sort of odd. In this respect, he is strangely like the Western logical positivist, though perhaps for different reasons. If you asked a logical positivist whether or not the Tao exists, he would declare the question "meaningless". He would first want the word "Tao" to be clearly defined. Now, if the question really has no meaning, as the positivist says, then I would be quite happy, since I can then reply, "If there's no meaning in it, that saves a world of trouble, as we needn't try to find any".

At this point, you may be a bit irritated and say, "Stop evading the issue! Does the Tao exist or doesn't it? Is it some-

thing *real* or is it a mere fantasy—a figment of the imagination?"

Well now, analagous questions on existence have been asked in other areas and are equally futile. There has been, for example, much metaphysical controversy as to the existence of so-called universals—things like *redness, triangularity, beauty, goodness,* and so on. Does *redness* exist? If so, where is it, how much does it weigh, what is its shape, what is its colour? [Would you say that the colour redness is itself red? Hardly!] Does redness really exist at all? Some may naïvely say, "Of course redness exists; look at roses, lipstick, certain apples, etc." But this only means that there exists certain *things* which are red; it does not prove that there exists a certain entity called "redness". The question of the existence of such an entity has been a lively one in the history of Western philosophy. There are those called "Nominalists" who believe the answer is "No". They, of course, admit the existence of particular things which are red, but they deny the existence of any entity called "redness". They accept the word "red" as an *adjective* (since there are red things), but they deny any legitimacy to the use of the word "redness" as a *noun.* They would deny that the word "redness" has any actual denotation; they do not believe that "redness" is an actual *name* of anything. On the other hand there are those called "Realists" (sometimes "Platonists") who believe that "redness" is indeed a legitimate noun—it is the name of redness. They also believe that the word "red" can be properly used both as an adjective and as a noun. It is used as an adjective, for example, in a statement like "This apple is red"; it is used as a noun in such statements as "Red is one of the primary colors". And the realist believes that "red" is indeed a name; it is the name of the color red.

Similarly, the realist—nominalist controversy extends to other so-called "universals". The realist like Plato believes in the existence of *Beauty, Goodness, Truth,* whereas the nomi-

nalist only believes that certain works of art are beautiful, certain acts might be labeled "good" and certain propositions are appropriately labeled "true".

It might surprise some nonmathematical readers that such controversies exist even in the realm known as the foundations of mathematics. This field is erroneously believed by the layman to be settled and non-controversial. But this is far from true! The so-called mathematical realist (or classicist or "Platonist") believes in a world of non-linguistic mathematical entities such as "numbers, sets, functions, groups, topological spaces", etc, and that it is the purpose of mathematics to discover and prove various statement about these entities which are *true*. On the other hand there is the so-called mathematical "formalist" who believes all these so-called mathematical entities are but figments of the imagination; the only reality is the symbols used to express them! So the interest of the mathematical formalist appears to be purely linguistic. For him, mathematics is but the study of strings of symbols called "formal expressions", and of how they are to be manipulated according to the prescribed rules of the system under study; the expressions themselves do not express anything! And the formalist (like the nominalist) denies the existence of things like "numbers" as other than certain linguistic expressions.

We might similarly approach the problem of the existence of the Tao. There are perhaps those who would deny the use of the word "Tao" as a noun; they would refuse to believe in the existence of some "entity" called the Tao, but they would nevertheless accept as quite meaningful the adjective "Taoistic". It certainly should be obvious to all students of Chinese art and thought—even those with absolutely no metaphysical commitments of any kind—that certain works are more Taoistic than others. For example, it is generally conceded that Sung landscape painting is more Taoistic than the art of the Tang. Thus few will object to the use of the

word "Taoistic" though many might object to the word "Tao".

Some of you may feel that I am still evading the issue of whether or not the Tao really exists. Actually now, do I know? "But", you might reply, "don't you even have some personal opinion on the matter?"

Suppose you actually cornered me in my study and said to me point blank: "Smullyan! Stop equivocating! Do you or do you not believe the Tao exists?" What would I answer? This would depend on whether I happened to be in a more Western or more Eastern mood at the time I was asked. If I were in a more Western mood (and abided in the duality of existence versus nonexistence), then, since I tend to be a Platonist, I would probably answer, "Yes, the Tao exists". But suppose I were in an Eastern mood? Well now, if you asked a Zen-Master whether the Tao exists, he would probably give you a good blow with his stick. Now I, being of a somewhat more mild disposition, would probably just smile at you (perhaps in a somewhat condescending fashion) and offer you a cup of tea.

5.

THE TAO IS VAGUE!

The Tao is Formless and Vague!
It is Hidden, Mysterious and Dark!
It is the source of all things!

(Laotse)[1]

If anyone should ask me to define the word "Tao", I would of course be unable to do so. Does this mean that my notion of it is vague and imprecise? I gues it does. But, strangely enough, it is no vaguer than most of my other notions in life! Such words as *beauty, goodness, truth, freedom, determinism, right, wrong, mind, matter,* seem equally vague—at least when I use them. Now, the idea that the notion of Tao is vague has one curious feature: The Tao itself is supposed to be vague, so is it not appropriate that our notion of it should be correspondingly vague? After all, if a notion of something is to be accurate, should not the notion mirror, reflect, picture, copy,—in some sense "be like" the object? The answer to that question is probably "no", but let me pretend that it is "yes", since something curious and intriguing would then follow: If this "picture theory" of knowledge is correct, and if the Tao is really as vague as the Taoists crack it up to be, then it would follow that any precise notion of the Tao would be inaccurate *by virtue of its very precision!* That is to say, a precise notion of the Tao differs radicaly from the

11

Tao in that the idea is precise, but the Tao is not, hence the idea must be inadequate. Stated otherwise, an adequate idea of the Tao must be as vague as the Tao itself.

Needless to say, one can pick holes galore in my above argument. For one thing, the picture theory of knowledge is highly open to suspicion. Indeed, to be perfectly frank, I regard this theory as utterly ridiculous! The idea of an idea *resembling* its object! What could it even mean for an idea to resemble an object? I know what it means to have an idea *of* an object, but for an idea to *resemble* an object! What kind of grotesquerie is that?* No, I certainly do not accept the picture theory of knowledge, hence the first premise of the argument is false. Now, what about the second premise— that the Tao itself is vague? This also can be questioned. Indeed, it may be argued that no *thing* can be vague; only *ideas* are vague. In other words, vagueness is a property not of things, but rather of ideas or statements. I tend to agree with this. I doubt that an object, a thing can be vague. Yet the Tao obviously is vague. Hence it follows that the Tao is not a thing!

It is curious that I have just given the world's second proof of the fact that the Tao is not a "thing"—a fact first stated and proved by a much earlier Taoist (about 500 or 600 B.C.). The earlier proof is interesting and instructive, and in a way anticipates the modern mathematical distinction between classes and sets. The proof is to the effect that the Tao is that through which all things have come into being, hence Tao cannot be a thing!

When I said a moment ago that I have given the world's second proof that the Tao is not a thing, I was of course using the word "proof" with tongue in cheek. (As if anyone could

*Some may say that ideas can resemble objects in the sense of isomorphism. But frankly, isomorphism strikes me as a crummy kind of resemblance!

possibly *prove* anything about the Tao!) Obviously I have not proved a damned thing! Just recall my "proof". I said that a thing in itself cannot be vague, but the Tao is vague, hence the Tao is not a thing. But how do I know in the first place that the Tao really is vague? Good question! How do I know it? For that matter, *do* I know it? The answer is "no". No, I do not know that the Tao is vague, but the funny part is that even though I don't know the Tao is vague the Tao is vague anyhow! (Fortunately the vagueness of the Tao is independent of any knowledge of its vagueness.) "But", you will scream, "are you not again assuming the very thing which needs to be proved? My answer is "no", and that for two reasons: In the first place, I am not *assuming* that the Tao is vague; I am simply telling you that the Tao is vague. In the second place, I don't believe it needs to be proved that the Tao is vague, because I don't believe it can be so proved. Indeed if it could be proved, then it could be known, and since I don't believe it can be known, then I don't believe it can be proved.

At this point, why don't I try a more rational scientific approach to this problem? Good idea; I will do this! I shall now approach the matter like a good analytic philosopher— or better still, a logical positivist. So the first thing is to perform an *analysis* of the statement "the Tao is vague". What about this statement? Is it true or false? Well, surely now, any good logical positivist will tell you that the statement is neither true nor false, but simply "meaningless" (like, for example, the statement "the Absolute is beautiful").* Indeed, the positivists can even prove to you that the statement is meaningless! They will give you an absolutely precise—a completely nonvague—definition of *meaningful* and by irrefutable logic will show you that the statement does not come in the category of the meaningful. Thus the statement does not

*Incidentally, the Absolute *is* beautiful!

come under either of the categories "true" or "false"—it is too *vague* to be either true or false! Yes, the positivists will assure you that the very statement "The Tao is vague" is itself completely vague!

And the amazing thing is that this time the positivists are actually right! They are even more right than they realize! The statement "The Tao is vague" is not only vague and meaningless according to the ridiculously restricted notion of *meaning* which the positivists give (for in fact all statements declared meaningless by them are indeed meaningless in this restricted sense), but the statement" "The Tao is vague" is really vague in the absolute sense! Indeed, it is one of the vaguest statements I know! It is about as vague as any statement can be. It is beautifully and wonderfully vague—almost as vague as the Tao itself!

6.

THE TAO IS FORMLESS

§1. IS THE TAO DEFINABLE?

Zen Buddhism might aptly be described as a combination of Chinese Taoism and Indian Buddhism with a touch of pepper and salt (particularly pepper) thrown in by the Japanese. It is questionable whether Zen Buddhism should be called a *philosophy*. As many Zen followers repeatedly emphasize, Zen is more a way of life, a set of attitudes, a certain *gestalt*, rather than a set of cognitively meaningful propositions. I believe there is much truth in this statement, but like many other statements, it can be overly exaggerated. I do believe that Zen is primarily a "way" rather than a "doctrine", but I don't believe Zen is totally devoid of doctrine.* And, it seems to me, one of the things definitely emphasized by Zen is the idea that the transcendent is to be found right in the immanent; indeed, the transcendent and the immanent are identical. This surely is most explicitly implicit in this Zen verse:

> "When the wild bird cries its melodies
> from the treetops,
> Its voice carries the message of the
> patriarch.
> When the mountain flowers are in bloom,
> Their full meaning comes along
> with their scent".[1]

*In fact, I know of no doctrine that is.

15

And, of course, the idea that the transcendent is right in the immanent is explicitly explicit in the well known incident of the Master who when asked, "What is the Tao?" replied, "Your everyday mind".

Some may ask, "If the Tao is nothing more than one's everyday mind, why call it the Tao; why not simply call it one's everyday mind?

This question is extremely difficult to answer logically. In the first place, I think it a mistake to interpret the statement "The Tao is your everyday mind" as "The Tao is *nothing more* than your everyday mind". I hardly think that in the statement "The Tao is your everyday mind" the word "is" is meant to equate the two concepts "Tao" and "Everyday mind". I would rather say that the Tao is your everyday mind *and more*. Indeed, in the Book of Tao it is said that the Tao antedates heaven and earth. Now then, does your everyday mind antedate heaven and earth? Maybe it does, who knows? At any rate, I find the statement "The Tao is your everyday mind" extremely enlightening provided, of course, it is not taken too literally.

But, you may continue to ask, if the Tao is simply one's everyday mind, why not call it one's everyday mind rather than the Tao? And, for that matter, just what *is* the Tao; how should one define the Tao?

The word has been translated in many different ways; *God, Nature, The Absolute, That through which all things have come into being, The Great Void, The Path, The Way,* etc. Perhaps one of my favorite definitions is: "the reason things are as they are". Yet I must ask: do any of these definitions —delightful and suggestive as they are—really clarify our notion of the Tao? And for that matter, is it really desirable that this notion be clarified?

Some say that the word "Tao" is untranslatable; others that the Tao is indefinable. Is the first statement so surprising? Those of you who know at least one foreign language know some words which can only be approximated in English but

which have no exact equivalent Now let us consider the assertion that the word "Tao" is indefinable. This arouses great suspicions in the minds of many who pride themselves on being "critical thinkers". But is this suspicion really justified? Many will sternly and heartlessly say that unless one can define one's terms, one does not really know what one is talking about. Yes, there is indeed this strange doctrine that the inability to define what one means only signifies that one means nothing. I think we should turn at this point to the philosopher Wittgenstein who wisely said, "Don't look for the meaning; look for the use!" This may well be the key to the matter. Though I might go a step further and say that the meaning *is* the use—at least the real meaning is the use. To me, the real meaning of a term is the sumtotal of all the uses and all the associations one has with the term. How can these all be captured in one short definition? Therefore I say that if you really want to find out the meaning of a word like *Tao* —as meant by the Taoist writers who have used it—you cannot possibly expect any shortcut like a "definition" to tell you. To understand the true meaning of the term "Tao" one must sample hundreds and thousands of cases in which the term is actually used. And this is not all. To understand the concept of Tao, one must also be thoroughly familiar with Taoist poetry and painting (as well, perhaps, as calligraphy) in which Taoistic feeling has found its most concrete and vivid embodiment. In short, to understand the meaning of "Tao" one must be thoroughly steeped in the whole philosophy and arts of Taoism.

After you have done this, after you have sampled thousands of uses of the word "Tao", you might try your hand at being clever and framing one single definition to cover this whole multitude of cases. But even if you succeed, how utterly empty your definition will be to those who have not had your concrete experience of actually living through this philosophy!

2. IN WHAT SENSE IS THE TAO REAL?

Some might claim that the Tao can be known only by mystical experience. Just what is mystical experience? Almost everyone knows what is meant by aesthetic experience, but what about mystical experience? These may be closely related, but I would hardly say they are identical! To me, the mystical sense is as different from the aesthetic sense as either is from the sense of humor.

But what is this mystical sense, and what is a mystical experience? Is it a free-floating experience, or is it an experience of something? And if it is an experience of something, is it an experience of something real or something existing only in the imagination?

So much controversy has ranged over this strange issue! Many psychologists of mysticism have gone to all sorts of lengths to prove that mystical experience is not an experience of anything real. They characterize mystics as people who are emotionally disturbed (often schizophrenic or hysterical) who populate their fantasy world with those things they were unable to find in the real world. On the other hand, apologists for mysticism (who are usually philosophers rather than true mystics) have gone to equal lengths to try to convince us that what mystics perceive is something very real indeed. Well, who is right? Do the mystics perceive something real or not?

Well now, suppose two people, one a musician and the other extremely unmusical, are listening to a theme. The unmusical one admits frankly "I hear the notes, but I don't hear the melody". The musician assures the other that in addition to the individual notes, he hears something much more important—the melody! Now, just what is this "melody" that the musician hears? The notes themselves—the sound waves, that is—are heard alike by musician and non-

musician and are universally acknowledged to be real in the purely physical sense. But what about the melody itself? Is it something real or does it exist only in the mind or imagination? The question is a rather strange one! I think it would be most misleading to say that it exists only in the imagination; the musician who says he hears a melody is not just imagining things. No, the melody heard is something very real indeed, though whether it should be said to exist in the mind is a much more subtle question which I cannot answer. At any rate, I don't think many will disagree when I say that melodies are real. And I think it is more in this sense of real that the Tao can be said to be real. The true Taoists (or so called mystics of other religions, or even nontheistic mystics) directly perceive that which they call the Tao (or which others call God, Nature, the Absolute, Cosmic Consciousness) just as the musician directly perceives the melody. The musician does not need to have "faith" that there is a melody, nor does he have to accept the existence of the melody on some scriptural authority; he obviously has a direct experience of the melody itself. And once the melody is heard, it is impossible ever again to doubt it.

Just how is the Tao perceived directly? Well, how is a melody perceived directly? Through the sense of hearing? Not quite! The physical hearing process obviously plays a necessary role, but this is not the whole story. The nonmusician can have just as good auditory equipment as the musician, yet the musician experiences the melody whereas the other one does not. So what we call "hearing a melody" involves use of the word *hearing* in a more extended and subtle sense than "hearing the sounds". The point is that the melody is far more than a group of sounds; it is their sounds together with some sort of pattern or superstructure somehow imposed.

Some might say that the Tao is nothing more than the physical universe. But this would seem to miss the crucial

point in much the same way as it would to say that a melody is nothing more than a group of sounds. Rather it might be said that the universe bears the same sort of relation to the Tao as the group of notes of a melody bears to the melody itself.

7.

THE TAO IS A MYSTERIOUS FEMALE

The Valley Spirit never dies.
It is named the Mysterious Female.
And the Doorway of the Mysterious Female
Is the base from which Heaven and Earth
 sprang.
It is there within us all the while
Draw upon it as you will, it never
 runs dry.

(Laotse, tr Arthur Waley)[1]

So! The Tao is a mysterious female! No wonder I love it so much! What could be more enthralling than a mysterious female? A mysterious female is delightfully enchanting for two reasons: (1) She is a female; (2) she is mysterious. Yes, femininity and mysteriousness are certainly two of the most entrancing things in life. But combined! Good God, what could be more divine? The two in conjunction are far more than twice as intriguing as either one separately. That is to say, a mysterious female is more than twice as attractive as either a female who is not mysterious or a mysterious something which is not female. So it is no wonder I love the Tao so much!

At this point perhaps I should try a more psychoanalytic

approach. Perhaps I should ask myself *why* I like mysterious females. For that matter, is there one particular mysterious female in my life of whom all other mysterious females are prototypes? Well now, let us see! What about my wife? Well, she is a female and is at times most mysterious indeed! What about some of my exparamours? Well, my exparamours were all female and were mysterious in varying degrees. Is that all? That's all I can think of. But is it not possible I am repressing something? I wonder what I am repressing? What *could* it be? Let me wrack my brains! Let's see now, doesn't Taoism say something about the Tao being the *mother* of the universe? That word "mother" seems vaguely relevant! I wonder what it symbolizes? Of course! My mother! My own flesh-and-blood mother! Why didn't I think of it before? Maybe my mother is *the* mysterious female of my life! Well now, let us see! My mother was female (which is not too surprising) and she definitely *was* mysterious! Beautifully and grandly mysterious in the true Victorian tradition! So maybe it is *she* who is the mysterious female of my life! Well now, let us see!

The theory of the Oedipus complex is a remarkable one, and suggests all sorts of interesting possibilities (like being attracted to one's mother, for example). When Europeans first heard of it, they were highly shocked! Nowadays, most Westerners—particularly Americans—just take it for granted—indeed, they swallow the theory hook, line and sinker! The more "avant-garde" are beginning to turn away from it. (Indeed, some young psychiatrists I know are seriously suspecting much of Freud as being "overly romantic".) Now, the most delightful reaction to the Oedipus complex that I know is that of the Chinese. When they hear of it, they are not the least bit shocked, nor do they fall for it; they are simply amused—most amused indeed! They laugh, and think it delightfully funny. I guess I must be essentially Chinese at heart, for I react very much the same way. It's not that I deny either the truth or the psychological significance of the Oedi-

pus complex, but I still think the idea is extremely funny. Is it not funny that a man should have to single out his mother either as a special female *not* to be attracted to or as one to be *especially* attracted to? Cannot one take a sane view of the matter and simply regard his mother as one of the many charming mysterious females he has known?

Speaking of mysterious females, I have never yet met a female who is *not* mysterious. To me, *all* females are mysterious! And I love them for their mysteriousness and femininity. But the idea of *the* mysterious female is, I think, but a romantic fiction. As I see it, the mysterious female is not one person but something generic, something embodied in all particular mysterious females. And the generic mysterious female is something dark, formless and vague—just like the Tao.

8.

THE TAO HAS NO NAME

Now that's going a bit too far! When some Taoists say the Tao has no name, then even I—with all my Eastern philosophy —am far too Western not to register a protest. Of course the Tao has a name! Its name is obviously "The Tao". Indeed, consider the following brief dialogue:

Easterner: The Tao has no name.
Westerner: What has no name?
Easterner: The Tao.
Westerner: There! You have just named it!

In the above dialogue, I have, of course, let the Westerner come off the better. Now that I have discharged my duty to Western logic and semantics, let me tell you how I really feel about the matter.

The funny thing is that if I heard the phrase "The Tao is nameless" rather than "The Tao has no name", I would have reacted differently. One might immediately ask, "But what is the logical difference between saying the Tao has no name and the Tao is nameless? Well, logically speaking, there is no difference. But is it appropriate to approach the Tao logically? This is an interesting question, but I shan't take time out to answer it now. As I said, there is no logical difference between the two statements, but there is a considerable *psychological* difference. How do I know this? Well, the very fact that I react so differently to the two statements would surely suggest that there is *some* psychological difference between them. The first statement "The Tao has no name" immediately awakens

my analytic Western bristles, and puts me in a condition where I am highly critical, whereas the statement "The Tao is nameless" tends rather to put me into a peaceful Eastern slumber. The first statement seems more precise, and insofar as it is precise, is clearly wrong. The second statement suggests to me something more vague, and insofar as it is vague, it allows all sorts of pleasant and interesting interpretations. Some people are always critical of vague statements. I tend rather to be critical of precise statements; they are the only ones which can be correctly labelled "wrong". What about precise statement which are not wrong—statements which in a precise sense are "true"? How to they compare with vague statements? Well, that depends a lot on the circumstance. In some contexts a good precise statement is called for; in others, a vague statement. It really should be borne in mind that a precise statement, though it often has its place, has only one meaning, whereas a vague statement may contain a multitude of interesting and fruitful meanings.

However, I digress. It is not quite clear just what I am digressing *from*, since this whole discussion is getting fantastically vague as it is, but I have a feeling that I am digressing from something. What is this something? Oh yes, let me get back to the statement "The Tao is nameless" I find this statement highly suggestive, mysterious, poetic and beautiful. But what does it *mean?* Well, of course, there is the possibility that it doesn't mean anything! If this be true, then it of course saves us the world of trouble of having to find a meaning for it. But it seems to me that it has all sorts of interesting meanings. Does it mean that the Tao has no name? No, I have already ruled that out. Maybe it means that there is no *appropriate* name for the Tao, that no name can do it justice. This interpretation raises several semantic difficulties. Just what on earth could be meant by a name doing *justice* to its designatum? Does my name "Raymond" do me justice? (Perhaps yes! My name means *wise protector*.] Does the name "Humpty Dumpty" do Humpty Dumpty justice? Yes, in this

case it definitely does, for as Humpty Dumpty wisely explained, "My name means the shape I am". Now, what about the name "Tao"—does it do the Tao justice? Yes, I think it does. It does not, of course, mean the shape it is, since it has no shape, but rather it means the *way* it is. And for this purpose, the name "Tao" serves perfectly!

So! It turns out that the Tao not only has a name, but a perfect one at that! So my idea that the Tao has no "appropriate" name, I wish to reject.

But I have another idea! A much better one! An idea which is exciting and fantastic! To tell you the truth, I've been secretly planning to tell it to you all along! What is this idea? I will now tell you.

Is it completely out of the question that there may be objects in the universe which are so sensitive that the very act of *naming* them throws them out of existence? Now I am not suggesting that the Tao behaves like that; I hardly think the Tao goes out of existence if one so much as names it. But it might well be that the Tao is so remarkably sensitive that when named, it changes ever so slightly—it is not quite the same Tao as it was before it was named. Indeed, if we identify the Tao with the universe as a whole, this must be the case, for the act of naming the universe is itself an event in the universe, hence the universe is not quite the same after as before the event. A better and more poetic way of looking at it is this: They say the Tao is like a mirror. Well, the act of looking into a mirror certainly changes its state, does it not? When you look into a mirror, it reflects you; when you don't, it doesn't. Would it not be difficult indeed to look into a mirror and see it as it would be if you were not looking into it?* And so it is with the Tao! When you name it, it cannot

*I think there should be a Zen Koan concerning this! (A koan is a problem given by Zen-Masters which has no logical solution; its purpose is to force the realization of the futility of logic in dealing with ultimate reality.)

be the un-named Tao which exists when you don't name it. And this unnamed Tao is perhaps more serene, *more truly itself* than the named Tao. In this sense, the true Tao, the unnamed *Tao* is nameless.

Incidentally, some Taoists have made a distinction between the nameless Tao and the Tao which can be named,

> Nameless, the Tao is the source of
> heaven and earth
> Named, it is the Mother of all beings.

In line with this interpretation, it might be more appropriate to refer to the true Tao as unnameable rather than nameless. It is unnameable because it changes in the very process of naming it.* Suppose instead of naming the Tao we merely think about it; does that also change it? I suspect it does! Doesn't the universe change whenever we think about it? Of course it does! When one thinks about the universe, the universe contains one who is thinking about it; when no one is thinking of the universe, the universe contains no one who is thinking of it. The situation reminds me of those elves who come in the night and make shoes for the family, but if anyone ever turns on the light and sees them at work, they vanish and never come back.

So perhaps the moral of the story is that the Tao needs a certain amount of privacy and withers away under too many prying eyes and prying minds. So we might conclude by saying:

> The Tao had best be left at rest,
> Like little birdies in their nest.

*This is reminiscent of the Heisenberg uncertainty principle that any measurement of the state of a small particle will itself change the state.

9.

THE TAO DOES NOT TALK

That's another reason I like the Tao so much; it doesn't talk! I hate people who talk too much. When I'm in company, *I* like to be the one to talk; others should just respectfully listen!

Is it not marvelous that I can talk to the Tao to my heart's content, and the Tao never contradicts me or answers back? The Tao never criticizes me for being egocentric or talking too much.

When I talk about talking to the Tao, the more sophisticated and psychoanalytically oriented reader will say that I am not really talking to the Tao, I am really talking to myself. But this is not so! Since all words come from the Tao, my talking to the Tao is not really me talking to myself but the Tao talking to *itself!* So, you see, the Tao talks to itself. Yet the Tao does not talk, it is silent! Is this not a remarkable paradox?

10.

THE TAO AND THE SAGE:
THEY NEVER ARGUE

1. THE TAO.

Does the Tao ever argue? Of course not! With whom could it argue? At least, I have never heard it argue; it has never once argued with me.

How unlike the Tao, in this respect, is God! The Old Testament is full of characters arguing with God about all sorts of things! But could you, in your wildest imagination, conceive anything as preposterous as arguing with the Tao?

2. AND THE SAGE?

What about the Sage? Does he ever argue? Let us see!

CHINESE SAGE: Laotse said, "The good man does not argue; he who argues is not good."

WESTERN LOGICIAN: I disagree!

SAGE: You disagree with what?

LOGICIAN: With what you said!

SAGE: And what was that?

LOGICIAN: That the good man does not argue.

SAGE: Wrong!

LOGICIAN: What do you mean "wrong"?

SAGE: I never said the good man does not argue.

LOGICIAN: Of course you did! You distinctly said that the

good man does not argue and that he who argues is not good.

SAGE: Nope! I merely said that Laotse said that.

LOGICIAN: Oh, all right! You knew what I meant.

SAGE: Whose being illogical now?

LOGICIAN: Oh, come off it! Why are you so argumentative?

SAGE: I am not being argumentative. I am merely being logical.

LOGICIAN: You are hardly being logical. I would say you are being irritatingly logical.

SAGE: Now, what kind of logic is that? If I am being irritatingly logical, then a-fortiori I am being logical.

LOGICIAN: Again you argue! Why are you being so argumentative? After all, as you said, the good man does not argue.

SAGE: I didn't say that! I said that Laotse said that.

LOGICIAN: And do you believe it?

SAGE: Do I believe what? That Laotse said that?

LOGICIAN: No, no! Do you believe that what Laotse said is true?

SAGE: Yes.

LOGICIAN: Oh, then you do believe that the good man does not argue.

SAGE: Yep!

LOGICIAN: So why didn't you say so?

SAGE: Why should I have?

LOGICIAN: There you go arguing again! You are so inconsistent!

SAGE: How so?

LOGICIAN: Because you admit that the good man does not argue, and you go on arguing with complete disregard of that fact.

SAGE: I am not being inconsistent. It just so happens that at the moment I feel more like arguing than being good.

Now let us discuss Laotse's statement. I, like the Westerner, do not agree—at least fully. There may be some

truth in it, but to say the good man *never* argues strikes me as a foolish exaggeration. After all, I argue, and am I really all that no-good? Now, it may be that the good man tends to argue less, but I hardly think the good man does not argue at all.

Take my cousin Arthur, for example. He is a good man, and he argues a great deal. He is a philosopher in the true Western tradition. When he was a student, he was taking a philosophy course with Morris Cohen at C.C.N.Y. All through the semester, he argued and argued and argued. At one point Professor Cohen said, "Now please, this is a history of philosophy course. No more argumentation! If you wish to ask questions, I will be happy to answer them, but no more argumentation!" My cousin respectfully replied, "Very well then, Professor Cohen, I wish to ask a question: How would you answer the following argument? . . ."

Now, if Laotse had said "The *Sage* does not argue", I might have agreed with him even more. Sages are usually quite sagacious, and part of sagacity is the realization of the futility of argument. But how many Sages are there? Even *I* am not yet a Sage—I argue far too much! I would love to be a Sage, but not if I have to pay the ridiculous price of not arguing!

This brings me now to a curious question: Supposing someone really believes that the Sage does not argue and also wants to become a Sage but he also loves to argue. What should he do? Is he really more likely to become a sage by deliberately refraining from arguing? Should he *inhibit* his argumentative impulses? I hardly think this will work! Instead of becoming a "sage", he will merely become a "frustrated arguer" and will most likely end up committing suicide. On the other hand, if he freely argues all day long to his heart's content, he will one day argue himself out, have nothing more to say, and thus will have reached true sagehood. Here is how I sum it up:

The Sage does not argue.
Not because of some *principle*,
But merely because he has nothing to say.
He is vacuous and stupid
Like a newborn infant
Taking his milk direct from the Mother Tao.
He has all the nourishment he needs.
So why should he argue?

11.

I AM LIKE A MIRROR

The Mind of the Sage is like a mirror which reflects the entire Universe.

Chuangtse

I do not claim to be a Sage. I admire Sages, I love Sages, but unfortunately I am not yet a Sage. But, by God, I am like a mirror! Not so much, perhaps, in the above Taoistic sense, but certainly in my relations with other people. I have simply observed from long experience that virtually everyone I contact seems to see in me *his own characteristics!* The most hostile people I know tell me how hostile I am, the nicest people I know tell me how nice I am, honest people trust me and tell me how genuine and sincere I am, hypocritical and mendacious people tell me that I am basically insincere and a big hypocrite, brilliant people tell me how brilliant I am, stupid people tell me how stupid I am, etc.

Why is this? One possibility is that I *am* a mirror. I simply reflect into people's faces their own souls. There may, however be other explanations. Perhaps I am more like a chameleon and simply take on the characteristics of those I am with. For example, I certainly feel more hostile in the presence of a hostile person, more selfish in the presence of a selfish person, more generous in the presence of a generous person, etc. A brilliant person will certainly stimulate me to my full-

33

est brilliance. But certain cases break down under this "chameleon" hypothesis. For example, a stupid person does not stupefy me into a state of stupidity, a dishonest person does not make me feel any the less honest, and a hypocritical person does not make me feel hypocritical. So this hypothesis has at best, it seems to me, only partial truth.

There is another hypothesis which should please some psychologists. Namely that I am so egocentric, that my judgments of other people may be conditioned primarily by their judgments of me. For example, when someone tells me how hostile I am, I would think, "What a hostile thing to say! He must be a very hostile person", or when told I am brilliant, "How brilliant of him to know what I am really like," or when told I am stupid, "How stupid of him not to recognize my intelligence", etc. This hypothesis would suggest not that I am like a mirror, but rather like an anti-mirror (whatever that is!). The funny thing is that some people I know would quite seriously suggest to me this hypothesis, that the phenomena I describe arise basically out of my own egocentricity. But all these people in question are themselves extremely egocentric! Seriously, though, I think this hypothesis has some elements of truth, but not too many. The reason I largely reject it is that when someone ascribes to me a certain characteristic it is not only I who see that characteristic in him, but virtually everyone else who knows us both assures me that he does in fact have that characteristic. From which it is not unreasonable to conclude that he really does.

So I am back to the hypothesis that I am a mirror. I certainly *feel* like a mirror. And in a way I think I *am* reflecting the entire universe.

12.

THE TAO IS EVERYWHERE

Tung-kuo Tzu asked Chuang-Tzu (Chuangste), "Where is that which you call Tao?" Chuang-Tzu said, "Everywhere". Tung-kuo Tzu said "You must be more specific". Chuang-Tzu said, "It is in this ant". "In what lower?" "In this grass". "In anything still lower?" "It is in tiles". "Is it in anything lower still?" Chuang-Tzu said, "It is in ordure and urine". Tung-kuo Tzu had nothing more to say.[1]

H. G. Creel[1] makes the following commentary on this passage:

This is indeed, in William James's phrase, a "tough-minded" conception of the universe. It makes not the least concession to human vanity or sentiment. The ultimate nature of the universe has just as much, and just as little, relation to my mind as it has to the smallest pebble lying in the road. Certainly other men, besides Chinese Taoists, have been able to accept a view so unflattering to the human race.

I see the situation differently from Creel (at least in that passage; later on he appears to see it differently too). More specifically, I do not see the Taoist viewpoint portrayed in the above passage of Chuangtse as unflattering to the human race, nor do I see it as a "tough-minded" conception of the universe.

It all depends on the point of view. Those who think of

human beings as somewhat "superior" to ants, grass, and the other things would of course regard Chuangtse's passage as somehow unflattering to the human race. But one could alternatively interpret Chuangtse's passage not as a deglorification of humans, but as a glorification or beautification—or even beatification—of these other things. At least that is the way I reacted to it. Also, I do not believe the philosophy of the passage represents a "tough-minded" view of the universe; rather I believe that it will appear to do so *in the eyes of the tough-minded!* The truly tender-minded will, I think, love this passage and see it as beautifully tender-minded. Thus the tough-minded will see it as tough-minded, the tender-minded as tender-minded. Which shows that Chuangste, being a true sage, is like a mirror—everyone sees in him his own qualities!

13.

THE TAO DOES NOT COMMAND

The great Tao flows everywhere,
 to the left and to the right
All things depend upon it to exist,
 and it does not abandon them.
To its accomplishments it lays
 no claim.
It loves and nourishes all things,
 but does not lord it over them.

(Laotse, tr. Alan Watts)[1]

That is another thing so nice about the Tao; it is not bossy! It loves and nourishes all things but does not lord it over them. Thus the Tao is something purely helpful—never coercive!

In the Judeo-Christian notion of God, one thing which is so rigidly stressed is *obedience* to God! The great sins are "disobedience, rebellion against God, pride, self-will", etc. The Christians are constantly stressing the infinite importance of "total surrender of one's will to God". They say, "Let thy will, not mine, be done".

How very different the Taoist! He never speaks of "obedience" to the Tao but only of "being in harmony" with the Tao—which seems so much more attractive! And being in

harmony with the Tao is not something "commanded", nor something which is one's "duty", nor something demanded by "moral law", nor something sought for some future reward, but is something which is its own reward; it is in itself a state of spiritual tranquility. In this respect it does resemble the Judeo-Christian notion of "communion".

Another thing, it would seem sort of odd to the Taoist to speak of "surrendering one's will to the Tao". In the first place, it doesn't sound quite right to say that the Tao has its own "will". The Tao is certainly not willful, and I think the Toist would tend to regard things having their own will as somehow "willfull"—but let that pass! At any rate, the idea of "surrendering" one's will to the Tao would seem inappropriate since an individual's so-called "will" is but part of the Tao. It's not that the Taoist denies free will (nor would he affirm it, for he would tend to regard the whole free will-determinism controversy as a confusing duality), but he would rather say that whatever it is which we call "free-will" is but part of the activities of the Tao. Goethe expressed a similar sentiment when he said that in trying to oppose nature we are only acting according to the laws of nature. Similarly Suzuki has said that Western man thinks he is controlling or conquering nature; he does not realize that in so doing, he is only acting according to the laws of nature.*

I must confess that all my life I have reacted with the utmost horror to the idea of "obedience to God"—and even more so to "surrendering one's will to God". Some Christians would tell me that I find this idea so horrifying because of my own pride, dissobedience, egotism and self-will. But is this really so? I could see some merit in that argument if I objected only to myself surrendering my will to God, but did not mind other people surrendering their wills to God. But

*I think that one who fully realized the shattering impact of this statement would attain a sort of Satori.

this is not the case. I hate the idea of anyone surrendering his will to God. Indeed, I am repelled by any situation in which one sentient being surrender's his will to another sentient being. I just cannot accept situations in which one commands and the other obeys.

There is, however, one mitigating feature of the situation which I only realized quite recently, as a result of reading some of the writings of Alan Watts. And that is that if a person decides to surrender his will to God, and spends several years undergoing the inner discipline, self-mortification, purgation, etc., he finally reaches a stage in which he suddenly realizes that the issue he has been so violently struggling with is purely illusory! That is to say, he suddenly realizes that his will has been part of God's will all along and that even his so-called "rebellion" has been but part of God's activities. In other words, he realizes not that he "shouldn't" rebel against God, but that he simply *cannot.* Put in less theological terms, it is like the man who suddenly has a Satori-like realization that he is not controlling Nature, as he had thought, but rather that Nature is controlling him to think that he is controlling Nature—or better still, that neither is he controlling Nature nor is Nature controlling him, but that he and Nature are one. (Who knows, perhaps that is what Jesus really meant when he said in the fourth Gospel, "The Father and I are one.")

Now, if "surrendering one's will to God" really does lead to this wonderful state—so close to Taoistic harmony or Zen Satori—then there is of course something to be said for it. But must one go through these horrible spiritual gymnastics to attain this end? Is there not a saner path?

I can only think again of the Taoist Sage by the river stream, not worrying about "obedience" or "surrendering his will" or not even conceptualizing the notion of "being in harmony with the Tao", but simply being in harmony with the Tao and enjoying it to his hearts content.

14.

THE TAO IS NOT
ARROGANT

The Tao is not arrogant,
Nor does it condemn arrogance.
Arrogance comes *from* the Tao,
 but is not *of* the Tao
Since the Tao is free from arrogance,
What need it to invent the
 concept "arrogance"?

There are many sayings uttered by great men of the past which, to my sorrow, have been labeled "arrogant". I wish to consider some of them, and to suggest an alternative viewpoint.

But first a word or two on arrogance in general. I have repeatedly observed that people who are quick to label others "arrogant", usually have in themselves that very quality which they call "arrogance". Take me for example: Here I am telling those who label other as arrogant that they themselves are arrogant. Is this not arrogant of me?

Now let us turn to some of the sayings.

1. I have told several people that I greatly prefer Confucious to many Western moralists because Confucious does not say, "You *should* do this; you *shouldn't* do that", but rather, "The superior man does this; the Sage does that," etc. Now many people—all of them arrogant—have reacted,

"How arrogant of Confucious! Who does he think *he* is to know what the superior man and Sage do!"

What can I tell such people?

2. Similarly Laotse said words to this effect:

> When the superior man hears of the Tao,
> he practices it.
> When the ordinary man hears of the Tao,
> he ignores it.
> When the inferior man hears of the Tao,
> he laughs at it.
> If it were not laughed at,
> it would not be the true Tao.[1]

Again some people will say, "So, Laotse thinks he is one of the "superior" people who really understands the Tao, while "lesser" people ignore or laugh at it". Again, what can I tell such people? Any argument I give is only dismissed as a "rationalization". Perhaps I should remember Laotse's words, "The good man does not argue. He who argues is not good".

But I feel like arguing a little. At the moment I feel more like arguing than being good. So I shall argue.

My argument is ridiculously simple, almost trivial: A person who recognizes greatness in others does not necessarily think of himself as great. To know what the Sage does, one does not necessarily have to be a Sage.

Coming back to Confucious, he not only did not think of himself as a sage but was evidently reluctant to say of anyone that he was a sage. Consider the following dialogue which, with minor modifications is from the Book of Lieh Tzu.[2]

"A high official from Shang said to Confucious, "You are a sage, are you not?"

"A sage!" replied Confucious in astonishment, "How could I venture to think so? I am a man with a wide range of learning and information, but I would hardly say I am a sage!"

The minister then asked "Were the Three Kings sages?"

"The Three Kings", replied Confucious "were great in wisdom and courage. I do not know, however, that they were sages".

"What of the Five Emperors?"

"The Five Emperors excelled in the exercise of altruism and righteousness, but I would hardly go so far as to say they were *sages*".

"And the Three Sovereigns? Surely they were sages."

"The Three Sovereigns excelled in the virtues that were suited to their age, but whether or not they were Sages, I cannot really say."

"Why, who is there then," cried the minister, much astonished, "that is really a Sage?"

Confucious looked thoughtful and after a pause said, "Among the people of the West dwells one who may be a true Sage. He governs not, yet there is no disorder. He speaks not, yet he is naturally trusted. He makes no reforms, yet right conduct is spontaneous and universal. So great and incomprehensible is he that the people can find no name to call him by. I suspect that this man is a Sage, but whether in truth he is a Sage or is not a Sage I do not know."[3]

3. Jesus said, "Father, forgive them, for they know not what they do." Many have told me they regard that as arrogant. "Who does this guy Jesus think he is taking such a superior, condescending, arrogant, forgiving attitude?" It should be pointed out that Jesus did not say "I forgive you" but "Father, forgive them" which is quite different.

4. One legend has it that when Buddha was born he exclaimed, "Above the heavens and below the heavens, I alone am the Honored One!"

Many will regard that as arrogant though I frankly regard the notion of arrogance in a newborn baby as rather comical. I love Buddha's statement and approve of it, but I equally love and approve of the Zen-Master Yün-men's comment. He said that had he been there when Buddha made such a

statement he would have killed him on the spot and thrown his body to the dogs!

Please don't misunderstand me. I would not have approved Yün-men's actually killing the baby Buddha and throwing his body to the dogs! I merely approve of, and am delighted with, the statement. It was obviously made for the purpose of counteracting the tendency to deify Buddha and to think that worshiping Buddha is the path to enlightenment. Incidentally, Zen-Masters are not necessarily against worship of the Buddha; some of them worship him and others don't,* but they seem pretty well agreed that worship of the Buddha—whatever value it may have on its own account —is irrelevant to the problem of enlightenment. Indeed, one often "worships" something as a substitute for understanding it! In worshiping an object, one tends to put it at a distance rather than make it one's own. If I needed vitamins, would it not be silly for me to worship them rather than actually take them? A fish abiding in the water hardly worships the water in which he abides. The Sage who abides in the Tao hardly worships the Tao. And to "worship" Buddha—or the Buddha nature—may often be a substitute for acquiring the Buddha nature. I think this is all Yün-men was really saying. At any rate, I hardly believe Yün-men said what he did because he believed the baby Buddha was "arrogant"!

*See chap. 15, "Worship of the Buddha."

15.

WORSHIP OF THE BUDDHA

The fourth Gospel is the only one in which Jesus claimed—or appeared to claim—to be *the* incarnation of God. He said, "The Father and I are one". Did Jesus add, "The Father and you are not one"? Had he added that, the implication would have been that Jesus had some special theological status not shared by other mortals. But he did not say that. From the statement "The Father and I are one" can be derived only the fact that Jesus was an incarnation rather than the incarnation of God. Good heavens, many a Hindoo or Vedantist will say, "Brahman and I are one", meaning that there exists only one Spirit in the universe which is me, also you, also Brahman, etc., and in so doing will certainly not be claiming the unique kind of deity believed by many Christians to be possessed by Jesus.

Some Christians prefer not to think of Jesus as an incarnation of God at all but rather as an unusually enlightened human being who was a great religious teacher and reformer. Some of them achieve this by simply denying the authenticity of the fourth Gospel. But, as I am trying to point out, the fourth Gospel can be consistently retained without entailing ones belief that of all the mortals who have lived, Jesus alone is the incarnation of God.

Now, since the fourth Gospel exists, and I don't see that it is necessary to interpret it in the unorthodox way which I have suggested, then it is not unfair for a Christian to say that there is at least some evidence that Jesus is *the* incarnation.

I personally have doubts about such evidence, but it is understandable to me that others should think differently. Therefore, it makes some sense that many Christians worship Jesus as an actual deity.

But what I cannot understand is that some Buddhists worship Buddha as a deity when Buddha himself most explicitly denied being one! With Jesus it was different; in the first three gospels, he neither affirmed nor denied his deity, and in the fourth, he at least appeared to affirm it. Therefore it makes some sense that some Christians worship Jesus as a deity. But how can Buddhists do this when it goes expressly against Buddha's very words? Do people believe, perhaps, that Buddha really was a deity, but was himself ignorant of the fact? Now, this is certainly logically possible, but it seems fantastic!

It is absolutely amazing how people need to "deify" things and to bring in the occult, telepathic and supernatural into situations where they simply don't belong. It is remarkable how many extremely intelligent people I have known—many of them outstanding scientists and mathematicians—who credit telepathic powers to magicians who do mind reading tricks. Now, I have been a professional magician and mind-reader (sic!) for many years, and here I know whereof I speak! I know the modus-operandi of almost all mind-reading demonstrations, and know they are nothing more than extremely clever tricks. The most remarkable thing of all is that people have sometimes sworn to me that I must be telepathic and have refused to believe me when I swore to them that I am not! I told them over and over again, "This is really a *trick!* It has a perfectly simple mechanical explanation, and any of you could do it yourself, if you knew the explanation (which professional ethics forbids me to disclose)." But they refused to believe me!

And so I think the reason some people insist on Buddha being a deity is their simple need to deify somebody or some-

thing. And so they take it out on poor Buddha!

Worse still, some people insist on deifying statues of the Buddha! Such practices the Hebrews call *idolatry*. Zen-Masters are like the Hebrews in their opposition to this—as well as their opposition to the deification of the personal Buddha. They say such things as, "If you ever meet the Buddha, kill him!" or "Every time you utter the name Buddha, wash out your mouth!"

Now, there is all the difference in the world between worshiping Buddha and worshiping him as a deity! Many worship Buddha in the same way I would worship Beethoven or Mozart, which is certainly not as a deity. Now, worship of Buddha in this sense is a very different story, and I think can have great spiritual value. I wish to tell you of four contrasting incidents about Buddha-worship.

The first, which is well known, is about a Zen-Master in a temple one cold day who needed wood for a fire. For want of any other wood around, he took a wooden statue of the Buddha, broke it into pieces and threw them into the fire. A monk entered the room at that time and was horrified with this "blasphemy". The Master smiled, and explained that he was burning nothing but wood, and that Buddha himself would surely have approved of the act. A great debate followed, and one would infer from it that the Master was the true believer and "follower of the Way" whereas the monk who objected was nothing more than an idolater.

This story is a tiny bit reminiscent of a Haiku poem of Issa:

> Out from the nostrils of the Great Buddha
> Flew a pair of nesting swallows.[1]

This poem strikes me as far more profound than the above story! It is a kind of shock to realize that the same mass of metal can be looked at in two such utterly different ways—as a statue of Buddha, or as a purely physical object with enormous caverns (the nostrils) in which birds can nest. The

same object has two such completely different functions! In a way, is not its function as a "bird nester" somehow more holy than the other? (Perhaps the Zen-master felt the same way about the wooden statue!) I also love the idea of a pair of birds, so beautifully innocent and free from any notions of "reverence" or "worship" making a nest in a statue of the Buddha. The "Buddha nature" of the statue is so delightfully irrelevent to its suitability as a bird-nester.

When I spoke before about "shock", can you not imagine what it would be like standing in the forest before such a statue, totally unaware of the nesting birds. Suddenly, without the slightest warning, you hear flapping wings, and two birds emerge! Can you not imagine obtaining Satori at such a moment?

To diverge a bit further, the above Haiku reminds me a little of the following well-known Haiku of Buson:

> Upon the temple bell, asleep
> A butterfly.[2]

Now for the second story: A Zen-Master was worshiping at a statue of the Buddha. A novice came by and asked, "Why do you worship the Buddha? I thought Zen teaches us not to. Do not some Zen-Masters spit at the Buddha?" The Master replied: "Some spit at the Buddha. I prefer to worship the Buddha".

The third story—which I like still better—goes as follows: A Zen-master was worshiping at a statue of the Buddha. A monk came by and said, "Why do you worship the Buddha?"

"I like to worship the Buddha".

"But I thought you said that one cannot obtain enlightenment by worshipping the Buddha?"

"I am not worshiping the Buddha in order to obtain enlightenment"

"Then why are you worshiping the Buddha? You must have *some* reason!"

"No reason whatsoever. I like to worship the Buddha".

"But you must be seeking something; you must have *some* end in view!"

"I do not worship the Buddha for any end."

"Then why do you worship the Buddha? What is your *purpose* in worshipping the Buddha?"

At this point, the Zen-Master gave the monk a good slap in the face!

Now at this point, it is extremely important to realize that the Master did not slap the monk for being "blasphemous" or "irreligious" or anything like that; he was simply irritated. He had no more "purpose" in slapping the Monk than he had in worshipping the Buddha. Had I been in the Master's place, I also would have felt like slapping the monk. To me, there is nothing more aggressive and hostile than to keep pestering a person as to what his "purpose" is in doing what he does! Some of the most beautiful and important acts in life are done with no purpose whatsoever—though they may serve a purpose, which is something very different! This is sometimes hard for Westerners to understand. I shall say more about this later.

Before I tell you the fourth story, I would like to say a few words on the subject of reverence and irreverence. I find it sad that so many people have to go to one extreme or the other. On the one hand are those who insist on always being solemnly reverent and who are shocked by any irreverence. On the other hand are those who delight in irreverence but are disgusted with and contemptuous of anything sembling of reverence; they dismiss it as romantic sentimental hogwash. The Taoists strike me as having found a happy mean; I have seldom known them to be either fervidly reverent or strikingly irreverent. On the other hand, Zen-Masters have a marvelous capacity for being one minute most reverent and the next as irreverent as can be and to see not the slightest conflict between these states.

I have told you three stories about worshiping the Buddha. Two of them might be characterized as showing natural reverence without any principle that one should be reverent. The other story (about burning the wooden statue) nicely synthesizes reverence and irreverence. Now I will tell you the fourth story which is delightfully irreverent—although I believe that on a deeper level it totally transcends the categories of reverence and irreverence.

A monk came to the Zen-master Ma-Tsu for enlightenment and asked: "What is the ultimate message of the Buddha?" The Master replied "I will show you. But when discussing such solemn matters, you should first make a bow to the Buddha". The monk meekly complied, and whilst in the bowing position, the Master gave him a terrific kick in the pants. This unexpected kick sent him into a paroxysm of laughter and totally dissolved all his morbid irresolutions; at that moment he obtained "immediate enlightenment". For years after he said to everyone he met, "Since I received that kick from Ma-Tsu, I haven't been able to stop laughing".

16.

ABIDING IN THE TAO

In the Judeo-Christian religions, one hears much of "fear of God" and "love of God"—also "obedience to God". In early Chinese Taoism, one speaks not so much in terms of "love of Tao"—and certainly not "fear of Tao"!—but rather of "being in harmony with the Tao".

Fear of Tao is completely ludicrous! Tao loves and nourishes all things, but does not lord it over them! Tao is something totally friendly and benevolent—friendly to *all* beings, not just those who believe in it or "accept it as their Saviour!" Thus Tao is the sort of thing which is impossible to believe in without loving. But the loving of Tao is not stressed for the simple reason that it is so obvious. To command love of Tao would be as silly as commanding one to love his closest friend!

By contrast the Bible commands us to "love the Lord thy God with all thy heart and all thy might". We are also enjoined to seek salvation; it is our duty to seek salvation, our very purpose is to be saved. Indeed some Protestant sects say that the purpose of man is to "love God and enjoy Him forever".

Now, is it not strange that the Taoist Sage abides in the Tao, not because he is "commanded" to nor because it is his "duty", but simply because he loves to! He is not seeking anything from the Tao; he is not striving to "save his soul", nor does he seek any "future reward"; he has no *purpose* in abiding in the Tao; he is in the Tao simply because it is delightful to be there.

The situation is like that of the many children and friends who visit us—sometimes for extended periods—in our country house in Elka Park. They abide with us not because they are commanded to, or because it is their duty, nor do they "discipline themselves" for some future good. They come because—to use the children's words—"we like it here".

17.

THE TAO IS EVER SPONTANEOUS

In the movie version of *Ring of Bright Water,* there is a picturesque episode of the hero (a writer) with the heroine (the village doctor) looking over a beautiful scene. The hero sighs and says, "I really must get back to work. I can't keep idling the rest of my life". The heroine replies: "Why not, if it serves the purpose?"

Just what this purpose was is not made explicit, which is part of the story's charm.

Does the Tao have a purpose? I once asked a female, materialistic, atheist biologist if she believed the universe has a purpose. She replied, "No, I would say that the universe has a direction, but not a purpose." This was an interesting response and quite Taoistic in a way. To attribute "purpose" to the Tao is sort of un-Taoistic. The Tao's inner principal is spontaneity rather than purpose. Unlike the Judeo-Christian God, the Tao does not create or make things; rather it "grows" or "individuates" into them. We might say, in the spirit of Laotse:

> The Tao has no purpose,
> And for this reason fulfills
> all its purposes admirably.

In "Worship of the Buddha", I made a distinction between having a purpose and serving or fulfilling a purpose. For example, it is questionable whether a tree *has* a purpose in

growing, or whether a stream has a purpose in flowing down-hill. Yet these things somehow seem to serve a purpose. One might object: "But a human being should not be compared with a tree or a stream. A human being is a rational creature and should accordingly have a purpose for what he does". Such an attitude beautifully typifies the difference between Taoistic and much Western so-called "rational" thought! It is unfortunately so typical of many thinkers who pride them-selves on their "rationality" to believe that rational human beings should always have a rational purpose. Fortunately, not all Westerners are like this. I am thinking of those authors I so love who in later life have written such things as: "Most of the things I have done in life, I could see no purpose for at the time I did them. Only now do I see the underlying purpose behind them."

Incidentally, to avoid misunderstanding, I am not *against* a person having a purpose; I only deplore the attitude that one always *should* have a purpose. Nor do I believe the Taoist is against the idea of having a purpose. I think he would agree that having a purpose might sometimes serve a very useful purpose indeed, just as spontaneous "purpose-less" activity also sometimes serves a grand purpose.

I have also said that I find it extremely hostile and destruc-tive to always ask a person what his purpose is. I am thinking of a particular case of an unsuccessful musician who once said to an aspiring musician, "I really think you ought to ask yourself *why* you want to give concerts". This struck me as horrible! Why on earth should an aspiring musician ask him-self such a ridiculous question as why he wants to give con-certs? Is it not enough that he *wants* to give them? Perhaps one should also have said to Joan of Arc, "I really think, Joan, that you should ask yourself *why* you want to fight all these battles!"

I have sometimes wondered what appropriate answer the aspiring musician should have given to the question "Why do

you want to give concerts?" I think one excellent answer might be the following short poem entitled "The Fiddler".

> The fiddler plays.
> Though no one listens,
> The fiddler plays.

Another good answer is the following Zen poem by Buk-koku Kokushi.[1]

> Although not conciously trying to guard
> the rice field from intruders,
> The scarecrow is not after all
> standing to no purpose.

I just came across the following poem and commentary from R. H. Blyth's *Zen and Zen Classics*[2] which constitutes a rather wonderful answer to the questions "Why do you want to give concerts?" The poem—by the Zen-master Ikkyu —is remarkably close in spirit to my poem "The Fiddler".

> To write something and leave it
> behind us,
> It is but a dream.
> When we awake we know
> There is not even anyone to read it.

Blyth comments:

> This verse is the conclusion of *The Skeleton*. It is in this transcendental spirit that Shakespeare wrote his plays, careless, so it seems, whether after all that labour and ecstasy they should survive in the form he wrote them, careless even whether they should survive at all.[2]

I can't tell you how much I love the above poem and commentary! I am not enough of a Shakespeare scholar to know whether or not the remarks on Shakespeare are histori-cally accurate, but if it was not Shakespeare who had this delightfully cavalier attitude towards his own work, surely

there are others who have. And nothing fascinates me more than a worker in the arts or sciences who has such a total love of what he does that considerations of fame—or even the nobler sentiment of wishing to share with others—though not necessarily absent, are only of secondary importance.

A Zen story tells of three men at the base of a hill who saw a solitary man standing at the top. They started discussing what his purpose was in being there. One suggested, "perhaps he is looking for a friend". Another suggested, "perhaps he is looking for his dog". The third suggested, "No, maybe he is standing there just to enjoy the fresh air". The three then climbed to the summit. One asked the man, "You have lost a friend?" The man replied "No". The second asked "Oh, you are looking for your dog?" The man replied, "No". The third said, "Ah, so I am right! You are standing there just to enjoy the fresh air!" The man replied, "No". The three were extremely puzzled! Finally one said "Then why are you standing here?" The man replied: "I am just standing here".

The following passage of William James[3] may well throw some light on the "reasons" we do some of the things we do.

> All the daily routine of life, our dressing and undressing, the coming and going from our work or carrying through of its various operations, is utterly without mental reference to pleasure and pain, except under rarely realized conditions. It is ideamotor action. As I do not breathe for the pleasure of the breathing, but simply find that I *am* breathing, so I do not write for the pleasure of the writing, but simply because I have once begun, and being in a state of intellectual excitement which keeps venting itself in that way, find that I *am* writing still. Who will pretend that when he idly fingers his knife-handle at the table, it is for the sake of any pleasure that it gives him, or pain which he thereby avoids. We do all these things because at the moment we cannot help it; our nervous systems are so shaped that they overflow in

just that way; and for many of our idle or purely
"nervous" and fidgety performances we can assign
absolutely no *reason* at all.

I find this passage of James remarkably Taoistic! It serves,
perhaps as still another answer to the question "Why do you
do such and such?" This answer—coming from a western
psychologist and philosopher—may seem less mystical than
the other answers I have given, but the difference is really
quite superficial.

I wish to also mention a gorgeous passage of Jacob Boehme
which perfectly answers the question of what purpose a mys-
tic has in traversing the way. What *is* the purpose of enlight-
enment anyhow? What is the mystic seeking? Perhaps he
should ask himself *why* he wants enlightenment. Is it be-
cause he feels it his duty to do so? Is he seeking the pleasures
of ectstatic rapture? Is he trying to "save his soul"? Just what
is he up to anyhow?

Jacob Boehme says:

> If thou climbest up this ladder on which I climb up
> unto the deep of God, as I have done, then *thou* hast
> climbed well: I am not come to this meaning or to
> this work and knowledge through my own reason, or
> through my own will and purpose; neither have I
> sought this knowledge, nor so much as anything con-
> cerning it.[4]

THE TAO
IS GOOD
BUT NOT
MORAL

道
雖
好
卻
無
倫
理

18.

ARE MEN FUNDAMENTALLY GOOD?

The Taoists and Confucianists both agreed that human nature is fundamentally good, that the unborn "natural" state of man was a good one. Some of the Taoists thought, of course, that Confucianism was corrupting the natural state of man by preaching morality, but there was no disagreement about the fact that man *was* fundamentally good. As Confucious said, "Men are by nature born good, but few retain their goodness till old age." As opposed to both the Taoists and the Confucianists stood the Chinese Legalists (sometimes called "Realists") who believed that human nature was fundamentally bad and hence that to govern realistically one must treat human beings according to their true corrupt nature.

The Legalists set up as hideous a totalitarian regime as has ever existed, in which thousands of Confucian scholars were executed. The government burned all the classics it could lay its hands on, torture and disfigurement were the approved punishments, and everyone was required to spy on everyone else. If a person failed to report a "crime against the government", he was held as guilty as the "criminal". The ideological differences between the Taoists and Confucianists were trivial compared to the enormous differences between either of them and the legalists.

Naturally, I am on the side of the Taoists and Confucianists.

Of course human nature is fundamentally good! Why am I so sure of this? That is what I want to tell you. The proposition "Human nature is fundamentally good" is a logical consequence of two other propositions, both of which are as self evident to me as any axioms, but either or both of which the reader is, of course, free to reject.

The first of my two axioms is that *I* am fundamentally good. This to me is so utterly obvious! By "fundamentally" good, I mean, of course, that I was born good. I say this because I distinctly remember coming into the world in complete good faith, loving and trusting everybody, with good will to all and malice towards none. I only developed hostilities, hatreds, pettinesses, envies, jealousies, etc. as a result of having been mistreated and distrusted. Now, I haven't been all that badly treated, and that's why I'm not half bad as I now stand. But whatever badness I have, t'is nothing more nor less than a reaction to the badness I have experienced. I did not bring this badness into the world when I arrived! Of this I am certain. Thus my first axiom is unequivocably, "I am fundamentally good".

My second axiom is that it is obvious that I am no better than anyone else! Fundamentally better, I mean. Of course, I sometimes act better than other people and sometimes worse. But it is inconceivable to me that human natures can be so radically different that some are good and others bad at birth! No, that is ridiculous! So, if I am fundamentally good, then everyone is fundamentally good. And since I *am* fundamentally good, then *everyone* is fundamentally good.

Postscript: I once told a friend that I believed human nature was fundamentally good. He became extremely excited, agitated, extremely disturbed, a bit angry, and said, "Oh, come now! Everybody knows better! To see how ridiculous your idea is, just look into your own nature!" Well, I took his advice and looked into my own nature. That's how this chapter was born.

19.

WHICHEVER THE WAY

1. MY SYSTEM OF ETHICS

Whichever the way the wind blows,
Whichever the way the world goes,
Is perfectly all right with me!

(Anonymous Taoist)

2. WHICHEVER THE WAY

MORALIST: I have just read your poem:

Whichever the way the wind blows,
Whichever the way the world goes,
Is good enough for me!

TAOIST: You misquoted it. The last line is "Is perfectly all right with me." But I like your version at least as well as mine —in a way, even better.

MORALIST: At any rate, I regard the poem as childish, irresponsible, illogical and morally reprehensible.

TAOIST: That's perfectly all right with me!

MORALIST: No, seriously, I cannot go along with the quietistic philosophy in your poem.

TAOIST: I don't think of it as quietistic.

MORALIST: Of course it is! Superficially your poem bears a resemblance to the Zen poem:

> Sitting quietly doing nothing,
> Spring comes, and the grass grows by itself.[1]

TAOIST: I love that poem; I think it is my favorite.

MORALIST: You would love it! Actually, I myself have nothing against that poem. There is nothing wrong with sitting quietly while the grass is growing because growing grass is something of value. But it is a very different thing to sit quietly while the world is going up in flames!

TAOIST: I never advocated sitting quietly while the world goes up in flames. I never advocated sitting quietly at all. In fact, my poem does not advocate anything.

MORALIST: You say the way things are going is good enough for you. Well, it may be good enough for you, but it sure is not good enough for me! With all the misery and injustice in the world, you might be content to sit quietly doing nothing, letting the wind blow where it listeth, but *I* intend to go out in the world and do something about it, whether you like it or not!

TAOIST: Whether *I* like it or not! Whether *I* like it? I just told you:

> Whichever the way the wind blows,
> Whichever the way the world goes,
> Is good enough for me!

So if you wish to go out and make changes in the world, your doing so is good enough for me.

MORALIST: Sure it's good enough for you if *I* go to the trouble of making changes in the world, but it evidently is not good enough for you if you have to go to the trouble of making the changes.

TAOIST: Why not? If I go out in the world and make changes, that is also good enough for me.

MORALIST: But if things are already good enough for you, why would you want to make any changes?

TAOIST: Why not?

MORALIST: Oh come now, don't be silly! Either things are good enough for you or they are not. You can't have it both ways. If things are good enough for you, then there is no need for you to make changes; if not, then there is. I judge whether things really are good enough for you on the basis of how you act.

TAOIST: I don't see it that way. I lead a very active life, as a matter of fact; I am always busy with some project or other. But I still say that whatever happens is good enough for me. Suppose some of my projects fail. Then I keep trying further until I succeed. Some of my projects I may not succeed in accomplishing in my lifetime. And this very fact is good enough for me.

MORALIST: Suppose you were a doctor and were working hard to save a patient's life. Would you honestly say to yourself, "I am trying my best to save the patient's life, but if he dies, it is perfectly all right with me?

TAOIST: Of course not! I would think it highly inappropriate to express this sentiment at such a time.

MORALIST: Ah, I've caught you! You are being inconsistent! On the one hand you say that *all* the things which happen are good enough for you, and yet you admit of a particular happening that it is not good enough for you. So plainly you are inconsistent!

TAOIST: Oh, for God's sake, come off it! You the great logician have caught *me* in an inconsistency! I affirm a universal statement and yet I deny an instance! Tut, tut, isn't that just terrible!

MORALIST: Well, what do you have to say for yourself?

TAOIST: What do I have to say for myself? Mainly that you are a first-class dope! That is the main thing I have to say.

Now look, will it make you any happier if I change the poem as follows? Suppose some very unpleasant event occurs —call it event E—then I can change the poem thus:

Whichever the way the wind blows,
Whichever the way the world goes,
Is perfectly all right with me
Except for event E.

MORALIST: That is still no good. This means that you have to change the poem every time you come across a different unpleasant event.

TAOIST: Not at all! I can simply use the symbol "E" once and for all as a variable ranging over all unpleasant events.

MORALIST: I think you are being facetious!

TAOIST: Of course I am! My facetiousness is obviously only an annoyance reaction to your pedantry.

MORALIST: But honestly now, why should you regard it as pedantic that I object to a simple inconsistency? How can you seriously maintain that everything that happens is all right with you and yet admit that certain things which happen are not all right with you.

TAOIST: I never maintained that everything that happens is all right with me. I never said that taking each thing that happens, that very thing is all right with me. I said "whichever the way the world goes" is all right with me. I was thinking of the direction of the world as a whole as one *unit.* The fact that I like the world as a whole does not mean that I like each part in isolation from the rest.

MORALIST: It has suddenly occurred to me that maybe I have misjudged you. Perhaps all you are trying to say is that you accept the will of God. Maybe you are trying to say, "Let thy will, not mine, be done."

TAOIST: If it makes you happy to think of it in these theological terms, by all means do so. I would not put it in those words, but perhaps they are not too far from what I have in mind. Your first suggestion, that I accept the will of God, comes closer than "Let thy will, not mine, be done."

MORALIST: What is the difference between the two?

TAOIST: To me they are, at least psychologically, very dif-

ferent. I recall in my bachelor days I spent one summer in Chicago in which I resided in a theological seminary. I had many conversations with the resident minister. One day he asked me whether I would not attend the evening services for the house. Although I did not feel quite right about it, I accepted as a matter of courtesy. And so I went, and at one point we were to fold our hands and pray to God, "Let thy will, not mine, be done." I vividly recall at this point that I felt hypocritical—indeed as if I actually were lying. Could I in all sincerity really wish that God would do his will rather than mine? Suppose, for example, that Christianity were true, and that God would will that I be damned and suffer eternal punishment. Could I really *sanction* God doing this to me? Or to anyone else, for that matter? Even Satan himself? Besides, if the Christian God really exists, it would seem rather ludicrous for a weak defenceless creature like myself to have to give his approval of God carrying out his own will. Obviously God will do what he wills, whether I like it or not. I'm sure this sentiment has often been expressed before, but I cannot help expressing it again. Anyhow, for these reasons, the phrase "Let thy will, not mine, be done" has never sounded right in my ears. Your first idea of "accepting the will of God" is different. Accepting something is not the same as desiring it. And that is why I say that your first suggestion comes closer to my meaning than your second although it still is not quite what I mean.

MORALIST: Well, if this is not what your poem means, then I am still puzzled as to what it really means.

TAOIST: Why do you work so hard trying to find its *meaning?* Can't you just accept it for what it is, and simply say "It's a good poem" or "It's a rotten poem"?

MORALIST: No, no, there must be a meaning in it. You say you are not advocating quietism, surely you are not advocating activism. I guess you are just advocating accepting the world as it is.

TAOIST: No, I am not *advocating* anything.

MORALIST: Surely your idea must somehow affect your attitude towards the world, and have some effect on your behavior.

TAOIST: Attitude, yes; behavior, no.

MORALIST: Have you always had this attitude?

TAOIST: Definitely not.

MORALIST: Well, since you had it, would you say that you have become more or less active than formerly?

TAOIST: Neither. My external actions have undergone no appreciable change.

MORALIST: But you must have *some* ethical message in your poem. Why did you choose such a pompous title as "My system of Ethics"? According to the last few things you have said, you seem to have no system at all.

TAOIST *(laughing):* I deliberately chose such a pompous title as a jest at moralists, who tend to take themselves so seriously! I was delighted at the very pomposity of the title "My System of Ethics" leading the reader to expect that I was going to come out with some ponderous analysis of what is the ultimate nature of the "Good", and how people should conduct their lives. And then all that comes out is this silly little poem. And yet, in a way, I honestly believe that this poem does contain—mainly, perhaps, on an unconscious level—a very serious message.

MORALIST: But you cannot tell me what the message is?

TAOIST: I have the same difficulty I would have in trying to explain why a joke is funny.

MORALIST: Well, now, you say that the message does not so much concern people's actions.

TAOIST: That's right.

MORALIST: It just concerns change in attitudes.

TAOIST: Right.

MORALIST: Can you give me any inkling as to what attitude you have in mind? Do you have any idea of what attitudes

you hope your message might engender?

TAOIST: I think so. I think it would tend to make one's actions no less directed or efficient than before—indeed, hopefully even more so—but it would tend to make the actions performed with less fear and anxiety.

MORALIST: Oh, then you *do* have a significant message. In which case I think you owe it to yourself and others to express it more precisely and clearly.

TAOIST: The clearest way *I* can express it is by saying

> Whichever the way the wind blows,
> Whichever the way the world goes,
> It's all the same to me!

EPILOGUE

Several days after I completed this chapter, there was a storm during the night and the wind blew out many of the screens from the porch. Next morning I was standing there looking at the desolation, and my wife came down and said: "Well Raymond, are you still satisfied with whichever the way the wind blows?"

20.

WHY DO YOU HELP YOUR FELLOW MAN?

Imagine a group of four people, each of whom is strenuously engaged in some charity work or some useful social or political activities, each from purely altruistic motives. Someone asks them: "Why do you work so hard helping your fellow man?" We get the following responses: The first says, "I regard it as my duty and moral obligation to help my fellow man". The second replies: "Moral obligations? To hell with moral obligations! It's just that I'll be God damned if I will stand around seeing my fellow man oppressed without *my* doing something about it!" The third replies: "I also have never been very much concerned with things like duties or moral obligations. Its just that I feel extremely sorry for these people and long to help them". The fourth says: *"Why* to I act as I do? To tell you the truth, I have absolutely no idea why. It is simply my nature to act as I act, and that's all I can say".

I should like to compare these four responses. The last one delights me utterly! He seems very Taoistic or Zen-like. He is the true Sage or saint who seems completely in harmony with the Tao. He is the one who is completely natural, spontaneous and unself-consciously helpful. If there is a God, I hope he lets him into heaven first! Close at his heels, I hope, would be the third man. He strikes me as sort of Buddhistic —not "moral" but compassionate, though perhaps a little too self-consciously so.

It is of interest to compare the first and second men. Both are being ego-assertive, but what a difference! The second, though somewhat gruff, is really kind of charming and humorous. He strikes me as the "tough man with a heart of gold" (like some of the rôles played by Humphrey Bogart). He is really a very sympathetic person who is somehow ashamed to admit the fact and does not wish to appear sentimental. If I were God, I would, of course, let him into heaven too.

But the first man! Good heavens, what a monstrosity! I'm sorry to offend those readers brought up in a puritanical tradition, but I can no more help feeling as I feel than you can. People like the first man are so often pompous, vain, ego-assertive, puritanical, inhuman, self-centered, dominating and unsympathetic. They are the people who act out of "principles". In a way, they are even worse than people who don't help others at all! Now if I were God, I would, of course, let him into heaven too, but not for awhile! I would first send him back to earth for a few years for a little more "discipline".

Some pragmatic readers may well say: "Why this emphasis on how a person phrases it; does it not really all come to the same thing? Isn't the important thing how helpfully a person acts rather than his motives or reasons for doing so?" My answer is "No". I feel that if people's actions are helpful, but engaged in the wrong spirit, they can—in the long run—be as harmful as no helpful actions at all. I guess I have been very influenced by the Chinese proverb: "When the wrong man does the right thing, it usually turns out wrong".

21.

TAOISM VERSUS MORALITY

MORALIST: I must say, I am intensely disturbed by the way the world is going from bad to worse. All objective moral standards seem to be disappearing. Nowadays, everyone is talking in terms of what's right for me or right for you or right for him—never what is really right in itself. All moral judgments—they say—reduce ultimately to purely subjective tastes and preferences. So with the disappearance of any objective code of morality, it is no wonder that civilization is rapidly going to its destruction!

TAOIST: Then you are talking to the right man. I happen to be one of those who do believe—and strongly—in objective moral standards.

MORALIST: Really! How wonderful! You have no idea what a relief it is to meet the likes of you in these amoral times. Are you also interested in the logic of ethics? Have you ever considered, for example, the question of whether ethics is finitely axiomatizable?

TAOIST: I don't think I follow you.

MORALIST: I mean, can all of ethics be dreived from a finite number of assumptions—ethical axioms—or are an infinite number of such axiomatic principles required?

TAOIST: Oh, a finite number, definitely! Indeed, only a very small finite number—one, to be exact! All of ethics can be reduced to just one principle.

MORALIST (*eagerly*): And what is this principle—the Golden Rule, perhaps?

TAOIST: Oh no! My principle is far more basic. It is simply that everyone has the right to do whatever he wants!

MORALIST *(after a moment of dazed silence):* Oh, my God! Never in my life have I been so foully, so brutally deceived! Here I was prepared to give you all my trust, to accept you as a fellow Moralist, and you come out with this monstrous sentiment—not an amoral sentiment—but positively the most antimoral sentiment I have ever heard! You will excuse me that I am still in a slight state of shock!

TAOIST: I do not see this sentiment as antimoral at all.

MORALIST: Of course it is! In the first place, the idea of everybody doing whatever he wants would, of course, lead to anarchy.

TAOIST: Oh, not at all! If the people want laws, they have a perfect right to pass them. The criminal has a perfect right to break them, the police have a perfect right to arrest him, the judge has a perfect right to sentence him to jail, and so on.

MORALIST: Now wait a minute, you're playing a sophistical trick on me! If the criminal had the right to break the laws (which of course he doesn't), then the police would not have the right to arrest him.

TAOIST: Why not?

MORALIST: Because obviously, if a person has the right to do something, then no one else has the right to stop him or punish him for what he has done.

TAOIST: But that obviously cannot be true, since I just told you that anyone has the right to do anything.

MORALIST: Then you are obviously using the word *right* in a way which is totally meaningless. According to any conceivable notion of *right*, if a person has the right to do something, then no one has the right to stop him.

TAOIST: But that is not true. According to the notion of right to which I adhere, your statement is simply false, since two different people can want to do conflicting things.

MORALIST: Then you are being inconsistent. There simply is no possible interpretation of the word *right* according to which everybody has the right to do exactly what he wants.

TAOIST: I will grant that according to your concept of *right* it is obviously false that everyone has the right to do what he wants. However it is not the case that under no interpretation of *right* is it true that everyone has the right to do what he wants.

MORALIST: There is no such interpretation!

TAOIST: There most certainly is.

MORALIST: There is not!

TAOIST: Would you care to bet on it?

MORALIST: With all my heart!

TAOIST: Then I'm afraid you would lose. Simply define an act to be *right* if the doer of the act wants to do it. Under that definition, it is trivial that one has the right to do what one wants.

MORALIST: Oh my God, what a cheap sophistical trick! You are playing silly meaningless word games, giving purely abstract arguments which have nothing to do with reality. Of course according to your purely ad hoc definition of *right,* what you say is trivially true. But who in his right mind would accept such a horrible definition?

TAOIST: You raise several interesting points. In the first place, you did not originally say that under no *acceptable* definition of *right* can it be true that one has the right to do whatever one wants, but that under no definition was this the case. Therefore, I gave you some definition—albeit possibly an unacceptable one—as a counterexample.

MORALIST: But that is exactly what I mean by playing word games! Why should you give me such a definition, knowing full well that I would find it most unacceptable?

TAOIST: In order to establish an extremely important point! Originally, you were decrying the lack of objective moral standards. I am trying to show you that it is not mere

objectivity you want. Many, many different objective defini-
tions of *right* and *wrong* can be given, all of them perfectly
precise. But for you to accept one, it must pass your own
purely subjective standards.

MORALIST: Of course! So what?

TAOIST: Originally you were decrying subjectivity in mor-
als, and I claim that in the last analysis you are being no less
subjective than those you criticize. Of course subjective mor-
alists are subjective, but they at least have the honesty to
realize it. My main criticism of so-called objective moralists
is that they are just as subjective as the subjective moralists,
only they don't realize it. They hide their subjectivity behind
a cloak of objectivity.

MORALIST: What about the objective moralist who be-
lieves in God? He defines the good as concordance with
God's will. Can there be anything subjective about that?

TAOIST: Of course there is! Abstractly it might appear ob-
jective. The only trouble is that one's choice of religion—the
nature of the God one believes in—is determined entirely by
subjective attitudes. Hence, when someone says, "You
should do so and so, not because I feel you should, but be-
cause God's morality demands it", then I feel strongly that he
is hiding his own purely subjective feelings behind a cloak of
objectivity. Mind you, I am not necessarily against subjectiv-
ity, provided it is honestly recognized as such.

MORALIST: If I really wish to hide my subjectivity behind
a facade of objectivity, then according to you I have the
perfect right to do so! After all, you said I have the right to
do whatever I want!

TAOIST: This is a silly attempt at a reductio ad absurdum
argument, but I'm glad you brought it up since it will serve
perfectly to illustrate a point.

Of course you have the *right* to! I am not questioning that.
But I don't believe you really want to! I know you well
enough to know that honesty is one of your values. I do not

believe that you are consciously or deliberately hiding your subjectivity behind a mask of objectivity. You don't know that you are doing this. And the only reason I am trying to convince you is my absolute faith that once you recognize what you are doing, you will no longer wish to continue doing it. You see, our main difference is that I have far more faith in the essential goodness of human wants than you do.

MORALIST: But really now, the statement that one has the right to do whatever one wants! It is this word *whatever* that I find so disturbing. Is not your statement honestly equivalent to the denial of morality altogether?

TAOIST: Logically equivalent, possibly, yes. Psychologically equivalent, certainly not! Most people are far more shocked by my statement than by a mere denial of morality. Amoralists have been in existence long enough that they are no longer a frightening novelty to moralists. So when an amoralist denies the objective reality of morality, the moralist will certainly disagree but still take it in his stride. But when somebody comes along and admits there is such a thing as right and wrong, and then proceeds to say that anyone has the right to do whatever he wants, this seems not like amorality but like a hideous perversion of morality!

MORALIST: True. Tell me, since you know your remark shocks people, why did you make it?

TAOIST: Because again, I know you well enough to realize that you would not want me to withhold the truth—or even what I believe to be the truth—just in order to avoid giving you a shock.

MORALIST: But do you really believe it is the truth? Don't you find anything dangerous in your statement? Don't you realize how it can be used to justify the most horrible behavior imaginable?

TAOIST: I can well imagine how it might appear to, but I am much less frightened than you that it actually will. Again, I feel that our main temperamental difference is that I have

far more confidence than you in the fundamental goodness
of human nature. Therefore I am less afraid than you of
people doing what they really want. Is there really so much
difference between my maxim and the well-known (and
much more acceptable) saying "Love God, and do as you
will"?

MORALIST: I am afraid you are being unrealistic. You be-
lieve that man's very instincts are good, whereas anyone
who, instead of indulging in wishful thinking, knows how
things really are, knows that man's natural primitive im-
pulses are extremely dangerous unless checked by reason
and morality. A man who is all id is a menace to himself and
society. The id must be disciplined by the ego and superego
to create a truly socialized being.

TAOIST: It seems to me that somewhere I have heard this
before!

MORALIST: I am hardly claiming this to be original! The
important thing is that it is true.

TAOIST: To me, the more important thing is that it is false.

MORALIST: Are you not being a bit on the dogmatic side?

TAOIST: Of course! But no more than you are being.

MORALIST: Let us not quibble about this childish point!
The thing is, how do you know that the point of view I hold
is false?

TAOIST: I do not claim to *know* it; the issue is highly contro-
versial. My own experiences in life have led me to feel that
the picture you describe is quite wrong—the picture of the
id as the wild, ferocious, dangerous beast, and the superego
as the avenging hero who holds the id in check. If I think in
these Freudian terms at all (which incidentally I usually
don't), my picture is rather the opposite; I see the poor ma-
ligned id as really of a sweet and loving nature, but the
superego, by chaining and torturing the id, drives it to re-
spond with counterhostility and then indeed sometimes to
commit acts of violence. Then the superego triumphantly

laughs and says "See what a vicious creature the id *really* is! You see now why I have to keep it in restraint? Just think how much more damage it would do if I didn't keep it in check!" The situation is perfectly analogous to a man who does not trust his dog and keeps him perpetually chained. The chaining process obviously makes the dog vicious, and the man then says, "You see why such a vicious dog has to be chained!"

MORALIST: We have discussed the id and superego. Where does the ego come in all this?

TAOIST: That depends upon the individual. Your ego is obviously on the side of the superego; mine is on the side of the id.

MORALIST: Tell me honestly, why are we moralists such a threat? What do you really have against us? Is it merely what you already said about our hiding our subjectivity behind a cloak of objectivity?

TAOIST: No, it is far more than that! You may remember George Berkeley's penetrating criticism of philosophers, "They first raise a dust, and then complain they cannot see." My criticism of moralists is very similar though perhaps even more drastic. You recall that our whole conversation started by your complaining about the increasing immorality in the world. Most moralists are constantly complaining about the world's so-called immoralities, but it is my sober contention that the moralists themselves are the primary source of this trouble. They, more than any other group, cause men to act immorally, despite the fact (or rather because of it!) that they preach morality. They are causing the very trouble they decry.

MORALIST: This is honestly the most unfair accusation I have ever heard in my life!

TAOIST: I'm sorry, but I must be honest. The situation is not without parallel. One medical expert recently said that the greatest health hazard of these times (next to cancer) is bad

doctors. I am not qualified to say whether or not this is true, but it wouldn't surprise me! I have also heard that nineteenth century medicine has killed and sickened far more people than it has saved. This is certainly most plausible! It is not out of the question that economists may have been the prime cause of many of the world's worst economic problems. Parents who go to psychiatrists sometimes find out—to their utter horror—that they are the primary cause of their children's juvenile delinquency and other neurotic problems. Psychiatry itself has not been immune to a similar sort of attack. Some people feel that psychiatry itself has been the major cause of the increasing neuroses of our civilization, despite the fact that it has indeed helped a few individuals. And so it seems that the phenomenon of "raising a dust and then complaining that one cannot see" is hardly confined to the philosophers alone. Why then should you moralists feel so immune from this criticism?

MORALIST: But all you have given me is analogies! You have not told me how we moralists are causing the moral problems of the world.

TAOIST: I have already indicated this somewhat. Recall what I said about the superego keeping the id chained up like a dog, thus causing the id to become vicious, and then blaming the id as being initially vicious. Let me now say more—and in less Freudian terms.

The key point to observe is that there is all the difference in the world between being moralistic and being humane. I think the word *humane* is central to our entire problem. You are pushing morality. I am encouraging humanity. You are emphasizing "right and wrong", I am emphasizing the value of natural love. I do not assert that it is logically impossible for a person to be both moralistic and humane, but I have yet to meet one who is! I don't believe in fact that there are any. My whole life experience has clearly shown me that the two are inversely related to an extraordinary degree. I have

never yet met a moralist who is a really kind person. I have never met a truly kind and humane person who is a moralist. And no wonder! Morality and humaneness are completely antithetical in spirit.

MORALIST: I'm not sure that I really understand your use of the word *humane*, and above all, I am totally puzzled as to why you should regard it as antithetical to morality.

TAOIST: A humane person is one who is simply kind, sympathetic and loving. He does not believe that he *should* be so, or that it is his "duty" to be so; he just simply is. He treats his neighbor well not because it is the "right thing to do" but because he feels like it. He feels like it out of sympathy or empathy—out of simple human feeling. So if a person is humane, what does he need morality for? Why should a person be told that he should do something which he wants to do anyway?

MORALIST: Oh, I see what you are talking about; you're talking about saints! Of course, in a world full of saints, moralists would no longer be needed—any more than doctors would be needed in a world full of healthy people. But the unfortunate reality is that the world is not full of saints. If everybody were what you call "humane", things would be fine. But most people are fundamentally not so nice. They don't love their neighbor; at the first opportunity they will exploit their neighbor for their own selfish ends. That's why we moralists are necessary to keep them in check.

TAOIST: To keep them in check! How perfectly said! And do you succeed in keeping them in check?

MORALIST: I don't say that we always succeed, but we try our best. After all, you can't blame a doctor for failing to keep a plague in check if he conscientiously does everything he can. We moralists are not gods, and we cannot guarantee our efforts will succeed. All we can do is tell people they *should* be more humane, we can't force them to. After all, people have free wills.

TAOIST: And it has never once occurred to you that what in fact you are doing is making people less humane rather than more humane?

MORALIST: Of course not, what a horrible thing to say! Don't we explicitly tell people that they should be *more* humane?

TAOIST: Exactly! And that is precisely the trouble. What makes you think that telling one that one should be humane or that it is one's "duty" to be humane is likely to influence one to be more humane? It seems to me, it would tend to have the opposite effect. What you are trying to do is to command love. And love, like a precious flower, will only wither at any attempt to force it. My whole criticism of you is to the effect that you are trying to force that which can thrive only if it is not forced. That's what I mean when I say that you moralists are creating the very problems about which you complain.

MORALIST: No, no, you don't understand! I am not commanding people to love each other. I know as well as you do that love cannot be commanded. I realize it would be a beautiful world if everyone loved one another so much that morality would not be necessary at all, but the hard facts of life are that we don't live in such a world. Therefore morality is necessary. But I am not commanding one to love one's neighbor—I know that is impossible. What I command is: even though you don't love your neighbor all that much, it is your duty to treat him right anyhow. I am a realist.

TAOIST: And I say you are not a realist. I say that right treatment or fairness or truthfulness or duty or obligation can no more be successfully commanded than love.

Even Jesus, in his more enlightened moments, realized the profound significance of this point. His attitude towards harlots and sinners was not "Shame on you, you are contemptible! I cannot love and accept you the way you are. If you want my love and acceptance you must first change." No, his

whole attitude was "I love you and understand you perfectly, and I understand why you sin. I love you and accept you as you are now. Since I love you, I hope *for your sake* that you stop sinning because I know your sinning is making you unhappy."

MORALIST: You are a fine one to interpret Jesus! Do you think Jesus would ever have said, "Everyone has the right to do whatever he wants"?

TAOIST: No, I do not believe he would. But in the context in which I said it, my motives were to the same effect. I was knocking down morality insofar as it goes counter to true humanity.

MORALIST: But why must morality go counter to humanity? Do we not preach humanity?

TAOIST: We've been through this before. My whole point is that humaneness cannot be preached. Preaching is just the thing to destroy it. I'm afraid you still don't get my central point.

Let me quote you another Christian source. In *Christian Ethics* by Waldo Beach and H. Richard Neibuhr occurs the following wonderful passage about St. Paul:

> In a sense Paul's whole thought on the law may be interpreted as a development of Jesus' idea that a good tree brings forth good fruit and that no amount of external conduct can make men really good. In so far as the imperative moral law remains something external to man, an affair of "You ought" and "You ought not," it cannot make him good at the core; it cannot transform his motives. The imperative form of the law, not its content, is a relative thing which presupposes the presence in man of a desire contrary to the intention of the law. Moreover, the giving of injunctions to men is likely to arouse their self-will and so tempt them to transgress the law. Where there are imperatives, adults as well as children are tempted to see how close they can come to the edge

of the forbidden. Again, imperative law cannot produce that innate, unforced graciousness of conduct evident in Jesus Christ which is so much more attractive and so much more fruitful than self-conscious goodness.[1]

I find this passage most remarkable! It expresses my ethical philosophy better than anything I have said. This represents a vein of Christianity which to my utter amazement is not well known to many practicing Christians.

MORALIST: I'm glad you said "a vein of Christianity" because it is hardly the whole of Christianity. To identify the whole doctrine with this one thread would be most misleading.

TAOIST: Yes, I realize this, unfortunately.

MORALIST: Why do you say unfortunately?

TAOIST: Because I find it painful to have to reject any religion—even atheism. I wish I could accept them all even though they all contradict one another. Each is a composite of many strains, some good, some bad, some indifferent. The best I can do is to pick the finest veins of each and synthesize them as well as I can. In particular, the above passage on Saint Paul emphasizes just that aspect of Christianity which I love.

MORALIST: Of course! You pick just that aspect which suits your purpose. You keep making the same mistake over and over again. Consider the last line of the passage you read: "Again, imperative law cannot produce that innate, unforced graciousness of conduct evident in Jesus Christ which is so much more attractive and so much more fruitful than self-conscious goodness." This is fine for beings like Christ, but I wish you would get it through your head that you and I are not Jesus Christ. We are human beings whose natures are partly good and partly evil. Of course the spontaneous goodness of Christ is more attractive and fruitful than self-conscious goodness. Yes, that is fine for Jesus Christ, but we

are not Jesus Christ. We mortals have to learn the hard way. Even though spontaneous goodness may be better than self-conscious goodness, self-conscious goodness is better than no goodness at all. And since most mortals can learn goodness only in a self-conscious way, at least at first, that's the way it unfortunately has to be.

I think the following considerations may be helpful here. Kant made a significant distinction between what he called a "good will" and a "holy will". A man with a good will is attracted to duty and virtue for their own sake, but that does not mean that he does not have base or ignoble impulses. However, by virtue of his good will, he overcomes his less worthy natural impulses by discipline and self-denial. It is a painful process, but he has the character to overcome this pain. Now, a person with a holy will would have no desire to do a wrong act in the first place. He has no evil desires to overcome, for he has no evil desires at all. So, for example, a man with a good will may have a desire to steal from his neighbor, but he will overcome his temptation to do so because he knows it is wrong. The man with a holy will will not even desire to steal from his neighbor.

TAOIST: Of the two, I prefer the holy will.

MORALIST: Naturally. So do I. The holy will is the greatest blessing one can enjoy. But it is something which must be earned! What have you or I done to deserve the privilege of having a holy will? A holy will belongs to beings like God or Christ or angels or saints. We mortals are rarely if ever born with a holy will; we are lucky enough if we have a good will. One must first struggle through the stage of the good will and by a great effort of discipline overcome one's baser impulses. Then one may be rewarded with a holy will. But the holy will is the reward. Remember that!

TAOIST: I understand perfectly what you are saying. I just don't believe it.

MORALIST: Of course you don't! That is your whole fallacy!

You regard goodness as something that grows spontaneously like a beautiful flower or a tree. But it doesn't. Like other valuable things in life, it requires deliberate cultivation. It requires sacrifice and discipline.

TAOIST: That is about the last thing in the world I believe!

MORALIST: It is your privilege to believe what you like. Nonetheless, what I say is true—harsh as it may sound.

TAOIST: It certainly does sound harsh! It not only sounds harsh, it is harsh! I'm glad you brought up the word "harsh" because I believe it is the key to our entire conversation. Yes, my main criticism of moralists is that they are too harsh. That's it exactly! Most moralists agree with me that human kindness is ultimately the most valuable thing of all. But our methods are as different as night and day. I think that my entire ethical philosophy can be paraphrased in one brief sentence: "Kindness cannot be taught by harshness—not by any amount of harshness." I think this is what I have been struggling to tell you all along. To attempt to teach kindness by harsh measures is like the proverbial war to end all wars. Harshness only encourages harshness; it never encourages kindness. I believe this is the central message of Christianity. It certainly is the central ethical message of Taoism. The Christian passage I just read you on Saint Paul can be summarized in the following single sentence of Laotse. When chiding Confucious for his "morality", Laotse said, "Give up all this advertizing of goodness and duty, and people will regain love of their fellows." That is my philosophy in a nutshell! Give up advertizing goodness and duty, and people will indeed regain love of their fellows.

MORALIST (after a pause): I did not realize you were this strongly Taoistic. I'm afraid it is then rather hopeless for me to convince you of the necessity of the sterner more heroic virtues of life like duty, discipline and sacrifice. I am indeed a moralist in the true Western style, and my views are truly dualistic. But this duality is something quite real, not some-

thing of my own making, as Taoists would claim. There really is a conflict between duty and inclination, and to simply close ones eyes to it does not make it vanish, it only leaves it unresolved. But as I have said, I have little hope that you will see this.

It is now getting late, and we must soon part. There is one last thing I must clear up which is still sorely bothering me. I cannot reconcile your change of attitude as this conversation has progressed. You started out with this monstrous statement "Anybody has the right to do whatever he wants" and then as the conversation developed, you spoke more and more of the virtues of humaneness, kindness, sympathy, empathy and love. Now, although I regard all your ideas of spontaneous goodness, gracious unself-conscious virtue, and so on as childishly unrealistic, I nevertheless realize that your motives are admirable. How then can you possibly reconcile all this with your original horrid statement? Please be really honest with me and tell me absolutely truthfully, do you really believe that anyone has the right to do whatever he wants, or were you merely being provocative?

TAOIST *(laughing):* In a way I was being provocative, and in a way I meant it. I didn't realize this statement was still bugging you! Look, let me put it this way. The statement itself isolated from any context is not one I would say I believe, nor is it the sort of statement I would normally make. But it does make sense in certain contexts. I would make the statement "everyone has the right to do what he wants" only to people who I feel are overly moralistic. I then make the statement only to counterbalance what I believe to be unfortunate tendencies in the opposite direction. I am particularly apt to say this to moralists who are overly strict with themselves rather than with others. All I am *really* trying to say to them is, "I wish you would let yourself alone and stop

beating yourself on the head; I believe you would be better off." That's all I really mean by "Everybody has the right to do whatever he wants." Perhaps a still better way of conveying my real message is to say that if one believes he has the right to do what he wants, then he is more likely to want to do what is right.

22.

IS GOD A TAOIST?

MORTAL: And therefore, O God, I pray thee, if thou hast one ounce of mercy for this thy suffering creature, absolve me of *having* to have free will!

GOD: You reject the greatest gift I have given thee?

MORTAL: How can you call that which was forced on me a gift? I have free will, but not of my own choice. I have never freely chosen to have free will. I have to have free will, whether I like it or not!

GOD: Why would you wish not to have free will?

MORTAL: Because free will means moral responsibility, and moral responsibility is more than I can bear!

GOD: Why do you find moral responsibility so unbearable?

MORTAL: Why? I honestly can't analyze why; all I know is that I do.

GOD: All right, in that case suppose I absolve you from all moral responsibility but leave you still with free will. Will this be satisfactory?

MORTAL *(after a pause):* No, I am afraid not.

GOD: Ah, just as I thought! So moral responsibility is not the only aspect of free will to which you object. What else about free will is bothering you?

MORTAL: With free will I am capable of sinning, and I don't want to sin!

GOD: If you don't want to sin, then why do you?

MORTAL: Good God! I don't know why I sin, I just do! Evil temptations come along, and try as I can, I cannot resist them.

GOD: If it is really true that you cannot resist them, then you are not sinning of your own free will and hence (at least according to me) not sinning at all.

MORTAL: No, no! I keep feeling that if only I tried harder I could avoid sinning. I understand that the will is infinite. If one wholeheartedly wills not to sin, then one won't.

GOD: Well now, you should know. Do you try as hard as you can to avoid sinning or don't you?

MORTAL: I honestly don't know! At the time, I feel I am trying as hard as I can, but in retrospect, I am worried that maybe I didn't!

GOD: So in other words, you don't really know whether or not you have been sinning. So the possibility is open that you haven't been sinning at all!

MORTAL: Of course this possibility is open, but maybe I have been sinning, and this thought is what so frightens me!

GOD: Why does the thought of your sinning frighten you?

MORTAL: I don't know why! For one thing, you do have a reputation for meting out rather gruesome punishments in the afterlife!

GOD: Oh, that's what's bothering you! Why didn't you say so in the first place instead of all this peripheral talk about free will and responsibility? Why didn't you simply request me not to punish you for any of your sins?

MORTAL: I think I am realistic enough to know that you would hardly grant such a request!

GOD: You don't say! *You* have a realistic knowledge of what requests I will grant, eh? Well, I'll tell you what I'm going to do! I will grant you a very, very special dispensation to sin as much as you like, and I give you my divine word of honor that I will never punish you for it in the least. Agreed?

MORTAL *(in great terror):* No, no, don't do that!

GOD: Why not? Don't you trust my divine word?

MORTAL: Of course I do! But don't you see, I don't want to sin! I have an utter abhorrence of sinning, quite apart from any punishments it may entail.

GOD: In that case, I'll go you one better. I'll remove your abhorrence of sinning. Here is a magic pill! Just swallow it, and you will lose all *abhorrence* of sinning. You will joyfully and merrily sin away, you will have no regrets, no abhorrence and I still promise you will never be punished by me, or yourself, or by any source whatever. You will be blissful for all eternity. So here is the pill!

MORTAL: No, no!

GOD: Are you not being irrational? I am even removing your abhorrence of sin, which is your last obstacle.

MORTAL: I still won't take it!

GOD: Why not?

MORTAL: I believe that the pill will indeed remove my future abhorrence for sin, but my present abhorrence is enought to prevent me from being willing to take it.

GOD: I command you to take it!

MORTAL: I refuse!

GOD: What, you refuse of your own free will?

MORTAL: Yes!

GOD: So it seems that your free will comes in pretty handy, doesn't it?

MORTAL: I don't understand!

GOD: Are you not glad now that you have the free will to refuse such a ghastly offer? How would you like it if I forced you to take this pill, whether you wanted it or not?

MORTAL: No, no! Please don't!

GOD: Of course I won't; I'm just trying to illustrate a point. All right, let me put it this way. Instead of forcing you to take the pill, suppose I grant your original prayer of removing your free will—but with the understanding that the moment you are no longer free, then you *will* take the pill.

MORTAL: Once my will is gone, how could I possibly choose to take the pill?

GOD: I did not say you would choose it; I merely said you would take it. You would act, let us say, according to purely

deterministic laws which are such that you would as a matter of fact take it.

MORTAL: I still refuse.

GOD: So you refuse my offer to remove your free will. This is rather different from your original prayer, isn't it?

MORTAL: Now I see what you are up to. Your argument is ingenious, but I'm not sure it is really correct. There are some points we will have to go over again.

GOD: Certainly.

MORTAL: There are two things you said which seem contradictory to me. First you said that one cannot sin unless one does so of one's own free will. But then you said you would give me a pill which would deprive me of my own free will, and then I could sin as much as I liked. But if I no longer had free will, then, according to your first statement, how could I be capable of sinning?

GOD: You are confusing two separate parts of our conversation. I never said the pill would deprive you of your free will, but only that it would remove your abhorrence of sinning.

MORTAL: I'm afraid I'm a bit confused.

GOD: All right, then let us make a fresh start. Suppose I agree to remove your free will, but with the understanding that you will then commit an enormous number of acts which you now regard as sinful. Technically speaking, you will not then be sinning since you will not be doing these acts of your own free will. And these acts will carry no moral responsibility, nor moral culpability, nor any punishment whatsoever. Nevertheless, these acts will all be of the type which you presently regard as sinful; they will all have this quality which you presently feel as abhorrent, but your abhorrence will dissapear; so you will not *then* feel abhorence toward the acts.

MORTAL: No, but I have present abhorrence towards the acts, and this present abhorrence is sufficient to prevent me from accepting your proposal.

GOD: Hm! So let me get this absolutely straight. I take it you no longer wish me to remove your free will.

MORTAL *(reluctantly):* No, I guess not.

GOD: All right, I agree not to. But I am still not exactly clear as to why you now no longer wish to be rid of your free will. Please tell me again.

MORTAL: Because, as you have told me, without free will I would sin even more than I do now.

GOD: But I have already told you that without free will you cannot sin.

MORTAL: But if I choose now to be rid of free will, then all my subsequent evil actions will be sins, not of the future, but of the present moment in which I choose not to have free will.

GOD: Sounds like you are pretty badly trapped, doesn't it?

MORTAL: Of course I am trapped! You have placed me in a hideous double bind! Now whatever I do is wrong. If I retain free will, I will continue to sin, and if I abandon free will (with your help, of course), I will now be sinning in so doing.

GOD: But by the same token, you place me in a double bind. I am willing to leave you free will or remove it as you choose, but neither alternative satisfies you. I wish to help you, but it seems I cannot.

MORTAL: True!

GOD: But since it is not my fault, why are you still angry with me?

MORTAL: For having placed me in such a horrible predicament in the first place!

GOD: But, according to you, there is nothing satisfactory I could have done.

MORTAL: You mean there is nothing satisfactory you can now do, but that does not mean that there is nothing you could have done.

GOD: Why? What could I have done?

MORTAL: Obviously you should never have given me free will in the first place. Now that you have given it to me, it is too late—anything I do will be bad. But you should never have given it to me in the first place.

GOD: Oh, that's it! Why would it have been better had I never given it to you?

MORTAL: Because then I never would have been capable of sinning at all.

GOD: Well, I'm always glad to learn from my mistakes.

MORTAL: What!

GOD: I know, that sounds sort of self-blasphemous, doesn't it? It almost involves a logical paradox! On the one hand, as you have been taught, it is morally wrong for any sentient being to claim that I am capable of making mistakes. On the other hand, I have the right to do anything. But I am also a sentient being. So the question is, Do I or do I not have the right to claim that I am capable of making mistakes?

MORTAL: That is a bad joke! One of your premises is simply false. I have not been taught that it is wrong for any sentient being to doubt your omniscience, but only for a mortal to doubt it. But since you are not mortal, then you are obviously free from this injunction.

GOD: Good, so you realize this on a rational level. Nevertheless, you did appear shocked when I said, "I am always glad to learn from my mistakes."

MORTAL: Of course I was shocked. I was shocked not by your self-blasphemy (as you jokingly called it), not by the fact that you had no right to say it, but just by the fact that you did say it, since I have been taught that as a matter of fact you don't make mistakes. So I was amazed that you claimed that it is possible for you to make mistakes.

GOD: I have not claimed that it is possible. All I am saying is that *if* I make mistakes, I will be happy to learn from them. But this says nothing about whether the *if* has or ever can be realized.

MORTAL: Let's please stop quibbling about this point. Do you or do you not admit it was a mistake to have given me free will?

GOD: Well now, this is precisely what I propose we should investigate. Let me review your present predicament. You don't want to have free will because with free will you can sin, and you don't want to sin. (Though I still find this puzzling; in a way you must want to sin, or else you wouldn't. But let this pass for now.) On the other hand, if you agreed to give up free will, then you would now be responsible for the acts of the future. Ergo, I should never have given you free will in the first place.

MORTAL: Exactly!

GOD: I understand exactly how you feel. Many mortals— even some theologians—have complained that I have been unfair in that it was I, not they, who decided that they should have free will, and then I hold *them* responsible for their actions. In other words, they feel that they are expected to live up to a contract with me which they never agreed to in the first place.

MORTAL: Exactly!

GOD: As I said, I understand the feeling perfectly. And I can appreciate the justice of the complaint. But the complaint arises only from an unrealistic understanding of the true issues involved. I am about to enlighten you as to what these are, and I think the results will surprise you! But instead of telling you outright, I shall continue to use the Socratic method.

To repeat, you regret that I ever gave you free will. I claim that when you see the true ramifications you will no longer have this regret. To prove my point, I'll tell you what I'm going to do. I am about to create a new universe—a new space-time continuum. In this new universe will be born a mortal just like you—for all practical purposes, we might say that you will be reborn. Now, I can give this new mortal— this new you—free will or not. What would you like me to do?

MORTAL *(in great relief):* Oh, please! Spare him from having to have free will!

GOD: All right, I'll do as you say. But you do realize that this new *you* without free will, will commit all sorts of horrible acts.

MORTAL: But they will not be sins since he will have no free will.

GOD: Whether you call them sins or not, the fact remains that they will be horrible acts in the sense that they will cause great pain to many sentient beings.

MORTAL *(after a pause):* Good God, you have trapped me again! Always the same game! If I now give you the go-ahead to create this new creature with no free will who will nevertheless commit atrocious acts, then true enough he will not be sinning, but I again will be the sinner to sanction this.

GOD: In that case, I'll go you one better! Here, I have already decided whether to create this new *you* with free will or not. Now, I am writing my decision on this piece of paper and I won't show it to you until later. But my decision is now made and is absolutely irrevocable. There is nothing you can possibly do to alter it; you have no responsibility in the matter. Now, what I wish to know is this: Which way do you hope I have decided? Remember now, the responsibility for the decision falls entirely on my shoulders, not yours. So you can tell me perfectly honestly and without any fear, which way do you hope I have decided?

MORTAL *(after a very long pause):* I hope you have decided to give him free will.

GOD: Most interesting! I have removed your last obstacle! If I do not give him free will, then no sin is to be imputed to anybody. So why do you hope I will give him free will?

MORTAL: Because sin or no sin, the important point is that if you do not give him free will, then (at least according to what you have said) he will go around hurting people, and I don't want to see people hurt.

GOD *(with an infinite sigh of relief):* At last! At last you see the real point!

MORTAL: What point is that?

GOD: That sinning is not the real issue! The important thing is that people as well as other sentient beings don't get hurt!

MORTAL: You sound like a utilitarian!

GOD: I am a utilitarian!

MORTAL: What!

GOD: Whats or no whats, I am a utilitarian. Not a unitarian, mind you, but a utilitarian.

MORTAL: I just can't believe it!

GOD: Yes, I know, your religious training has taught you otherwise. You have probably thought of me more like a Kantian than a utilitarian, but your training was simply wrong.

MORTAL: You leave me speechless!

GOD: I leave you speechless, do I! Well, that is perhaps not too bad a thing—you have a tendency to speak too much as it is. Seriously, though, why do you think I ever did give you free will in the first place?

MORTAL: Why did you? I never have thought much about why you did; all I have been arguing for is that you shouldn't have! But why did you? I guess all I can think of is the standard religious explanation: Without free will, one is not capable of meriting either salvation or damnation. So without free will, we could not earn the right to eternal life.

GOD: Most interesting! *I* have eternal life; do you think I have ever done anything to merit it?

MORTAL: Of course not! With you it is different. You are already so good and perfect (at least allegedly) that it is not necessary for you to merit eternal life.

GOD: Really now? That puts me in a rather enviable position, doesn't it?

MORTAL: I don't think I understand you.

GOD: Here I am eternally blissful without ever having to suffer or make sacrifices or struggle against evil temptations or anything like that. Without any of that type of "merit", I enjoy blissful eternal existence. By contrast, you poor mortals have to sweat and suffer and have all sorts of horrible conflicts about morality, and all for what? You don't even know whether I really exist or not, or if there really is any afterlife, or if there is, where you come into the picture. No matter how much you try to placate me by being "good", you never have any real assurance that your "best" is good enough for me, and hence you have no real security in obtaining salvation. Just think of it! I already *have* the equivalent of "salvation"—and have never had to go through this infinitely lugubrious process of earning it. Don't you ever envy me for this?

MORTAL: But it is blasphemous to envy you!

GOD: Oh come off it! You're not now talking to your Sunday school teacher, you are talking to *me*. Blasphemous or not, the important question is not whether you have the right to be envious of me but whether you are. Are you?

MORTAL: Of course I am!

GOD: Good! Under your present world view, you sure should be most envious of me. But I think with a more realistic world-view, you no longer will be. So you really have swallowed the idea which has been taught you that your life on earth is like an examination period and that the purpose of providing you with free will is to test you, to see if you merit blissful eternal life. But what puzzles me is this: If you really believe I am as good and benevolent as I am cracked up to be, why should I require people to merit things like happiness and eternal life? Why should I not grant such things to everyone regardless of whether or not he deserves them?

MORTAL: But I have been taught that your sense of morality—your sense of justice—demands that goodness be rewarded with happiness and evil be punished with pain.

GOD: Then you have been taught wrong.

MORTAL: But the religious literature is so full of this idea! Take for example Jonathan Edwards "Sinners in the hands of an angry God." How he describes you as holding your enemies like loathesome scorpions over the flaming pit of hell, preventing them from falling into the fate that they deserve only by dint of your mercy.

GOD: Fortunately, I have not been exposed to the tirades of Mr. Jonathan Edwards. Few sermons have ever been preached which are more misleading. The very title "Sinners in the Hands of an Angry God" tells its own tale. In the first place, I am never angry. In the second place, I do not think at all in terms of "sin". In the third place, I have no enemies.

MORTAL: By that, do you mean that there are no people whom you hate, or that there are no people who hate you?

GOD: I meant the former although the latter also happens to be true.

MORTAL: Oh come now, I know people who have openly claimed to have hated you. At times *I* have hated you!

GOD: You mean you have hated your image of me. That is not the same thing as hating me as I really am.

MORTAL: Are you trying to say that it is not wrong to hate a false conception of you, but that it is wrong to hate you as you really are?

GOD: No, I am not saying that at all; I am saying something far more drastic! What I am saying has absolutely nothing to do with right or wrong. What I am saying is that one who knows me for what I really am would simply find it psychologically impossible to hate me.

MORTAL: Tell me, since we mortals seem to have such erroneous views about your real nature, why don't you enlighten us? Why don't you guide us the right way?

GOD: What makes you think I'm not?

MORTAL: I mean, why don't you appear to our very senses and simply tell us that we are wrong?

GOD: Are you really so naïeve as to believe that I am the sort of being which can *appear* to your senses? It would be more correct to say that I *am* your senses.

MORTAL *(astonished):* You are my senses?

GOD: Not quite, I am more than that. But it comes closer to the truth than the idea that I am perceivable by the senses. I am not an object; like you, I am a subject, and a subject can perceive, but cannot be perceived. You can no more see me than you can see your own thoughts. You can see an apple, but the event of your seeing an apple is itself not seeable. And I am far more like the seeing of an apple than the apple itself.

MORTAL: If I can't see you, how do I know you exist?

GOD: Good question! How in fact do you know I exist?

MORTAL: Well, I am talking to you, am I not?

GOD: How do you know you are talking to me? Suppose you told a psychiatrist, "Yesterday I talked to God". What do you think he would say?

MORTAL: That might depend on the psychiatrist. Since most of them are atheistic, I guess most would tell me I had simply been talking to myself.

GOD: And they would be right!

MORTAL: What? You mean you don't exist?

GOD: You have the strangest faculty of drawing false conclusions! Just because you are talking to yourself, it follows that *I* don't exist?

MORTAL: Well, if I think I am talking to you, but I am really talking to myself, in what sense do you exist?

GOD: Your question is based on two fallacies plus a confusion. The question of whether or not you are now talking to me and the question of whether or not I exist are totally separate. Even if you were not now talking to me (which obviously you are), it still would not mean that I don't exist.

MORTAL: Well, all right, of course! So instead of saying "if I am talking to myself, then you don't exist", I should rather

have said, "if I am talking to myself, then I obviously am not talking to you."

GOD: A very different statement indeed, but still false.

MORTAL: Oh, come now, if I am only talking to myself, then how can I be talking to you?

GOD: Your use of the word "only" is quite misleading! I can suggest several logical possibilities under which your talking to yourself does not imply that you are not talking to me.

MORTAL: Suggest just one!

GOD: Well obviously, one such possibility is that you and I are identical.

MORTAL: Such a blasphemous thought—at least had *I* uttered it!

GOD: According to some religions, yes. According to others, it is the plain, simple, immediately perceived truth.

MORTAL: So the only way out of my dilemma is to believe that you and I are identical?

GOD: Not at all! This is only one way out. There are several others. For example, it may be that you are part of me, in which case you may be talking to that part of me which is you. Or I may be part of you, in which case you may be talking to that part of you which is me. Or again, you and I might partially overlap, in which case you may be talking to the intersection and hence talking to both to you and to me. The only way your talking to yourself might seem to imply that you are not talking to me is if you and I were totally disjoint—and even then, you could conceivably be talking to both of us.

MORTAL: So you claim you do exist.

GOD: Not at all. Again you draw false conclusions! The question of my existence has not even come up. All I have said is that from the fact that you are talking to yourself one cannot possibly infer my nonexistence, let alone the weaker fact that you are not talking to me.

MORTAL: All right, I'll grant your point! But what I really want to know is *do* you exist?

GOD: What a strange question!

MORTAL: Why? Men have been asking it for countless millennia.

GOD: I know that! The question itself is not strange; what I mean is that it is a most strange question to ask of *me!*

MORTAL: Why?

GOD: Because I am the very one whose existence you doubt! I perfectly well understand your anxiety. You are worried that your present experience with me is a mere hallucination. But how can you possibly expect to obtain reliable information from a being about his very existence when you suspect the nonexistence of the very same being?

MORTAL: So you won't tell me whether or not you exist?

GOD: I am not being willful! I merely wish to point out that no answer I could give could possibly satisfy you. All right, suppose I said, "No, I don't exist." What would that prove? Absolutely nothing! Or if I said, "Yes, I exist." Would that convince you? Of course not!

MORTAL: Well, if you can't tell me whether or not you exist, then who possibly can?

GOD: That is something which no one can tell you. It is something which only you can find out for yourself.

MORTAL: How do I go about finding this out for myself?

GOD: That also, no one can tell you. This is another thing you will have to find out for yourself.

MORTAL: So there is no way you can help me?

GOD: I didn't say that. I said there is no way I can tell you. But that doesn't mean there is no way I can help you.

MORTAL: In what manner then can you help me?

GOD: I suggest you leave that to me! We have gotten sidetracked as it is, and I would like to return to the question of what you believed my purpose to be in giving you free will. You're first idea of my giving you free will in order to test whether you merit salvation or not may appeal to many moralists, but the idea is quite hideous to me. You cannot

think of any nicer reason—any more humane reason—why I gave you free will?

MORTAL: Well now, I once asked this question to an Orthodox rabbi. He told me that the way we are constituted, it is simply not possible for us to enjoy salvation unless we feel we have earned it. And to earn it, we of course need free will.

GOD: That explanation is indeed much nicer than your former but still is far from correct. According to Orthodox Judaism, I created angels, and they have no free will. They are in actual sight of me and are so completely attracted by goodness that they never have even the slightest temptation towards evil. They really have no choice in the matter. Yet they are eternally happy even though they have never earned it. So if your rabbi's explanation were correct, why wouldn't I have simply created only angels rather than mortals?

MORTAL: Beats me! Why didn't you?

GOD: Because the explanation is simply not correct. In the first place, I have never created any ready made angels. All sentient beings ultimately approach the state which might be called "angelhood". But just as the race of human beings is in a certain stage of biologic evolution, so angels are simply the end result of a process of Cosmic Evolution. The only difference between the so-called *saint* and the so called *sinner* is that the former is vastly older than the latter. Unfortunately it takes countless life cycles to learn what is perhaps the most important fact of the universe—evil is simply painful. All the arguments of the moralists—all the alleged reasons why people *shouldn't* commit evil acts—simply pale into insignificance in light of the one basic truth that *evil is suffering*.

No, my dear friend, I am not a moralist. I am wholly a utilitarian. That I should have been conceived in the rôle of a moralist is one of the great tragedies of the human race. My rôle in the sceme of things (if one can use this misleading

expression) is neither to punish nor reward, but to aid the process by which all sentient beings achieve ultimate perfection.

MORTAL: Why did you say your expression is misleading?

GOD: What I said was misleading in two respects. First of all it is inaccurate to speak of my rôle in the scheme of things. I *am* the scheme of things. Secondly, it is equally misleading to speak of my aiding the process of sentient beings attaining enlightenment. I *am* the process. The ancient Taoists were quite close when they said of me (whom they called "Tao") that I do not *do* things, yet through me all things get done. In more modern terms, I am not the cause of Cosmic Process, I am Cosmic Process itself. I think the most accurate and fruitful definition of me which man can frame—at least in his present state of evolution—is that I am the very process of enlightenment. Those who wish to think of the devil (although I wish they wouldn't!) might analogously define him as the unfortunate length of time the process takes. In this sense, the devil is necessary; the process simply does take an enormous length of time, and there is absolutely nothing I can do about it. But, I assure you, once the process is more correctly understood, the painful length of time will no longer be regarded as an essential limitation or an evil. It will be seen to be the very essence of the process itself. I know this is not completely consoling to you who are now in the finite sea of suffering, but the amazing thing is that once you grasp this fundamental attitude, your very finite suffering will begin to diminish—ultimately to the vanishing point.

MORTAL: I have been told this, and I tend to believe it. But suppose I personally succeed in seeing things through your eternal eyes. Then I will be happier, but don't I have a duty to others?

GOD *(laughing):* You remind me of the Mahayana Buddhists! Each one says, "I will not enter Nirvana until I first see that all other sentient beings do so." So each one waits for the

other fellow to go first. No wonder it takes them so long! The Hinayana Buddhist errs in a different direction. He believes that no one can be of the slightest help to others in obtaining salvation; each one has to do it entirely by himself. And so each tries only for his own salvation. But this very detached attitude makes salvation impossible. The truth of the matter is that salvation is partly an individual and partly a social process. But it is a grave mistake to believe—as do many Mahayana Buddhists—that the attaining of enlightenment puts one out of commission, so to speak, for helping others. The best way of helping others is by first seeing the light oneself.

MORTAL: There is one thing about your self description which is somewhat disturbing. You describe yourself essentially as a *process*. This puts you in such an impersonal light, and so many people have a need for a personal God.

GOD: So because they need a personal God, it follows that I am one?

MORTAL: Of course not. But to be acceptable to a mortal a religion must satisfy his needs.

GOD: I realize that. But the so-called "personality" of a being is really more in the eyes of the beholder than in the being itself. The controversies which have raged about whether I am a personal or an impersonal being are rather silly because neither side is right or wrong. From one point of view, I am personal, from another, I am not. It is the same with a human being. A creature from another planet may look at him purely impersonally as a mere collection of atomic particles behaving according to strictly prescribed physical laws. He may have no more feeling for the personality of a human than the average human has for an ant. Yet an ant has just as much individual personality as a human to beings like myself who really know the ant. To look at something impersonally is no more correct or incorrect than to look at it personally, but in general, the better you get to

know something, the more personal it becomes. To illustrate my point, do you think of me as a personal or impersonal being?

MORTAL: Well, I'm talking to you, am I not?

GOD: Exactly! From that point of view, your attitude toward me might be described as a personal one. And yet, from another point of view—no less valid—I can also be looked at impersonally.

MORTAL: But if you are really such an abstract thing as a process, I don't see what sense it can make my talking to a mere "process".

GOD: I love the way you say "mere". You might just as well say that you are living in a "mere universe". Also, why must everything one does make sense? Does it make sense to talk to a tree?

MORTAL: Of course not!

GOD: And yet, many children and primitives do just that.

MORTAL: But I am neither a child nor a primitive.

GOD: I realize that, unfortunately.

MORTAL: Why unfortunately?

GOD: Because many children and primitives have a primal intuition which the likes of you have lost. Frankly, I think it would do you a lot of good to talk to a tree once in awhile, even more good than talking to me! But we seem always to be getting sidetracked! For the last time, I would like us to try to come to an understanding about why I gave you free will.

MORTAL: I have been thinking about this all the while.

GOD: You mean you haven't been paying attention to our conversation?

MORTAL: Of course I have. But all the while, on another level, I have been thinking about it.

GOD: And have you come to any conclusion?

MORTAL: Well, you say the reason is not to test our worthiness. And you disclaimed the reason that we need to feel that

we must merit things in order to enjoy them. And you claim to be a utilitarian. Most significant of all, you appeared so delighted when I came to the sudden realization that it is not sinning in itself which is bad but only the suffering which it causes.

GOD: Well of course! What else could conceivably be bad about sinning?

MORTAL: All right, you know that, and now I know that. But all my life I unfortunately have been under the influence of those moralists who hold sinning to be bad in itself. Anyway, putting all these pieces together, it occurs to me that the only reason you gave free will is because of your belief that with free will, people will tend to hurt each other—and themselves—less than without free will.

GOD: Bravo! That is by far the best reason you have yet given! I can assure you that had I *chosen* to give free will that would have been my very reason for so choosing.

MORTAL: What! You mean to say you did not choose to give us free will?

GOD: My dear fellow, I could no more choose to give you free will than I could choose to make an equilateral triangle equiangular. I could choose to make or not to make an equilateral triangle in the first place, but having chosen to make one, I would then have no choice but to make it equiangular.

MORTAL: I thought you could do anything!

GOD: Only things which are logically possible. As St. Thomas said, "It is a sin to regard the fact that God cannot do the impossible, as a limitation on His powers". I agree, except that in place of his using the word *sin* I would use the term *error*.

MORTAL: Anyhow, I am still puzzled by your implication that you did not choose to give me free will.

GOD: Well, it is high time I inform you that the entire discussion—from the very beginning—has been based on one monstrous fallacy! We have been talking purely on a

moral level—you originally complained that I gave you free will, and raised the whole question as to whether I should have. It never once occurred to you that I had absolutely no choice in the matter.

MORTAL: I am still in the dark!

GOD: Absolutely! Because you are only able to look at it through the eyes of a moralist. The more fundamental *metaphysical* aspects of the question you never even considered.

MORTAL: I still do not see what you are driving at.

GOD: Before you requested me to remove your free will, shouldn't your first question have been whether as a matter of fact you *do* have free will?

MORTAL: That I simply took for granted.

GOD: But why should you?

MORTAL: I don't know. Do I have free will?

GOD: Yes.

MORTAL: Then why did you say I shouldn't have taken it for granted?

GOD: Because you shouldn't. Just because something happens to be true, it does not follow that it should be taken for granted.

MORTAL: Anyway, it is reassuring to know that my natural intuition about having free will is correct. Sometimes I have been worried that determinists are correct.

GOD: They are correct.

MORTAL: Wait a minute now, do I have free will or don't I?

GOD: I already told you you do. But that does not mean that determinism is incorrect.

MORTAL: Well, are my acts determined by the laws of nature or aren't they?

GOD: The word *determined* here is subtly but powerfully misleading and has contributed so much to the confusions of the free will versus determinism controversies. Your acts are certainly in accordance with the laws of nature, but to say

they are *determined* by the laws of nature creates a totally misleading psychological image which is that your will could somehow be in conflict with the laws of nature and that the latter is somehow more powerful than you, and could "determine" your acts whether you liked it or not. But it is simply impossible for your will to ever conflict with natural law. You and natural law are really one and the same.

MORTAL: What do you mean that I cannot conflict with nature? Suppose I were to become very stubborn, and I *determined* not to obey the laws of nature. What could stop me? If I became sufficiently stubborn, even you could not stop me!

GOD: You are absolutely right! *I* certainly could not stop you. Nothing could stop you. But there is no need to stop you, because you could not even start! As Goethe very beautifully expressed it, "In trying to oppose Nature, we are in the very process of doing so, acting according to the laws of nature!" Don't you see, that the so-called "laws of nature" are nothing more than a description of how in fact you and other beings *do* act. They are merely a description of how you act, not a prescription of of how you should act, not a power or force which compels or determines your acts. To be valid a law of nature must take into account how in fact you do act, or, if you like, how you choose to act.

MORTAL: So you really claim that I am incapable of determining to act against natural law?

GOD: It is interesting that you have twice now used the phrase "determined to act" instead of "chosen to act". This identification is quite common. Often one uses the statement "I am determined to do this" synonomously with "I have chosen to do this". This very psychological identification should reveal that determinism and choice are much closer than they might appear. Of course, you might well say that the doctrine of free will says that it is *you* who are doing the determining, whereas the doctrine of determinism appears

to say that your acts are determined by something apparently outside you. But the confusion is largely caused by your bifurcation of reality into the "you" and the "not you". Really now, just where do you leave off and the rest of the universe begin? Or where does the rest of the universe leave off and you begin? Once you can see the so-called "you" and the so-called "nature" as a continuous whole, then you can never again be bothered by such questions as whether it is you who are controlling nature or nature who is controlling you. Thus the muddle of free will versus determinism will vanish. If I may use a crude analogy, imagine two bodies moving toward each other by virtue of gravitational attraction. Each body, if sentient, might wonder whether it is he or the other fellow who is exerting the "force". In a way it is both, in a way it is neither. It is best to say that it is the configuration of the two which is crucial.

MORTAL: You said a short while ago that our whole discussion was based on a monstrous fallacy. You still have not told me what this fallacy is.

GOD: Why the idea that I could possibly have created you without free will! You acted as if this were a genuine possibility, and wondered why I did not choose it! It never occurred to you that a sentient being without free will is no more conceivable than a physical object which exerts no gravitational attraction. (There is, incidentally, more analogy than you realize between a physical object exerting gravitational attraction and a sentient being exerting free will!) Can you honestly even imagine a conscious being without free will? What on earth could it be like? I think that one thing in your life that has so misled you is your having been told that I gave man the *gift* of free will. As if I first created man, and then as an afterthought endowed him with the extra property of free will. Maybe you think I have some sort of "paint brush" with which I daub some creatures with free will, and not others. No, free will is not an "extra"; it is part and parcel of

the very essence of consciousness. A conscious being without free will is simply a metaphysical absurdity.

MORTAL: Then why did you play along with me all this while discussing what I thought was a moral problem, when, as you say my basic confusion was metaphysical?

GOD: Because I thought it would be good therapy for you to get some of this moral poison out of your system. Much of your metaphysical confusion was due to faulty moral notions, and so the latter had to be dealt with first.

And now we must part—at least until you need me again. I think our present union will do much to sustain you for a long while. But do remember what I told you about trees. Of course, you don't have to literally talk to them if doing so makes you feel silly. But there is so much you can learn from them, as well as from the rocks and streams and other aspects of nature. There is nothing like a naturalistic orientation to dispel all these morbid thoughts of "sin" and "free will" and "moral responsibility". At one stage of history, such notions were actually useful. I refer to the days when tyrants had unlimited power and nothing short of fears of hell could possibly restrain them. But mankind has grown up since then, and this gruesome way of thinking is no longer necessary.

It might be helpful to you to recall what I once said through the writings of the great Zen poet Seng—Ts'an:

> If you want to get the plain truth,
> Be not concerned with right and wrong.
> The conflict between right and wrong
> Is the sickness of the mind.[1]

I can see by your expression that you are simultaneously soothed and terrified by these words! What are you afraid of? That if in your mind you abolish the distinction between right and wrong you are more likely to commit acts which are wrong? What makes you so sure that self consciousness

about right and wrong does not in fact lead to more wrong acts than right ones? Do you honestly believe that so-called amoral people, when it comes to action rather than theory, behave less ethically than moralists? Of course not! Even most moralists acknowledge the ethical superiority of the behavior of most of those who theoretically take an amoral position. They seem so surprised that without ethical *principles* these people behave so nicely! It never seems to occur to them that it is by virtue of the very lack of moral principles that their good behavior flows so freely! Do the words "The conflict between right and wrong is the sickness of the human mind" express an idea so different from the story of the Garden of Eden and the fall of Man due to Adam's eating of the fruit of knowledge? This knowledge, mind you, was of ethical principles, not ethical feelings—these Adam already had. There is much truth in this story, though I never commanded Adam not to eat the apple, I merely advised him not to. I told him it would not be good for him. If the damn fool had only listened to me, so much trouble could have been avoided! But no, he thought he knew everything! But I wish the theologians would finally learn that I am not punishing Adam and his descendants for the act, but rather that the fruit in question is poisonous in its own right and its effects, unfortunately, last countless generations.

And now really I must take leave. I do hope that our discussion will dispel some of your ethical morbidity and replace it by a more naturalistic orientation. Remember also the marvelous words I once uttered through the mouth of Laotse when I chided Confucious for his moralizing:

> All this talk of goodness and duty, these perpetual pin-pricks unnerve and irritate the hearer—You had best study how it is that Heaven and Earth maintain their eternal course, that the sun and moon maintain their light, the stars their seried ranks, the birds and beasts their flocks, the trees and shrubs their station.

> This you too should learn to guide your steps by In-
> ward Power, to follow the course that the Way of
> Nature sets; and soon you will no longer need to go
> round laboriously advertising goodness and duty.
> . . . The swan does not need a daily bath in order to
> remain white.[2]

MORTAL: You certainly seem partial to Eastern philosophy!

GOD: Oh, not at all! Some of my finest thoughts have
bloomed in your native American soil. For example, I never
expressed my notion of "duty" more eloquently than
through the thoughts of Walt Whitman:

> I give nothing as duties,
> What others give as duties, I give as living impulses.

23.

THE TAO IS GOOD BUT NOT MORAL

If you want to get at the plain truth,
Forget about right and wrong.
For the conflict between right and wrong,
Is the sickness of the human mind.[1]

It is most revealing how differently people react to the above passage! Some declare it beautiful, wonderful, profoundly wise and most helpful. Others declare it horrible, evil, psychopathic and most destructive. One friend to whom I read it said, "That could have been written by the Marquis de Sade". He is right! It could have been written by the Marquis de Sade. It also could have been written by Laotse. But how different would be the intentions!

The phrase "transcending morality" strikes great fear in the hearts of some and great serenity and hope in the hearts of others. One friend once very wisely remarked, "One can, so to speak, transcend morality from above or transcend it from below. They are very different things. Laotse evidently transcended it from above; De Sade from below".

This point is an important one! If De Sade would talk about "abolishing distinctions of right and wrong", I would agree with the moralists (with whom I usually disagree) that he did so primarily to assuage his own guilt feelings for acting sadis-

111

tically, which surely he felt in his heart was "wrong". It would appear that De Sade placed positive value on cruelty and suffering and hence would oppose morality insofar as it would interfere with his acting in such a way as to cause suffering. The Taoists, on the other hand, appeared to feel that morality itself—"principles of morality", that is—was a major cause of suffering, since it only weakened that natural goodness in us which would spontaneously manifest itself if not interfered with or commanded by moral principles or moral law. (In this respect, Taoism comes close to Pauline Christianity.) Indeed, one day Laotse chided Confucious for "bringing great confusion" (should I say "confucian"?) to the human race by his moralistic teachings. He said "Stop going around advertising goodness and duty, and people will regain love of their fellows".

It is important that Laotse spoke in terms of "loving ones fellows". In this respect he was like Jesus, and most unlike the Marquis De Sade! Therefore I say that if Laotse and De Sade approve of "transcending morality", they do so for virtually opposite reasons.

There is, perhaps, a vital difference between transcending morality and denying or rejecting it. To reject morality is, in a way, to be involved with it. A person who is truly free from morality (which was certainly not the case with the Marquis De Sade) has no need to reject it; he is free and simply leads a good life. Some may be afraid that he will then simply lead a bad life; this is one of the key differences between Taoistic thought and the thought of some Westerners, as well as some Easterners like the Chinese Legalists or Realists who regarded human nature as fundamentally evil and therefore believed that humans would act evilly unless checked by extremely rigid laws. Now, the Taoist ideal is not so much to feel that we *shouldn't* be moral (which is, of course, a kind of morality of its own), but rather to be independent, free, unentangled with moral "principles"—to return, so to speak,

to the Garden of Eden days before we ate of the fruit of knowledge of good and evil. I think this ideal is perhaps best expressed by the following beautiful translation by Thomas Merton of a passage of Chuangtse entitled "When Life Was Full, There Was no History".[2] First let me remark that Laotse, Chuangtse, Confucious, Mencius, and many others constantly wrote of the "good old days" when men were "naturally virtuous". Now, I do not believe there is any evidence that there ever were such "good old days", but this is really beside the point. The important thing about the following passage is not the glorification of the past but the way of life valued by the Taoist, and which it is to be hoped may prevail in the future.

> In the age when life on earth was full, no one paid any special attention to worthy men, nor did they single out the man of ability. Rulers were simply the highest branches of the tree, and the people were like deer in the woods. They were honest and righteous without realizing they were "doing their duty". They loved each other and did not know that this was "love of neighbor". They deceived no one, yet they did not know they were "men to be trusted". They were reliable and did not know that this was "good faith". They lived freely together giving and taking, and did not know that they were generous. For this reason their deeds have not been narrated. They made no history.

THE
TAO IS
LEISURELY

道
是
從
容
的

24.

ON GARDENING

At one stage of Emerson's development—at the time he fell in love with the ideal of "communing with nature"—he felt that he himself should be more directly "part of nature" and do some actual garden work. So he went to work in the garden. It lasted half a day! He came to the conclusion that he preferred writing to gardening.

Similar experiences have happened to many others. When Nathaniel Hawthorne got "bitten by the ideal", he went to Brook Farm. At first he was ecstatic over his new "wholesome, simple life", but he soon realized that he had no energy left for writing, and the whole experience palled on him more and more as the months went by. (Also, I don't think he was too happy having to milk Margarite Fuller's cow!) So, a few months later he left and returned to normal life (thank God!)

Now, I have never tried my hand at farming or gardening. I know in advance I wouldn't like it. I find the *idea* of gardening most beautiful, poetic, spiritual and full of religious significance, and I feel great love, respect, and spiritual kinship with those who love to garden. But if it should ever come to my actually *doing* any gardening, I would run a mile like a frightened rabbit!

Now, if for some unfortunate economic reason I *had* to do farming or gardening, then, of course, it would be a different story. In that case I would figure that my best course would be to try to get to like gardening. Maybe I would first pretend

to myself how much I loved gardening; I would keep remind-
ing myself of its "poetic and spiritual" value, and who knows,
after a while I might actually find myself liking it. But this
seems to me a little like brainwashing oneself, and so I react
to the idea with revulsion. Which would be worse, to suffer
the painful state of doing hateful work or to "condition"
oneself to like it?

Someone once compared freedom with Zen by saying that
freedom is doing what one likes; Zen is liking what one does.
The comparison strikes me as a very clever one! From the
Zen point of view, I guess I would be better off conditioning
myself to like what I do. But there is something unpleasant
about this idea, and besides it raises a curious logical diffi-
culty:

Zen not only teaches us to like what we do, but to accept
ourselves as we are rather than try to be something we are
not. Now then, suppose I am doing something which in fact
I don't like. What should I do? If I accept myself as I am, then
I must also accept the fact that I *as I am* simply don't like
doing what I do. On the other hand, if I try changing my state
to the point where I do like doing what I do, then I am not
accepting myself as I am but am trying to be different than
I am. This is the dilemma as I see it (it is perhaps somewhat
Talmudic in spirit). I suppose if I confronted a Zen master
with such a "dualistic" dilemma, he would probably give me
a blow—and I would probably deserve it.

25.

ON DOGS

I am very partial to dogs—one reason being that I am a dog lover.*

In an essay on the dog, John Burroughs says that the outstanding thing about the dog is not his intelligence but his lovingness. I tend to think that Burroughs underestimates the intelligence of the dog, but I am glad he realizes how loving the dog really is.

I wonder if there is a Chinese proverb to the following effect?

> The Sage and the Dog are
> indistinguishable.

Now let us turn to Japan. I love the following Haiku poem of Issa:[1]

> Visiting the graves;
> The old dog
> Leads the way.

Concerning this poem, R.H. Blythe comments:

> There is something deeply pathetic in the unknowing knowledge of the old dog. We feel, by inference, the shallowness of our own understanding of the meaning of life and death.[1]

*If the more sophisticated reader objects to this statement on the grounds of its being a mere tautology, then please at least give the statement credit for not being inconsistent.

There is something else about the dog—and I would probably say about other animals too, if I knew them better—which is most noteworthy, and that is its capacity for seeing things directly as they are, unencumbered by any obscuring conceptualization. This is the condition known as "Satori". If any sentient beings I know are in a state of Satori, it is obviously my dogs. Good God, they seem to be swimming in the Tao from morning till night! Whether sleeping, romping, chasing rabbits, eating, or communing with their canine or human friends, they are always the same. When in the deep forest, they are awestruck—a state I would describe as a "fantastically relaxed kind of high tension."*

There is a very famous koan: "Does the dog have the Buddha nature?" All sorts of curious answers have been given to this, such as "Mu". I guess a typical answer of a Western philosopher would be, "It all depends on how you define the Buddha nature". I'm afraid I am not a Western philosopher in this respect, for were I asked the question, I would spontaneously and wholeheartedly answer "Of course!" Or, I might answer, "Obviously! What a stupid question!"

Let me tell you a cute story about this koan. A monk once asked a Zen-Master, "Does a dog have the Buddha nature?"

He replied "Yes, it does".

The monk then asked, "Do you have the Buddha nature?"

He replied, "No, I do not".

The monk then said "But I thought everybody has the Buddha nature!" The Master replied, "Yes, but I am not everybody".

In relation to the question, Does the dog have the Buddha nature? Issa wrote the following profound Haiku:[2]

> The puppy that knows not
> That autumn has come,
> is a Buddha.

*If I appear overly romantic at this point, I must beg to be excused on the grounds that I am a dog lover.

About this, Blyth says:[3]

> The puppy even more than the mature dog takes
> each day, each moment as it comes. It does not
>
> > look before and after
> > And pine for what is not.
>
> When it is warm, it basks in the sun; when it rains, it
> whimpers to be let in. There is nothing between the
> sun and the puppy, the rain and the whimper.

One of the finest passages on the dog I have ever read is
the following of Suzuki:[4]

> Let us observe the dog and see how it devours its
> food. When he is hungry and smells something to eat
> he goes right to it and finishes it in no time. He asks
> no question whatever about it. The food was proba-
> bly meant for somebody else, but this is no concern
> of his. He takes it for granted that the fact that he is
> hungry unconditionally entitles him to anything
> which he knows will satisfy his need at the moment.
> When finished he goes away. No saying "Thank you".
> He has asserted his natural rights, no more, no less,
> and he has nothing further to worry about—not only
> his being but the entire world around him. He is
> perfect. The idea of sin is an altogether unnecessary
> blemish, whether intellectual, moral or spiritual, on
> his being what he is. He comes directly from God. He
> might declare as is reported of the Buddha, "I alone
> am the most honored one on earth". In truth, he does
> not require any such "ego-centered" statement. It is
> enough for him just to bark and run away from any
> sin-concious human beings who try to do harm to this
> "innocent" creature still fresh from the Garden of
> Eden.

26.

ON THE ART OF
MANAGEMENT

Chuangtse has a marvelous passage in which (in the words of Lin Yutang) he discusses the idea of preserving man's original nature by comparing the harm done to that nature by the Confucianists and the harm done to a horse by a famous horse-trainer.

> Horses have hoofs to carry them over frost and snow, and hair to protect them from wind and cold. They feed on grass and drink water, and fling up their tails and gallop. Such is the real nature of horses. They have no use for ceremonial halls and big dwellings.
>
> One day Polo (famous horse-trainer) appeared, saying, "I am good at managing horses." So he burned their hair and clipped them, and pared their hoofs and branded them. He put halters around their necks and shackles around their legs and numbered them according to their stables. The result was that two or three in every ten died. Then he kept them hungry and thirsty, trotting them and galloping them, and taught them to run in formation, with the misery of the tasselled bridle in front of them and the fear of the knotted whip behind, until more than half of them died.
>
> The potter says, "I am good at managing clay. If I want it round, I use compasses; if rectangular, a square." The carpenter says, "I am good at managing wood. If I want it curved, I use an arc; if straight, a

line." But on what grounds can we think that the nature of clay and wood desires this application of compasses and square, and arc and line? Nevertheless, every age extolls Polo for his skill in training horses, and potters and carpenters for their skill with clay and wood. Those who manage (govern) the affairs of the empire make the same mistake.

I think one who knows how to govern the empire should not do so. For the people have certain natural instincts—to weave and clothe themselves, to till the fields and feed themselves. This is their common character, in which all share. Such instincts may be called "Heaven-born." So in the days of perfect nature, men were quiet in their movements and serene in their looks. At that time, there were no paths over mountains, no boats or bridges over water. All things were produced, each in its natural district. Birds and beasts multiplied; trees and shrubs survived. Thus it was that birds and beasts could be led by the hand, and one could climb up and peep into the magpie's nest. For in the days of perfect nature, man lived together with birds and beasts, and there was no distinction of kind. Who could know of the distinctions between gentlemen and common people? Being all equally without knowledge, their character could not go astray. Being all equally without desires, they were in a state of natural integrity. In this state of natural integrity, the people did not lose their (original) nature.[1]

I read this passage to Vincent, a teen-age relative. He loved it as much as I did. Several days later one of my dogs had to be taken to the vet. It was a beautiful spring day, and we walked the dog on a grassy terrace just outside the office. The dog, seeing the office and having been there before, was trembling like a leaf. Several other dogs were there being walked by their owners, and they were all trembling like leaves. At this point Vincent glanced in the direction of the office, glanced back at me, and said, "I see he knows how to manage dogs".

27.

ON SELFISHNESS

As opposed to the Chinese philosopher Mo Tzu's principle of "all embracing love" was the very early Taoist Yang Chu's principle of "each one for himself". He was reputed to have said, "I would not sacrifice one single hair of my head even to save the entire human race!" Just think of it! Not a *single* hair to save the *entire* human race!

I find this statement absolutely beautiful! I cannot tell you with what joy, satisfaction, and utter relief I read it. I once expressed this sentiment to a friend who asked in genuine astonishment, "Why? Do you believe the world would be better off if everyone acted selfishly rather than unselfishly?" Of course I don't believe this. Of course I prefer universal love to total selfishness. Who in his right mind wouldn't? Then why do I love Yang Chu's statement so much? Sounds pretty inconsistent, doesn't it? Well, it isn't. Let me explain.

In the first place there is a vast difference between loving a proposition and believing it. What I love is Yang Chu's beautifully honest expression of this sentiment (in contrast to the usual hypocritical moralizing about unselfishness). But I do not believe it, nor do I believe that Yang Chu really believed it. My grounds for this opinion are as follows. If someone were to say that he would not sacrifice his life for others, I would tend to believe that he really meant it. But to say that one would not sacrifice a hair of his head sounds unconvincing. The fact is that the loss of a single hair is not even painful and represents absolutely no sacrifice whatever.

(Wouldn't it be funny if someone said, "I will sacrifice one hair for the human race, but no more!") So it is of interest that Yang Chu deliberately went to this extreme. I don't think that Yang Chu was literally worried by the thought of losing a hair. He went to this extreme in order to express a *principle*. But I believe the principle was not overtly manifest in the statement but only latent. Indeed it is possible that he himself was not even conscious of it, but I regard this principle as of the highest importance.

What is this principle? Is it really that one *should* be selfish? If I thought this, I would consider it just as ridiculous as the idea that one shouldn't be selfish. I believe that what he was really objecting to was the idea that we should apply moral criteria to the question of selfishness.

If it actually came to a test case, there is absolutely no evidence that Yang Chu would act more selfishly than, say, Mo Tsu. Furthermore, I believe that the statement of Yang Chu will do far more good in this world from the actual point of view of helping us liberate our natural unselfishness than the opposite course of preaching universal love.

Now let me come to the central matter, and tell you my interpretation of what Yang Chu meant (although had he said it this way, it may have been far less effective than the apparently brutal manner in which he expressed it). The point is this. If I should feel like being helpful to others, then I might indeed sacrifice considerably more than a hair of my head. I would then do so of my own accord without being told by others that I *should* do so. And if I should not feel disposed to being helpful, then no amount of reason or morality or being told that I should will in any way increase my desire to be helpful and will not in effect lead me to sacrifice even one hair of my head. In other words, there is absolutely no point in telling another person what he *should* do. If he already wants to, it is superfluous (nay, maybe even harmful), and if he doesn't, it is useless. I think this is what Yang Chu

was really saying. His statement sounds more like a simple declaration of independence then an ethical plea for selfishness.

There is even more to Yang Chu's statement. There are those who believe that selfishness is the natural state of man and that it is social influences such as religion and education which "train" a man into the superior state of unselfishness. But there are those who believe the very opposite and would say that at birth our natures contain as much (if not more) unselfishness as selfishness and that the very process of trying to educate unselfishness only serves to cripple it and prevent it from growing, which it would naturally do if let alone. It seems that this is also part of Yang Chu's message (though it may not sound like it!), and this was made quite explicit by later Taoists in such statements as "Give up advertising things like goodness and duty, and people will regain love of their fellows."

Afterthoughts. Cardinal Newman has somewhere said:

> The Church holds that it were better for sun and moon to drop from the heavens, for the earth to fail, and for all the many millions who are upon it to die of starvation in extremest agony, so far as temporal affliction goes, than that one soul, I will not say should be lost, but should commit one single venial sin, should tell one wilful untruth, though it harmed no one, or steal one poor farthing without excuse.

Fichte has somewhere said, "I would not break my word even to save humanity."

To my mind, both these statements are so remarkably like Yang Chu's. Of course, many moralists will see the two cases as totally different; the first case (Newman and Fichte) as a silly exaggeration of a moral principle and the second (Yang Chu) as not a moral principle at all, I think this is a mistake. I would say Yang Chu's principle *was* a moral one albeit an

unusual one, and indeed an immoral one by most moral standards. The very fact that Yang Chu founded a school and taught this statement to others substantiates my point. Why would a purely selfish one want others to follow such a principle?

It now occurs to me that just as there is a difference between morality and moral fanaticism, a distinction should be made between selfishness and what might aptly be called *selfish fanaticism*. Repugnance to lying might be called a moral principle, but pushing this to the extreme of Newman or Fichte would certainly be called fanaticism even by most moralists. Similarly, an ordinary, everyday selfish person would hardly be likely to utter a statement like Yang Chu's; such a statement should certainly be called selfish fanaticism. But what strikes me most about Yang Chu's statement is that —like the other two statements—it seems to be said with such moral fervor.

28.

SELFISHNESS AND
ALTRUISM

I am fond of asking the following question—particularly to
clergymen: "How do you think of altruism? Do you think of
altruism as sacrificing ones own happiness for the sake of
others or as gaining one's happiness through the happiness of
others?" This question always seems to provoke the most
curious reactions! Those to whom I have asked this have
usually seemed uneasy and nonplussed. The answers have
not been very clear; some have frankly replied: "Hm, I have
never thought of this before". I wonder how Moses and Jesus
would answer this? If I ever get to heaven, I plan to ask this
of them. Or would such a question be kind of anticlimactic
in heaven?

A related matter is the following: A mother was once scold-
ing her teen-age son for being "selfish". The boy—who was
very bright—suddenly turned to the mother and said:
"Mother, one thing I would like to know: For whose sake do
you wish me to be unselfish?" The mother was totally per-
plexed, and all she could answer was "You really should be-
come a scientist".

The question is not a bad one! For whose sake should I
become unselfish? For other people's? But if I am selfish, why
on earth would I care about the welfare of others? On the
other hand, if I am not selfish and do care for the welfare of
others, then I do not need to become unselfish, since I al-

ready am. To put the matter otherwise, if I feel like acting selfishly, no argument for unselfishness can possibly appeal to me, and if I don't feel like acting selfishly, no argument is necessary. Some may say this is an oversimplification. There is some truth in that. The situation may be complicated by the fact that a person may be partly selfish and partly unselfish; hence the moralist feels it his duty to appeal to the unselfish part of the individual to overcome—to triumph over—the selfish part. One such moralist once said to me: "Obviously it is not possible to make a purely selfish appeal to one to become unselfish. All one can do is to appeal to the more noble side of his nature to overcome the side of him which is more base—more like an animal—which considers only his selfish pleasures".

I think this remark just about perfectly epitomizes that aspect of Western ethics—or more specifically Victorian ethics—which is so utterly different from both Taoism and Buddhism. It presupposes—nay, takes as axiomatic—a necessary bifurcation of the human being into the "noble" and the "base" eternally at war with each other, and that we should, of course, choose the "noble". The entire implication is that we should "sacrifice" our selfishness for the higher cause of altruism. Now, one thing which is so marvellous about Buddhist as well as Taoist ethics is that this whole nightmarish duality is transcended. A perfect passage on this point is the following from Holmes' book *The Creed of Buddha* in which the author discusses the alleged egoism of Buddhism.

> On this point the western critics of Buddhism are divided. Some of them, including Dr. Rhys Davids, Dr. Paul Carus, and other enemies of the Ego, contend that Buddha's teaching was ultra-stoical, in that he bade men do right for right's sake only, the sole reward which the doer was allowed to look forward to being the inward peace during that twilight hour which should precede the final extinction of his life.

Others, including the critics who seek to depreciate Buddhism in the supposed interests of Christianity, contend that Buddha was an egoistic hedonist, who taught each man in turn to think of himself and his own welfare only, and whose conception of happiness had so little in it of idealism or aspiration that it scarcely rose above the level of providing for humanity an early escape from sorrow and pain. The answer to those who regard Buddha as ultra-stoical is that, as a matter of plain historical fact, what he set before men, when he bade them enter the Path, was the prospect, not of doing right for right's sake (he probably would have seen no meaning in those words) but of winning release from suffering—the suffering of those who struggle in the whirlpool of rebirth—and of entering into bliss,—the bliss of those who will return to earth no more.

In giving this answer I may seem to justify the critics who brand Buddha's scheme of life as being egoistic. But no; Buddha's scheme of life was as far from being egoistic as from being stoical. It is the word *self* that misleads us. With the doubtful exception of the word *Nature,* there is no word in which there are so many pitfalls. When we ask whether a given scheme of life is egoistic or not, our answer will entirely depend on the range of the self for which the scheme in question makes provision. To get away from self is impossible; but it may be possible to widen self till it loses its individuality and becomes wholly selfless. Long before that ideal point has been reached, long before the individual has become one with the Universal Self, the word "egoistic" will have lost its accepted meaning.[1]

29.

ON EGOTISM

I love the following verses of the poet Tachibama Akemi (1812–68) from a poem entitled "Solitary Pleasures". (tr. Donald Keene)[1]

> It is a pleasure
> When, spreading out some paper
> I take brush in hand
> And write far more skilfully
> Than I could have expected.

> It is a pleasure
> When after a hundred days
> Of twisting my words
> Without success, suddenly
> A poem turns out nicely.

> It is a pleasure
> When, without receiving help,
> I can understand
> The meaning of a volume
> Reputed most difficult.

> It is a pleasure
> When, a most infrequent treat,
> We've fish for dinner
> And my children cry with joy
> "Yum-yum!" and gobble it down.

> It is a pleasure
> When, in a book which by chance
> I am perusing,
> I come on a character
> Who is exactly like me.

It is the last verse which is particularly relevant to this chapter (the other verses I quoted mainly because I like them so much).

You see, I also love to come across characters just like me, and so when I come across a character who loves to come across characters just like him, I come across a character just like me. Stated otherwise, as a corollary of the fact that I love to come across characters just like me, it follows that I love to come across characters who say "I love to come across characters just like me". As a second corollary, it would follow that I love to come across characters who say "I love to come across characters who say "I love to come across characters just like me" ". I could state and prove a 3rd, 4th, . . . , nth . . . corollary by an obvious mathematical induction argument which I prefer to leave to the reader.

Now I wish to talk a little about my own so-called "egotism" and then about the "egotism" of others.

Once, in a happy frame of mind, I made the following little verse entitled "Egotists":

> Most people hate egotists.
> They remind them of themselves.
> I love egotists.
> They remind me of me.

Another time, I wrote another poem, and my first thought was to entitle it "In praise of myself". However, this title (delightfully egocentric as it is) fails to capture a deeper and rather tragic meaning of the poem, and so I forthwith change the title to "I Am Egoless".

> Most people,
> When criticized for being egocentric
> Only find clever means
> Of hiding it from others.
> After a while
> They fool even themselves

They then take secret egocentric delight
In imagining themselves egoless.

Now, with me it is different!
I am truly egoless.
Like a lonely orphan marooned nowhere.
In my very exhultant shout "I am egoless"
I lose my ego.
My ego remains
But it no longer belongs to me.

I am just as surprised as you that this poem turned out so sad! I originally planned to be joyful, exuberant, exultant, jubilant, and almost defiantly egocentric; I let myself go and look what happened! The height of egocentricity was reached, of course, in the line "Now with me it is different!" —which implies that I am better than you, since you only think you have lost your ego, whereas I *really* have. But then it turns out that my losing my ego is something sad rather than joyful. Is this not funny? Tell me, dear reader, do you feel *sorry* for me for having lost my ego? You don't? How come? I would feel sorry for you if you lost yours, so how come you don't feel sorry for me for having lost mine? Perhaps some of you who are religiously or mystically oriented will say that all I have lost is my individual ego, or individual self, but that one must "die" to one's individual self before one can be born to one's greater—ones "universal"—self. Now, I am not unsympathetic to the notion of the "universal I", nor do I deny its importance, but I feel there should be some nicer—some *saner* way of achieving it than by "dying" to one's individual ego. Perhaps no such way has yet been found, but that does not mean that it won't be found in the future. And if it is (which I am optimistic enough to believe will happen), then at last will be found the perfect synthesis of Eastern and Western philosophy.

In spirit, one line of my poem "Like an orphan marooned nowhere" is quite reminiscent of one of Laotse's verses:

> Cut out cleverness and there are
> no anxieties
> People in general are so happy as if
> enjoying a feast
> Or as going up a tower in spring.
> I alone am tranquil, and have made no signs,
> Like a baby who is yet unable to smile;
> Forlorn as if I had no home to go to.
> Others all have more than enough,
> And I alone seem to be in want.
> Possibly mine is the mind of a fool,
> Which is so ignorant!
> The others are bright,
> And I alone seem to be dull.
> The others are discriminative,
> And I alone seem to be blunt.
> I am negligent as if being obscure;
> Drifting, as if being attached to nothing.
> The people in general all have
> something to do,
> And I alone seem to be impractical
> and awkward.
> I alone am different from others,
> I seek my sustenance direct
> from the mother Tao.[2]

This is one of my favorite verses of the Book of Tao. To my sorrow, many regard it as too egocentric. One person, to whom I read it, irately remarked that this kind of thinking is typical of one who affects the air of being inferior but who really feels most superior! I reacted to this poem quite differently! It seems to me rather the reaction of one who is consoling himself in the midst of a depression. It is amazing how differently people react to this verse! One very interesting reaction was as follows.

I read this verse to one person and I read it quite jubilantly (as I usually do) and laughed a great deal. He remained quite solemn during the reading, and when it was over said "Why do you laugh so when you read it? What is so funny about it?

I can see that it may be profound, but I cannot see it as funny". I replied, "I never thought of it as profound, but I think it is extremely funny". He was thoughtful for awhile and then said: "The philosophy of this verse goes against just about everything I believe. If it is true, then I have been on the wrong track all my life".

Let me say a little more about my own reactions to Laotse's verse. If I were asked why I think it—or at least parts of it—funny, I would be at a loss to answer. Perhaps part of my laughter is triumphant rather than humorous, since I find in this verse a philosophy which is so close to what I believe and so far from that which society has tried to teach me. Put otherwise, it may be that my laughter is that of joy in finding an influence which goes completely counter to those influences I have most hated. I am sure that at this point many readers will find what I am saying singularly unimpressive, and will feel I am being childish. Who knows, maybe they are right!

To end this chapter on a more cheerful note, let me tell you of Chuangtse's self evaluation! If you think Walt Whitman was egocentric in writing a song of himself, just wait till you get a load of this!

> Silent and formless, changing and impermanent, now dead, now living, equal with Heaven and Earth, moving with the spiritual and intelligent; disappearing where? Suddenly whither?; all things are what they are, no one more attractive than others: these were some of the aspects of the Tao of the ancients. Chuangtse heard of them and was delighted. In strange and vague expressions, wild and extravagant language, indefinite terms, he indulged himself in his own ideas without partiality or peculiar appearance. He regarded the world as submerged and ignorant, so that it could not be spoken too seriously. So he put his ideas into indefinite cup-like words, ascribing them to others for authority and illustrating with sto-

ries for variety. He came and went alone with the
spirit of Heaven and Earth, but had no sense of pride
in his superiority to all things. He did not condemn
either right or wrong, so he was able to get along
with ordinary people. His writings, though they have
a grand style, are not opposed to things and so are
harmless. His phrases, though full of irregularities,
are yet attractive and full of humor. The richness of
his ideas cannot be exhausted. Above he roams with
the Creator. Below he makes friends of those who,
without beginning or end, are beyond life and death.
In regard to the fundamental he was comprehensive
and great, profound and free. In regard to the essen-
tial he may be called the harmonious adapter to
higher things. Nevertheless, in his response to
change and his interpretation of things, his reasons
were inexhaustible and not derived from his pre-
decessors. Indefinite and obscure, he is not one to be
exhausted![3]

This is one of my favorite passages in all literature. In
reading it, I came across a character, not who is just like me,
but who is just like what I would like to be.

30.

EGOTISM AND COSMIC CONSCIOUSNESS

I have always been deeply disturbed by the enormous amount of prejudice against egocentricity. Why this prejudice? Is it that we have been taught that we *shouldn't* be egocentric, and are therefore jealous of those who have no such inhibitions? Of course, there is egocentricity and egocentricity! I, as much as anyone else, am disturbed by the loveless, gloomy kind of egocentricity which we sometimes encounter. But this is so different from the so-called "egocentricity" of the passage of Chuangtse (see the preceding chapter) which is like the gorgeous spontaneous egocentricity of the unspoiled child.

I think a sharp distinction should be drawn between egotism in the sense of "love of self" and ego-assertiveness. I have always hated ego-assertive people, whereas I have loved people who love themselves. Ego-assertive people are usually quite power driven and tend to step on others, so it is no wonder they are disliked. But a person who is purely egocentric is usually content with just praising himself and does not find it necessary to disparage others. Someone once said to me, "I think an ego-assertive person needs other people—if just to assert his ego against them—whereas an ego-centric person simply has no need of other people at all". I agree with the first half of this statement, but find the second half doubtful. I would say that a truly egocentric person (in

the best sense of the term) does need to have other people around. Take me for example; without other people around, who would I have to impress?

I have also been very disturbed by people's feelings of shame and guilt toward their own egocentricity. Why do people feel this way? The most enlightening information I have ever gotten on this point is from a section of Dr. Richard Bucke's great book *Cosmic Consciousness*. In Chapter 9 he quotes several of Shakespeare's sonnets and analyzes them from the point of view of Cosmic Consciousness. The following sonnet and its analysis are particularly relavent:

SONNET LXII

Sin of self-love possesseth all mine eye,
And all my soul, and all my every part;
And for this sin there is no remedy,
It is so grounded in my heart.
Methinks no face so gracious is as mine,
No shape so true, no truth of such account;
And for myself my own worth do define,
As I all other in all worth surmount.
But when my glass shows me myself indeed,
Beated and chopp'd with tann'd antiquity,
Mine own self love quite contrary I read;
Self so self-loving were iniquity.
'Tis thee (myself) that for myself I praise,
Painting my age with beauty of thy days.

Bucke's commentary:

In this sonnet the duality of the person writing is brought out very strongly—no doubt purposely. When he dwells on his Cosmic Conscious self he is, as it were, lost in admiration of himself. When he turns to the physical and self conscious self he is inclined, on the contrary, to despise himself. He is at the same time very much and very little of an egotist. Those who knew the man Walt Whitman know that this same seeming contradiction, resting on the same

foundation, existed most markedly in him. Whitman's admiration for the cosmic conscious Whitman and his works (the "Leaves") was just such as pictured in this sonnet, while he was absolutely devoid of egotism in the ordinary way of the self conscious individual. It is believed that the above remarks would remain true if applied to Paul, Mohammed or Balzac. Reduced to last analysis, the matter seems to stand about as follows: The Cosmic Conscious self, from all points of view, appears superb, divine. From the point of view of the Cosmic Conscious self, the body and the self conscious self appear equally divine. But from the point of view of the ordinary self consciousness, and so compared with the Cosmic Conscious self, the self conscious self and the body seem insignificant and even, as well shown in Paul's case, contemptible.[1]

31.

ON TRUSTING ONE'S OWN NATURE

I wish to begin by quoting two poems of Po Chu-I (tr. A. Waley).

I. *A Mad Poem Addressed to*
My Nephews and Nieces
(A.D. 835)

The World cheats those who cannot read;
I, happily, have mastered script and pen.
The world cheats those who hold no office;
I am blessed with high official rank.
The old are often ill;
I, at this day have not an ache or pain.
They are often burdened with ties;
But I have finished with marriage and giving in
 marriage.
No changes happen to disturb the quiet of my
 mind;
No business comes to impair the vigor of my limbs.
Hence it is that now for ten years
Body and soul have rested in hermit peace.
And all the more, in the last lingering years
What I shall need are very few things.
A single rug to warm me through the winter;
One meal to last me the whole day.
It does not matter that my house is rather small;
One cannot sleep in more than one room!
It does not matter that I have not many horses;
One cannot ride in two coaches at once!

As fortunate as me among the people of the world
Possibly one would find seven out of ten.
As contented as me among a hundred men
Look as you may, you will not find one.
In the affairs of others even fools are wise
In their own business even sages err.
To no one else would I dare to speak my heart,
So my wild words are addressed to my nephews
 and nieces.

II. *Thinking of the Past*
(A.D. 833)
In an idle hour I thought of former days;
And former friends seemed to be standing in the
 room.
And then I wondered "Where are they now?"
Like fallen leaves they have tumbled to the
 Nether Springs.
Han Yu swallowed his sulphur pills,
Yet a single illness carried him straight to the
 grave.
Yuan smelted autumn stone
But before he was old, his strength crumbled away.
Master Tu possessed the "Secret of Health":
All day long he fasted from meat and spice.
The Lord Ts'ui, trusting a strong drug,
Through the whole winter wore his summer coat.
Yet some by illness and some by sudden death . . .
All vanished ere their middle years were passed.

Only I, who have never dieted myself
Have thus protracted as tedious span of age,
I who in young days
Yielded lightly to every lust and greed;
Whose palate craved only for the richest meat
And knew nothing of bismuth and calomel.
When hunger came, I gulped steaming food;
When thirst came, I drank from the frozen stream.
With verse I served the spirits of my Five Guts;
With wine I watered the three Vital Spots.
Day by day joining the broken clod
I have lived till now almost sound and whole.

There is no gap in my two rows of teeth;
Limbs and body still serve me well.
Already I have opened the seventh book of years;
Yet I eat my fill and sleep quietly;
I drink, while I may, the wine that lies in my cup,
And all else commit to Heaven's care.[1]

I like these two poems very much (as I do all the poems I quote in this book). Neither is particularly beautiful or inspiring, nor does either one elicit anything like "mystical insight" (as do most of the other poems which are quoted in this volume). I love these poems mainly for their sound philosophy of life—or rather philosophy of "good sensible living". The philosophy of the second poem in particular comes so remarkably close to my own that I could not believe my good fortune when I stumbled on it! I have always lived my life eating exactly what I feel like rather than guiding my diet by science or medical opinion and have never had any trouble with health. Of course, I am only in my mid-fifties so I cannot yet—like Po Chu-I—hold myself up as a living example of the desirability or workability of such a life-style. But I am always delighted when I come across an older person who can. Anyway, for better or for worse, this is the way I have always lived. Even as a child, I had instinctive certainly that ones own tastes and appetites are the best guide. I recall that someone once told me that I shouldn't drink water with my meals (a theory popular about forty-five years ago). I replied, "But I like to drink water with my meals". The other retorted, "But you *shouldn't* drink water with your meals; its bad for your health!" I asked "Why?" He said "because doctors have explained that water dilutes the saliva, hence we cannot digest our food properly". I thought about this for several days but decided to go on drinking water with my meals. I said to myself, "There must be something wrong with this theory! It is obvious that I am digesting my food perfectly as matters now stand—indeed, when I don't drink

enough water with my meals, *then* things seem dry and to stick in my throat and be indigestible. Therefore there must be something wrong with medical theory. Just what is wrong, I do not know, but surely there is something wrong". And so I trusted my own intuition rather than medical theory. In this I was fortunate! Subsequent medical research revealed that saliva is an enzyme, and enzymes work just as well in dilution as in concentration. All that counts is the total quantity of the enzyme present. Thus the dilution of saliva with water does not in the least interfere with its action as a digestive agent. So, medical opinion at my time was wrong, and my intuition right.

I have faced such problems all my life! The number of food fads and health fads I have heard is fantastic! So many people are just scared to death to eat what they really like! One woman I know assures me that it is known that chocolate is poisonous and that sugar rots the brain! (God knows where she picked that one up!) Another person—an emminent economist and sociologist—once told me that we should not eat charcoal broiled meat since it is now known that charcoal broiled meat causes cancer! As evidence he cited that rubbing coal tar in the skin of mice causes cancer. Well, of course rubbing coal tar in the skin of mice will cause cancer. That doesn't surprise me, but this hardly implies that a little charcoal lying in the stomach (not *rubbed* into the lining of the stomach but merely being there) will cause cancer. A less extreme but more common example of food phobias is the belief that fried foods are unhealthy, that they are indigestible. The amazing thing is that this is believed by many who themselves have never had the slightest difficulty in digesting fried foods those times when they "dared" to eat them. Doesn't a person know, without being told, when he can or cannot easily digest a given food?

I must also mention the very important cholesterol scare which has arisen in recent years. This—like other medical

fads—I ignore completely! I eat no more and no less fats than I feel my system requires. But how different are others! I know one perfectly healthy and rosy British mathematician whose wife decided to put him on a cholesterol free diet. At least he was perfectly healthy and rosy before he went on this diet. About a year later I saw him again, and he was a changed man! He looked utterly emaciated, and in general very bad.

Another case: A medical doctor I knew about fifteen years ago was arguing with me about the question of cholesterol. He said "If you worked in a children's hospital as I do and saw the evidence with your own eyes, you would not have the slightest doubt that soft fats are as dangerous as we say. You really should trust the judgment of us doctors who certainly know more about medicine than you". He put himself, his wife, and his child on a strict diet. A few months later, I met his wife who told me that she and her husband had both been very sick and had been in the hospital. The doctors told them they had been seriously starving themselves and that they must go back to a normal diet! It is incidents like this which, I will not say "cause", but rather reinforce my own intuitive conviction that the best guide in these matters is one's own tastes and feelings. I do not insist that one's own feelings and tastes constitute an infallible guide in these matters; I believe Nature may sometimes err. But I also know that doctors often err, and of the two, I happen to trust Nature more.

Several years after the above incident, I met a British research physician who told me that his team had definitely come to the conclusion that the injestion of fats was not the cause of cholesterol deposits; there seemed to be very little correlation between the amount of fat consumed and the amount which the body deposits. Indeed, it was suspected that an inverse correlation exists—people who eat *more* fat are less likely to have cholesterol problems. The whole point is that eating cholesterol is one thing; depositing it in arteries

is something very different! The "guilty" agent suspected by this British research team was not fat but sugar! They believed that eating too much sugar, rather than soft fats, was a significant cause of cholesterol problems. Now, I understand, the sugar theory has gone out, and the last I heard, the real culprit is supposed to be lack of exercise. I must say, this last theory, if true, would surprise me least of all (it has a kind of intuitive ring of truth to it). However, I understand there is a very recent medical theory which expresses grave doubts that exercise—especially in advancing years—is as generally healthful as formerly believed.

Before I leave the subject of cholesterol I want to report that one researcher at Rockefeller University told me that cholesterol never deposits in a healthy artery! This would mean that a person with healthy arteries will never have a cholesterol problem; cholesterol cannot cause sick arteries but will only make sick arteries worse. I therefore cannot but be concerned about the vast number people with perfectly healthy arteries who are depriving themselves of useful and much needed fats and sugars because of their worries about a problem which does not even apply to them!

I understand that in Europe both doctors and laymen are far less worried about what they *should* and *shouldn't* eat than in America! I am delighted to hear this. A friend of mine was recently visiting her sister—a very influential doctor working for public health—in Prague. My friend was amazed at how little the people there worried about what they should and shouldn't eat. She became alarmed when her sister offered her so much rich food, but the sister laughed and said, "Oh come on now, you can eat whatever you like; it's not going to hurt you!" I wonder why it is that Americans are so hung up on all this? Perhaps it is an unconscious survival of Puritanism which so distrusts "pleasures" and is so frightened that the things we most like are not good for us.

To come back to the poem of Po Chu-I, I have rather

laboriously tried to point out that my own intuition—ever since childhood—has always been along these lines and that so far my own life experiences have tended only to confirm it. I subsequently discovered—again to my great delight— that the poet Robert Browning also trusted his own nature —at least with regard to food. The following passage is from William Lyon Phelp's book *Robert Browning*.[2]

> Browning's life was healthy, comfortable, and happy. With the exception of frequent headaches in his earlier years, he never knew sickness or physical distress. His son said that he had never seen him in bed in the daytime until the last illness. He had a truly wonderful digestion; it was his firm belief that one should eat only what one really enjoyed, desire being the infallible sign that the food was healthful.

This is about as much as I have to say about the matter except for one more thing: The thesis I am defending is obviously that one's own nature—one's own desires—is, in general, the most reliable guide to what is good for one. It is remarkable the anxiety this thesis engenders in those who oppose it! Still more remarkable, when such people see or hear of those who have lived their whole lives eating and drinking exactly what they felt like and who have always enjoyed perfect health, they invariably say "Of course! These people must have had exceptionally good constitutions". To which I reply: Why is it necessary that they had exceptionally healthy constitutions? Is it not possible that it is the other way around, that the reason they had such healthy constitiutions is that they ate and drank what they liked?

32.

ON LETTING THINGS GO
THEIR OWN WAY

There is one ethical philosophy which might be character-
ized as "letting things go their own way, not interfering, not
imposing one's will on nature, letting things happen of their
own accord, not trying to reform the world, not trying to
"improve" the world, but simply accepting things as they
come." Such a philosophy is, I believe, called "quietism."
This philosophy is intensely irritating to many people called
"activists" who believe this is the worse course possible and
is in fact responsible for most of the evils in the world. They
would say that the last thing we should do is to let things go
their own way; if we do that, things will go terribly! It is up
to *us* to prevent the bad things in the world from happening!
I cannot think of any philosophy more irritating to some than
quietism! Indeed, many will say that quietism is the perfect
philosophy for the "purely selfish individual who has every-
thing *he* wants in life and to hell with the others!"

In opposition to the activists, the quietist quietly points out
(or sometimes actively points out) that the trouble with activ-
ism is that people who go forth trying to "improve" the world
—even those with the best intentions (at least on a conscious
level!)—usually "bungle" matters, and only succeed in mak-
ing things even worse than they already are. The quietist
reminds us, for example, that revolutions often establish
even worse tyrannies than they overthrow.

It is not my function here to take sides in the quietism-activism controversy. I admit that my personal bias is towards the quietists—I trust them more than I do the activists. But I do not believe that most efforts to improve the world are "bungling" rather than helpful. Some are bungling, and some are helpful, and I do not have enough statistical data to decide which are preponderant. But, as I said, my sympathies lie more with the quietist. However, if a quietist *advocates* quietism, if he tells an activist that he *shouldn't* be active, I regard this as ridiculous as an activist telling a quietist that he *should* be more active. This brings me to my central point.

In the last analysis, I regard the whole quietist-activist controversy as one silly duality! I am, of course, taking the viewpoint that a person is part of Nature (or the Universe or Cosmos, or what you will) rather than apart from it. Now then, suppose I have a burning desire to make certain changes in the world. Unless I positively and actively inhibit this desire, then I will go forth and make these changes. Is not my desiring to make changes, and hence my making them, part of the way things go? On the other hand, if I inhibit my desire to change things, and hence do not change them, is not my very inhibition—and consequent nonaction—also part of the way things go? How on earth can I *not* let things go their own way, when the way *I* go is part of the way things go?

The point I am trying to make is that is is impossible for things not to go their own way, for whichever way things go, they go that way and no other. And whichever the way they do go, might be appropriately called "their way."

Thus, considered purely logically, the doctrine of quietism is vacuous. Nevertheless, I like the doctrine very much. In the last analysis, quietism and activism represent not so much different philosophical viewpoints, but differences in personal temperament. I am really a quietist by temperament

rather than philosophical conviction. I tend to live and let live rather than interfere with the world's affairs. I am not fanatically committed to any doctrine of noninterference; it's just that I usually don't like to interfere. As for activists who love to busy and bustle and meddle about and who constantly interfere, I don't interfere with them either—I also let them go their own way.

33.

ON NOT WANTING TO
AMOUNT TO ANYTHING

Once upon a time there was a hippie. His main philosophy of life was that one should *not* amount to something. More specifically, he believed that the three greatest evils which can befall a man are: (1) acquisition of fame; (2) acquisition of wealth; (3) acquisition of prestige. His parents were extremely bourgeois (at least according to him) and always insisted that he *should* amount to something. For years and years they pleaded, cajoled, threatened, argued and did everything in their power possible to rid him of this "childish" notion that one should not amount to something. They said, "And it is especially tragic with you who have so much talent and who could amount to so much that you should waste your life not amounting to anything." But no, the hippie was as adamant and stubborn as his parents; he simply refused to amount to anything. It was not that the hippie was lazy or inactive; he had an unusually active and fertile mind. True, he could not stand school and was a very early dropout, but he spent all his time in the public library. He was an avid reader and scholar and had a thirst for knowledge as great as any willow tree for water. But when asked, "What will you do with all this knowledge? To what practical use will you put it? How is it going to help you amount to something?" he would answer, "I've told you a thousand times, I have no practical use for this knowledge; I *don't* plan to amount to

something. In fact, I plan most definitely *not* to amount to something!"

You realize, of course, that it was not laziness or lack of ability that prevented our hero from amounting to something. With him it was purely a matter of ideology—of principle—that it was wrong to amount to something. In one particularly passionate outburst against his parents he said, "Damn it all, I would rather be crucified ten billion times and suffer each time the most unspeakably agonizing deaths than have to *amount* to something!" At this point, the parents got alarmed and decided to send the boy to a psychiatrist. Needless to say, *they* chose the psychiatrist, who happened to be a senile old fogey with absolutely no insight into the boy's nature. The boy, though outwardly highly respectful to the psychiatrist, was totally noncooperative and constantly irritated him by his superior, aloof, and almost smirking silence. After a few months, the psychiatrist helplessly threw up his hands and told the parents that although he was quite sure that he had correctly diagnosed the boy's condition, there was very little he could do in the way of cure. "And what," asked the parents eagerly, "is the diagnosis?" "Well," responded the psychiatrist sagely, "I believe the boy's main trouble is that he doesn't want to amount to anything."

Our hero's relationships with his fellow hippies are of considerable interest. He was one of them, yet somehow different. His fellow hippies were hippies more out of natural inclination than ideological principle. To them, it was so obvious that anybody in his right mind would not dream of wanting to amount to something, that it could not even occur to them to do otherwise. They had no passionate prophetic messianic need to preach their gospel. They were perfectly content that they themselves should not amount to something; it was not necessary to convince others not to amount to something. But with our friend, it was so different! He was not content that just he should not amount to something;

others too needed salvation, and it was his mission to save the world from amounting to something. Actually, he did not so much mind the world as a whole amounting to something, but he found the idea horrible that an individual should amount to something.

His friends tended to be very sweet natured but on the whole quite apathetic. Also, they took drugs, which he never did. He felt that taking drugs would interfere with his energies which he sorely needed to find better and better arguments to prove to the world that it is wrong to amount to something. Also, unlike most of his friends, he had a tremendous zest for life. He kept saying, "Life is wonderful! If I weren't alive, then how would I have this marvellous opportunity of proving that one should not amount to something?" Indeed, to him life had two and only two great purposes: (1) not amounting to something; (2) proving that one shouldn't amount to something.

To his hippie friends, he was, of course, *the* spokesman for hippie philosophy. He was considered a great prophet. He traveled much and delivered many speeches on why people shouldn't amount to something. And his speeches were utter masterpieces of eloquence. By and by he came to be regarded as a very dangerous force in his neighborhood—in a way, even more dangerous than the drug pushers. He converted many high-school students to his way of life—students who, but for him, would have been on the path of amounting to something. One by one they dropped out of school and followed him to the public library. They all started studying intensively, but to no *practical* purpose! After awhile, his following got too large for the library, and he started entertaining them in his magnificently spacious home. (His parents had such a home, because they had amounted to something!) There he formed a famous literary club, whose work is well known to this day.

His ideas spread further and farther from home. One day

the book publishers came to his door and said, "Young man, you have some very interesting ideas! You should systematically write them up in the form of a book." This seemed to our hippie an excellent idea. He thought, "Since I have influenced so many people by just talking to them, how many more people will I not reach by publication?" And so after a few months intensive work, he finished his well known masterpiece, "Why You Shouldn't Amount to Anything". The publishers were delighted and anticipated a big sale. Nor were they disappointed; the book spread like wildfire throughout the entire world! Not only were copies bought by all the world's hippies, but also by all parents who were afraid their children might become hippies. After all, the arguments in the book were so ingeniously clever and persuasive that the parents had to master them thoroughly so they could provide counterarguments for their children. At any rate, in a matter of weeks, the boy became a multi-multi-millionaire.

Then one sad day, the entire horror of the situation stabbed the boy like a knife! He exclaimed, "My God! My God! What has happened! *I*, of all people; *I*, *I* have suddenly amounted to something! More specifically, I have acquired: (1) enormous fame; (2) enormous wealth; (3) enormous prestige. I have betrayed my entire life! Oh, dear God, what can I do? What can I do?"

Now at this point, dear reader, I would like to know what *I* can do—about finishing this story! Shall I have our hero commit suicide? No, that would be too sad. What else can I do? Actually, does this story really need finishing? Perhaps my more forbearing readers will let me off with just a few concluding remarks.

In the first place, this story is hardly supposed to have a moral. Rather it is intended to illustrate a philosophical point although just what this point is, is hard for me to say. In summary, we have a case of someone amounting to something by virtue of his very opposition to the idea of amount-

ing to something. Does this perhaps suggest the Hegelian dialectical process? Or does it not perhaps suggest the Taoistic idea of "action through inaction" or of "succeeding by virtue of not striving"? Of course, one might argue that this is not fair. After all the hippie was striving in his own way, for did he not work hard in writing his book? To which I would answer that this charge seems to me unfair. I would rather give the hippie the benefit of the doubt and claim that in writing the book he was not striving for fame, wealth and prestige, but rather was honestly striving to adequately express his own philosophy.

One last point about the story itself—and this might perhaps serve as an ending: One thing that particularly distressed our hero was the thought that his fellow hippies would no longer love him—they might feel he had totally betrayed their cause. In this he was completely mistaken! They loved him all the more and were utterly delighted with his success. They all said, "How wonderful! How marvelous! Just think! One of *us* has amounted to something!" When one of his hippie friends conveyed to him these sentiments, he was horrified! He said, "How can you possibly congratulate me on my success? How can you so thoroughly betray your own philosophy?" His friend wisely answered, "I have not betrayed my philosophy, rather I have modified my philosophy. Your experience led me—and I believe the rest of us— to realize that we do not object so much to one amounting to something, but rather to trying to amount to something."

34

ON MAKING AN EFFORT

All my life I have been intensely repelled by the idea of "making an effort". I hate this idea today as much as I did as a child. I don't know why I hate it so much; I just do.

It is perfectly possible that had I "made an effort" in life, I would have accomplished more than I have. (Who knows, I might have even "amounted to something"!) As I say, this may be *possible*, though I am far from knowing it to be true. If this were true, it would pose a horrible dilemma! On the one hand, it is great fun to amount to something (despite what anybody, including myself, might say to the contrary). On the other hand, it is horrible to make an effort. At least I find it so; if you don't, then the dilemma I am discussing does not apply to you. So the problem is, how does one amount to something without making any effort?

There are two ways out of this dilemma. One can escape it by saying "As for *me*, I don't mind making an effort! I am not lazy, I am not a weakling, I'm not afraid of a little work. In fact, I don't like this whole decadent effete idea of rewards without effort! To me, life *should* involve some effort! What's wrong with a little effort? No, I don't mind making an effort at all—providing, of course, that I amount to something."

Yes, that is one way out of the dilemma. To the person who takes this attitude, I can only doff my hat and wish him the best of luck.

Then there is another way out: One can say "But who wants to amount to something? Why all this egocentric con-

cern with amounting to something? One should be con-
cerned with one's duties to God and one's fellow man rather
than get involved with this sinful preoccupation with person-
ally amounting to something. Now, fortunately *I* am above
wanting to amount to something. Hence for me, this di-
lemma does not exist."

Well, to the person who takes *that* attitude, I also doff my
hat and wish him the best of luck.

But I am primarily concerned with the third type—the
type who damm well *does* want to amount to something, but
who just as strongly wants not to make any effort to do so. Is
his case hopeless? Has he no way out of the dilemma? Many
people will say to him, "Yes! Your case is hopeless! Indeed,
your case is doubly hopeless, for you are committing two sins
—two foolishnesses! In the first place, it is unworthy of you
to want to amount to something. Truly great men are humble—the last thing they desire is personal agrandizement.*
Therefore your desire to amount to something may be the
very thing which is preventing you from doing so. Your sec-
ond sin is your refusal to make any effort. How can you
expect to accomplish anything without effort? Do you really
think your talents alone will carry you through? Nooh! Tal-
ents without effort to see them through are a shameful waste!
Did not Edison say "genius is 1 percent inspiration and 99
percent perspiration"? So, you won't make any effort! All you
want in life is instant gratification! But you can't always have
instant gratification and expect to amount to something too!
So your second sin is your stubborn refusal to make any effort.
Thus you are doubly prevented from amounting to some-
thing. It is wrong of you to want to amount to something in
the first place, but if you insist on wanting to amount to
something, the least you can do is to make an effort to do so!
Discipline, my boy, discipline!"

I am not altogether kidding that some people will talk this

*Good God, how false that is!

way! Of course, my account is foolishly exaggerated and rather old-fashioned, but in principle many people still think like this. At least I have been spoken to like this, which has been one of the bains of my existence!

Now, let us get back to the problems of the third type who wishes to amount to something, but who, like the author, hates the idea of making an effort. Is his case really hopeless? Of course not! Just look at history! As we are at it, lets take a look at some of the author's favorite characters—the Taoist philosphers.

Take Laotse and Chuangtse for example. Surely, they amounted to something! Good heavens, to be avidly read through the ages—for twenty-six hundred years! If that is not amounting to something, what on earth is? Yes, they amounted to a great deal! In a way, they are like the hippie of my preceding tale. They philosophized about nonaction, nonassertiveness, the futility of seeking fame and of trying to amount to something, and they made great names for themselves in this very process! Their success delights me more than any other successes I know. Here is Taoism at its best! Their very success is a living proof of their philosophy.

The relevant question now is, Did they make an *effort?* This is a highly controversial and most subtle point. Indeed, to understand the answer correctly, is to penetrate to the very heart of the Tao itself! One of the main Taoistic principles is *Wu-Wei*—the doctrine of "action through inaction". Did they merely preach this philosophy or did they actually live it? They must have lived it, or they couldn't have written as they did.

Just what is Wu-Wei? Unfortunately, no definition or rational explanation I know can adequately do it justice. The only way one can get a good feeling for this notion is by sampling many cases in which it is used.* If the translation of "Wu-

*I am reminded of Wittgenstein's maxim "Don't look for the meaning; look for the use!"

Wei" as "action through inaction" seems too meaningless
and contradictory, another translation "effortless action"
might be better, and is perhaps more relevent for the pur-
pose at hand. So let us then agree to mean effortless action
by "Wu Wei".

One Taoist saying is "The Tao does not *do* anything. Yet
through it, all things get done". In spirit, this comes very
close to the idea of effortless action. If anything, the Tao is
certainly something which acts "effortlessly". Now, insofar
as the Taoist Sages were in harmony with the Tao, did they
not also act effortlessly? Did they really "make an effort"
to write what they wrote, or did they not rather draw upon
the powers of the Tao? Of the Tao, Laotse said words to the
effect:

> When you look for it, you cannot see it
> When you listen for it, you cannot hear it
> But when you use it, it is inexhaustible

So is not their success due to their using the inexhaustible
powers of the Tao? Did the Taoists feel they were the authors
and inventors of their words and ideas, or that their words
and ideas were coming through them? Did they feel like
active instigators or like mediums? Did they feel active or
passive in writing, or neither? That is, was it really they who
wrote or did their writings seem to have a sort of life of their
own that flowed back and forth like aimless clouds riding on
the winds?

Consider the following beautiful prose passage of the
Northern Sung poet Su Tung-po concerning his own writ-
ings.

> My writings are like the waters of an inexhaustible
> spring which spread out everywhere over the land.
> Along the level ground they surge and billow, flow-
> ing with ease a thousand li in a single day. And when

they encounter hills and boulders, bends and turns,
they take form from the things about them, though
I do not know how they do it. All I know is that they
always go where they should, and stop where they
should stop, that is all. Beyond that, even I do not
understand.[1]

One striking thing about this passage is that the author's
writings come and go by themselves rather than being di-
rected or even produced by *him*. This is another illustration
of Wu-Wei. Elsewhere Su says, "Poems flow out like water
spilled". And again:

A new poem is like a crossbow pellet;
Once it's left the hand it never stops a moment.[2]

The following two poems I'm about to quote are not really
necessary for this chapter, but I love them both so much that
I'd like an excuse for including them. The first is part of a
poem by Tao Yuan-Ming (4th century) and is one of a set of
twenty poems entitled "Drinking Wine".

A thousand years the way's been lost;
Men are stingy with their hearts.
They have wine, but they're unwilling to drink;
They think of nothing but worldly fame.[2]

The following poem by Su Tung-Pu is based upon the
above and employs the same rhyme words. It is about Tao
Yuan-Ming.

The way is lost, and men have lost themselves;
Words spoken now are never from the heart
The refined gentlemen south of the Yangtze
In the midst of drunkenness still sought fame.
Yuan-ming alone was pure and true,
Living his life in talk and laughter.
He was like a bamboo before the wind,
Swaying and bending, all its leaves atremble,
Some facing up, some down, each a different
 shape—

> When he had his wine, the poems wrote
> themselves.[2]

At this point, many readers will object and say, "Of course an artist's work becomes effortless once he has obtained mastery! Indeed, true mastery consists precisely in the fact that his work seems so "effortless". A good writer's writing seems effortless. A good juggler juggles so effortlessly. A good driver drives effortlessly. A virtuoso musician's playing is effortless indeed; if it were not effortless, he would not be a true virtuoso. But what you totally forget is the enormous amount of energy, work, discipline, and effort involved in learning the skill! That's where the real effort comes in—in learning the skill rather than in practising it. So all this fine sounding Chinese "Wu-Wei" stuff is highly misleading! It focuses only on the end product and totally ignores all the painful steps of the learning process!"

To this I reply that I have not forgotten it. I simply don't believe it! I do believe that much learning does involve making an effort, but my point is that it not always does, and more important yet, in many cases where it does, it really doesn't have to! In other words I am asserting that Wu-Wei—effortless action—is applicable *to the very learning process itself!* Yes, this is the main thesis of this chapter.

Consider the Chinese landscape painters. It took about twenty or thirty years to become a true landscape master. Chao Meng-fu said:

> A child hardly weaned starts to paint in the morning and in the evening boasts of his skill." Really such a person still smells of his mother's milk. It takes generally ten years for an artist to gain familiarity with painting materials, another ten years to complete the general training and yet another ten to be able to develop his own style. The open-minded student is too busily concerned with corrections of his

shortcomings to be thinking of sudden popularity. The reward will come to him inevitably with maturity of his craft. Therefore I say, avoid early popularity in order to reach a higher goal.[3]

So, thirty years! It sounds like a lot of effort, doesn't it? But is it really? Or is it a labor of love? And does a true labor of love ever seem like an effort?

I think this last question is quite crucial! Unfortunately, I know of no objective scientific way of settling it. I am not claiming that such a way does not exist—or may not be found in the future—but I know of no such objective way. The only answer I can give to the question is based on my own personal experience. I have repeatedly observed that when I study a subject which I love,—no matter how many years it takes me to learn it—I never feel that I am making any effort, whereas when I learn a subject which I *hate*, (which I have sometimes had to do just to satisfy stupid and useless school requirements) then I have had to make the most gruesome and utterly wasteful efforts indeed! And the subjects I loved, I learned well, with no conscious effort, whereas the subjects I hated, I learned very poorly, despite all my efforts to the contrary.

The question whether painful effort is really necessary to master a subject is still highly controversial. There are those like myself who say, "If you really love a subject, it is not necessary to make an effort to learn it". Others say "Posch! That sounds nice, but is only wishful thinking". Well, who is really right? Or is there a third possibility? I think the situation is most beautifully summed up in the following passage.[4]

In the *Dialogue of P'ang Yün* and the *Records of Pointing at the Moon* we find that P'ang Yün and his wife had a son and daughter, and that the whole family were devoted to Ch'an. One day P'ang Yün, sitting quietly in his temple, made this remark:

"How difficult it is!
How difficult it is!
My studies are like drying the fibers of a thousand
 pounds
of flax in the sun by hanging them on the trees!"

But his wife responded:

> "My way is easy indeed!
> I found the teachings of the
> Patriarchs right on
> the tops
> of the flowering plants!"

When their daughter overheard this exchange, she
sang:

> "My study is neither difficult nor easy.
> When I am hungry I eat,
> When I am tired I rest."

THE TAO IS A DELIGHTFUL PARADOX

道是一個悅人的悖論

thought to believe will happen, then at last will he learn
the perfect synthesis of Eastern and Western philosophy.
In spirit, one line of my poem "Tibetan orphan marooned
nowhere" is quite reminiscent of one of Laotse's verses:

35.

CRAZY PHILOSOPHY AND
SENSIBLE PHILOSOPHY

I would roughly divide philosophies into two categories, "crazy" and "sensible". Of the two, I definitely prefer the former. Sensible philosophies are noted for their sobriety, propriety, rationality, analytic skill, and other things. One definite advantage they have is that they are usually quite sensible. Crazy philosophies are characterized by their madness, spontaneity, sense of humor, total freedom from the most basic conventions of thought, amorality, beauty, divinity, naturalness, poesy, absolute honesty, freedom from inhibitions, contrariness, paradoxicalness, lack of discipline and general yum-yummyness. Their most important advantage over the sensible philosophies is that they come far closer to the truth! Many philosophers of the "sensible" school will surely dispute this, and ask me whether I can "prove" this statement. My answer is, "Yes, quite easily, providing I am allowed to give a crazy proof rather than a sensible one". But of course they will not allow this!

It is of interest how different people fall into the two categories. In general I would say that psychologists, pychiatrists, economists, sociologists and political scientists tend towards the "sensible", whereas artists, poets, musicians, and (to my great delight!) chemists, theoretical physicists, mathematicians—especially mathematical logicians—tend towards what I call the "crazy". I have found from experience that

the most brilliant logicians I have met have both a deep understanding of the "sensible" and also a wonderful feeling for the "crazy". And no wonder! Crazy philosophy is the most refreshing thing in the world, is thoroughly enlightening, and is an absolute prerequisite to understanding things as they really are.

One marvelous thing about this whole crazifying process is that it makes one ever more loving, lovable, and tolerant. If one goes crazy enough, even sanity—normally so gruesome—becomes bearable after a while. At a still higher stage of craziness, the entire duality between craziness and sanity becomes transcended, and the two are seen to be really the same thing.

I am in no way *against* sensible philosophy. It only serves to show how wonderful crazy philosophy is by contrast.

Perhaps I should give you some examples of sensible and crazy philosophies. Well, the former abounds in the literature—particularly the Western literature. Just open a page of Aristotle at random, and you are bound to see what I have in mind. As to crazy philosophy, the following passage from Chuangtse affords a perfect illustration:

> The knowledge of the ancients was perfect. How perfect? I will tell you. At first they did not yet know that there were things. This is the most perfect knowledge; nothing can be added. Next they knew things but did not yet make distinctions between them. Next they made distinctions between them but did not yet pass judgements upon them. When judgement was passed, Tao was destroyed. With the destruction of Tao, individual preferences come into being.[1]

My only apology for this chapter is that it is too damn sensible! As partial mitigation, perhaps, one astute friend of mine observed: "Yes, it is really quite sensible—in a crazy sort of way".

36.

WOULDN'T IT BE FUNNY IF—

Many of you know the famous story of the Chinese Taoist philosopher Chuangtse who dreamed he was a butterfly. Next day he mused, "Yesterday I dreamed I was a butterfly. Today I am Chuangtse. Or is it that I am now a butterfly who is dreaming that he is Chuangtse?"

Wittgenstein somewhere said: "Sometimes I feel that my real body lies elsewhere". I think the fantasy is fairly common that life is a dream, that one's body is unreal, and that one might have a real body elsewhere.

Now, wouldn't it be funny if your life *were* a dream, and when you awoke, you would find that you did have a real body elsewhere, but your real body was not a human, nor a butterfly, nor a mammal, nor any biological creature at all, but was, of all things, an electronic computer! Yes, the computer, who is really you, had been asleep for several years and had been dreaming up this "human body" of yours. It would be particularly ironic if in your dream as a human you had denied that computers really think or have souls. They are (you used to say) purely mechanical beings. Let us say that in your dream days you were a very careful thinker, and gave a rigorous behavioristic definition of "thinking" which logically excluded the possibility that inorganic beings can think—that is, part of your very definition of a thinking being would be that it be a biological organism. So obviously, according to this definition, computers can't think. But now you are awake, and you know perfectly well that you do

167

think, ergo computers—at least some of them—do think. I guess under these circumstances, you would care to revise your definition of "thinking", would you not? Or would you prefer to stick stubbornly to your old definition even though it would force you to say, "Since I am a computer, then obviously I don't think".

It would be equally ironic if in your dream days you had upheld the "identity thesis" of body and mind, which says that all mental events are physical events; a human being's so called "thoughts" are nothing more than certain physiological processes taking place in his brain. So, you used to identify your "thinking" with brain processes in this "body of yours", and you used to identify yourself with this body—which in fact never really existed! So now you are awake, and you clearly see you were wrong. Of course, this does not mean you have to abandon the identity thesis; you merely have to modify it. That is, you might still believe that physical events are the sole reality, that all thinking is purely physical, and that you were right to identify the *you* with some physical structure. Only you now realize that due to misleading evidence you had identified yourself with the wrong body. Had you been awake, you would have not made the mistake of identifying yourself with a nonexistent body but would have known all along that the real you is this computer and that your so-called "thoughts" are nothing more than certain of its electronic processes.

What would be your present thoughts about life and death? Let us say that during your dream days you fervently upheld the belief that you cannot survive the biological death of this "human body". You used to worry that as soon as this body died, poof, you'd go out like a candle! Now you realize that this "body"—whose dissolution so grimly threatened the annihilation of *you*—never even existed! Wouldn't you feel a bit silly? Or would such feelings be overshadowed by your present fear of what will happen to you if the computer should stop functioning. Just think, some mischievous

human might turn off your current, and, poof, you'll go out like a candle! Well, suppose you find yourself on a planet where there are no mischievous human beings, in fact no human beings at all. The only thinking beings are the stationary computers like you and a few ambient computers (robots, if you will) who go around taking care of the others. And these ambient computers are very kind and friendly, and assure you that as long as *they* have anything to say about it you will never be turned off; so you don't have to worry about going out like a candle. Furthermore, if any of your transistors or other parts wear out, they can be easily replaced; so this is no problem. You might say, "This is all very fine, but what happens when the solar system runs down, and there is no more energy to supply me with electric current; what will happen to me *then?*" "No problem," you will be told, "long before that, science will find a way of transporting you (your body, that is) to another solar system—a young, fresh solar system with plenty of energy to keep you going for billions of years". "Yes", you shriek, "but what happens when the *entire* universe runs down? What will happen *then?*"

At this point, you *really* wake up, and find to your amazement that you are not a computer at all, nor a human being, nor anything like that, but a totally different kind of being than you or I have ever imagined, which all this time had been merely *dreaming* that he is a computer.

Now my fantasy is over. Or is it really a fantasy? I, for one, take the possibility very seriously. I don't mean merely that it is logically possible (which is kind of obvious), but I really wouldn't be too surprised if all this would actually happen.

Postscript. I also think it would be funny if for some odd reason this piece would be read a century or two hence, and some future historian would write a brief biographical sketch of the author thus: "Smullyan, Raymond M. An eccentric twentieth-century philosopher who believed he was a computer".

37.

A DREAM

Some of my favorite passages in Eastern philosophy are those in which the Master says something blatantly false. For example, I love one sermon of a Zen-Master in which he says, "From the very beginning, not a thing has ever existed".

I have always been extremely intrigued with the Hindu (?) idea that nothing exists. I would not go so far as to say that I believe it, but I find the idea attractive and, in a strange sort of way, extremely useful. I also find the idea profound and highly suggestive. The only trouble is that when I try to explain just *what* it suggests I somehow get lost.

One of the memorable events of this "nonexistent" life of mine was the following dream (about thirty years ago). A great Yogi appeared and said:

Lo and Behold!
An empty universe!

One might, of course say: "Well, if the universe is empty, then at least *something* exists—viz. an empty universe. So perhaps I should modify my poem and say:

Lo and Behold!
Not even an empty universe!

38.

ASTROLOGY

I understand universities now have courses in astrology. As a clever mathematician friend of mine once remarked: "The problem of hiring astrology professors is relatively easy. Hiring a mathematician or a physicist involves knowing his work, reading his papers, looking at letters of recommendation, etc., but to hire an astrologer, all one has to do is cast his horoscope and see if he would make a good astrology professor."

Until recently I have always looked at astrology as about the most ridiculous business imaginable. And the reasons its proponents give to justify their beliefs strike me as far more implausible than the beliefs themselves! As an adolescent I had a conversation with a high school teacher who believed in astrology. I asked, "But how can the astronomical configuration at the time of a person's birth have the slightest effect on his personality?" She gave the usual answer—"Gravitation." I irritatedly pointed out that the gravitational attraction exerted by a planet like Mars or Venus on a baby born on Earth is far less than that of a chair or table in the room at the time of birth. I don't recall her reply. Now, if an astrologer would tell me frankly that the planets exert a *magical* rather than a significant gravitational influence on us, I could more readily believe it. I would not go so far as to say I would believe it, but I would not reject it outright, as I do pseudoscientific explanations. Magic, you see, is something I know nothing about (despite the fact that I have been

a professional magician for many years), whereas I know a little bit about gravitation. At least I know that the planets do not exert a significant gravitational influence on us. But magic? How do I know how much magical influence things have on each other? Since I know nothing about magic, I am in no position to refute magical explanations. But please let them be purely magical and not pseudoscientific!

Speaking of magic, I am genuinely open to the possibility that the entire universe works ultimately by magic rather than by scientific principle. Who knows, perhaps the Universe is a great magician who does not want us to suspect his magical powers and so arranges most of the visible phenomena in a scientific and orderly fashion in order to fool us and prevent us from knowing him as he really is! Yes, this is a genuine possibility, and the more I think about it, the more I like the idea! So let us assume that magic is the ultimate principle of the universe, and let us suppose that the planets exert a very important magical influence on our lives. The only question is, which planet exerts which type of magical influence? Assuming Mars and Venus affect us differently, how do I know which one affects us in which way? Who can tell me, the astrologers? My point is that even if we allow things like magic and the supernatural, we are still not committed to listening to the astrologers, for how do they know what laws govern magic or the supernatural? (Incidentally, if magic had its "laws", would it still be magic?)

Now that I have made fun of the astrologers, let me defend them, which, surprisingly enough, was my original purpose in writing this chapter. This purpose has become stronger with me in recent years, due in part to a reaction towards a certain scientific smugness, snobbishness, and intolerance I have encountered in others. I recently had a conversation with a mathematician in which he asserted that no intelligent person could possibly believe in such a thing as astrology. Later in the conversation, to my amazement, he con-

tradicted himself by saying how worried he was that so many intelligent people he knows are believing in astrology these days! Now, I do not believe that belief in astrology is necessarily indicative of lack of intelligence. It so happens that I have personally known only about three or four people who believe in astrology, and every one of them impressed me as being extremely stupid. So as far as my personal experiences go, I should agree with my friend. But I don't. I'm not so sure that the belief in astrology is wholly irrational—I'll speak more of this later. But even if it were irrational, I still wouldn't believe that the belief in it is necessarily due to lack of intelligence. In general, I don't believe that irrational beliefs are necessarily due to lack of intelligence. Even superstitions are not necessarily due to lack of intelligence. I have known many extremely intelligent people who have all sorts of strange superstitions, sometimes overt, sometimes repressed. Of course, the thing to do these days is to deny one's superstitions to oneself; but this does not always get rid of them, and sometimes merely represses them so that they may generate great anxiety. For example, there is the genuinely and honestly superstitious person who will not travel on Friday the thirteenth. Then there is the rationalistic scientific scoffer who would not think of not traveling just because it is Friday the thirteenth, and so he travels on those days but for some totally unknown reason gets an anxiety attack. Would you say about such a person that deep down he is lacking in intelligence?

Let's leave superstition now and talk about religion. Those of you who believe there is no such thing as an afterlife, what would you say about a person who on a wholly rational and conscious level agreed with you but who nevertheless had terrible fears his whole life long of one day going to hell? Would you say that he was simply being stupid? More or less stupid than, say, Pascal who believed in heaven and hell on a conscious level? Or would you say that in Pascal's time, it

was possible for intelligent people to believe these things but nowadays with the philosophical enlightenment modern science has given us only stupid people can believe in "all this rot"? I know many people who feel this way. In my judgment, these people are fairly intelligent but not as intelligent as they think. For example, one psychiatrist I know (who incidentally is strongly anti-Freudian) was once speaking with me of a mutual friend. He said of this friend, "He is the most intelligent person I have ever met except for myself." For some odd reason the psychiatrist did not know that our mutual friend was a devout Catholic. When I told him, he was absolutely horrified! He said, "But that is impossible! No intelligent person could possibly believe in the existence of God!" I gently explained to him that even if the belief in God is false it does not necessarily arise out of lack of intelligence. I said, "It is certainly not a sign of lack of intelligence to be inwardly compelled to follow a post-hypnotic suggestion, and religious training in childhood may well have the same psychological effect as the giving of post-hypnotic suggestions." Being a psychologist, he at once saw the point, but to my amazement he said, "I never realized that before. Your analogy of religious beliefs to posthypnotic suggestions is a very good one." And so he revised his temporarily fallen estimate of our Catholic friend.

The amount of intellectual intolerance to religions, superstitions, and various irrational beliefs is quite remarkable and quite revealing. In my simple opinion, those who are most intolerant of irrationality are not those who are most rational, but those who repress their irrationalities while at the same time "priding themselves" on being so rational.

And so it is with astrology. My mathematician friend who could not understand how any intelligent person could believe in such things also said that the belief in astrology is something very dangerous and harmful and impedes the course of scientific progress. As a practical example of such

dangers, he cited cases of young couples using astrology as a guide to their marriage! Now, I ask: Is there any statistical data to show that marriages based on astrological considerations are less successful than those based on so called rational considerations? If anything, I would tend to guess the opposite. If two people feel that their horoscopes are favorable for their marriage, then they expect to be happy, and their very expectation of happiness—their very belief that they are compatible—would, it seems to me, increase their chance of being so. For such people, their astrological beliefs may be self-fulfilling. I pointed this out to my friend, and he laughingly agreed that it might be true. Still he thought astrology is on the whole something stupid and harmful. The conversation ended by his saying that one should not be too tolerant.

I must at this point digress on the subject of tolerance. My immediate reaction to the remark "one should not be too tolerant" was to be intolerant of it although I did not voice my intolerance at the time. (I wonder if he would have approved of this intolerance of mine?) I am quite sensitive to the issue of tolerance, and, generally speaking, I believe I am quite tolerant, but the one thing I have not yet learned to tolerate is intolerance itself. Mind you, I don't believe that one *should* be intolerant of intolerance; I believe it is better to be tolerant even of intolerance, but I have not yet learned to. Perhaps one day, hopefully, I will reach the stage where I will be tolerant of intolerance, or, if I fail in that, will at least be tolerant of myself for not being able to tolerate intolerance. At any rate, as matters now stand, I am less tolerant of an intolerant attitude towards astrology than I am of astrology itself. Indeed, even though I do not believe in astrology, if I had my choice of believing in astrology, or in being intolerant of astrology, I would far rather believe in astrology.

So far, I have treated astrology as if it were something wholly irrational, but have advocated a certain tolerance toward it anyhow. But is it really all that irrational? Well, as

I said earlier, the pseudoscientific explanations involving things like gravity or waves emitted by planets are simply ridiculous, and would never be given by anybody who knows the least bit about physics. As to my hypothesis of "magic", I was of course kidding—though I mean it when I say I could sooner believe even this than these pseudophysicalistic explanations. So I am ruling out both physical forces and magic. What is left? Something which may be of extreme importance! It is the principle which Carl Jung calls *synchronicity*. This is a concept extremely difficult to explain to the mind steeped in the Western scientific principle of causality. This principle of synchronicity, though in no way incompatible with causality, is very different from it and when studied further might in the future, prove the basis of an alternative and quite remarkable science.

The idea of the synchronicity of two events is not that one is the cause of the other, but that they, so to speak, have a common cause. Applying synchronicity to astrology, for example, the idea is that if it really were true that there is a significant correlation between the astronomical configuration of the universe at the time of a person's birth and the characteristics of the person, then it is not that the heavenly bodies themselves are a cause of the person's characteristics, but rather that the circumstances which gave rise to the universal configuration are the very same circumstances which gave rise to the birth of the individual at that particular time.

There is a rather well-known, allegedly true story of a Zen-Master who was one day absorbed in meditation in his garden while the cherry blossoms were in full bloom. Suddenly he sensed a danger. He wheeled around but saw nobody except his boy attendant. This upset him dreadfully, for he had never been wrong before about such matters; in the past whenever he had sensed a danger, there always was a danger. He was so troubled by this inexplicable incident that

he retired to his room, not even coming out for food. Some of his servants were worried about him and went up to inquire of his health. He explained what was troubling him and kept saying, "I don't understand; I've never been wrong before!" News of the matter spread to the other servants and attendants, and finally the boy attendant who had been in the garden came up tremblingly to the master and confessed, "When I saw your lordship so absorbed in the garden, I could not help think that despite our lordship's skill with the sword he probably could not defend himself if I at this moment suddenly struck him from behind. It is likely that this secret thought of mine was sensed by the lord." The boy expected to be punished, but the master was in no mind for doing so, being thoroughly relieved for having solved the mystery.

What should we make of this story? One logical possibility, of course, is that it isn't true. But suppose it is true. How should we explain it? One possibility is that it was a sheer coincidence, but I discard that as being exceedingly unlikely.* I guess the most popular explanation of such an incident would be mental telepathy, but I wish to go on record as categorically denying the existence of mental telepathy.† No, the only explanation that makes any sense to me is a synchronistic one—there was a common cause for the master's feeling of danger and the attendant's thought of attack. Perhaps earlier conversations or other incidents may have set parallel thought processes going in the two minds.

I relate this incident because I read it over four years ago before I ever heard of Jung's principle of synchronicity, and the idea of parallel thought processes immediately leapt to my mind as an explanation (and so I was doubly delighted to subsequently come across Jung's principle). Curiously

*Most coincidences are.

†My apologies to some of you for being so childishly and stubbornly dogmatic on this point, but that's the way I am. If future knowledge should prove me wrong, I will be delighted.

enough, when I once related this incident to a mathematical logician and offered my synchronistic explanation, he replied, "I could sooner believe in mental telepathy." I am really amazed at the readiness of many scientific minds to jump at the possibility of mental telepathy! I have in my life seen many cases which might easily *seem* like telepathy, but in almost all such cases, I have been able to find a most plausible explanation in terms of parallel thought processes.*

The kind of synchronicity of which I have just been speaking applies to parallel thought processes and would hardly apply to something like astrology which, if it could be explained along these lines, would involve a synchronicity of a far more profound order. Indeed, I tell you frankly that I cannot imagine what such a synchronicity could be, unless I allowed some such hypothesis as that of a Universal Intelligence. If there were a Universal Intelligence, then no synchronicity—no matter how seemingly far-fetched—would surprise me. (For that matter, under such a drastic hypothesis —to which I am not completely closed—nothing else would surprise me either!) But for want of such an hypothesis, the kind of synchronicity which would explain something like astrology I find extremely puzzling, as well as quite fascinating and somewhat frightening.

At any rate, the main interest for me in something like astrology is its possibility as a future testing ground for the principle of synchronicity. As matters now stand, I suspect that most astrologers† are fraudulent. After all, the astrologers claim that certain important correlations exist, and they claim to know what these correlations are. Now, I do not

*I am really quite good at this! People are often astounded that I sometimes tell them just what they are thinking. They are astounded, that is, until I remind them of some remark or other which occured three or four minutes earlier.

†I mean astrologers, and not those people who merely believe in astrology.

suspect them of being fraudulent because they are unable to give a scientific causal explanation for these alleged correlations, since my whole thesis is that such correlations could in principle exist without any such causal basis. My suspicion of fraudulence is simply that I do not believe that the alleged correlations have actually been verified nor that astrologers are open to any objective means of such verification. Perhaps I am premature in saying this; perhaps there are some intellectually honest astrologers who are laboriously gathering large amounts of statistical data to test these alleged correlations. Such astrologers—if they exist—I would call "scientific astrologers" and my charge of fraudulence would hardly apply to them! Indeed, such work might prove of great value.

In summary, I am open to the possibility of some sort of astrological science, but I have grave doubts that present-day astrology fits the bill. But it might be the forerunner of something that one day will. Thus I cannot reject it as easily as do my more purely empirical friends. And besides, it is fascinating in an eerie sort of way!

39.

TWO ZEN INCIDENTS

I wish to relate and compare two Zen incidents which superficially seem to point in opposite directions yet which in a far deeper sense appear to me—for reasons I cannot rationally explain—to point in the very same direction. I wish I understood better what I am saying.

The first incident concerns my favorite Zen-Master Bankei. From his earliest age, he had a terrible fear of death. He says that at the age of three, his mother, as a punishment, constantly frightened him with death. When he misbehaved, his mother would immediately remind him of death or frighten him out of his wits by imitating a corpse, whereupon the boy would become "good" again. This intense fear of death was perhaps a major factor in driving Bankei into Zen. As a late adolescent, he entered a Zen monastery and way overdid all the austerities. He practiced Zazen sitting for such long periods at a time that the places where he sat became covered with sores and boils. (Incidentally, would you say that Bankei was acting under self-discipline or under compulsion? I have heard so much talk about Zen training requiring "discipline". But it seems to me that Bankei was acting more out of compulsion than discipline. Was Bankei "choosing" to act this way, or did his fear of death "drive him" to this?) He became so ill, he nearly lost his life! Then he withdrew for a few months to recuperate. It was during a feverish period of his convalescence that he had his satori. And this consisted of an instantaneous realization that he

could not die for the simple reason that he had *never been born!* The crux of the matter is that he had never been born.

Now for the second incident. Someone asked a Zen Master, "Where will you be after you die?" The Master replied: "Where will I be? I will probably be lying on the ground with my four limbs pointing straight up at the sky. That's where I will be".

Now, what do these two incidents have in common? To me, they both equally suggest the nonreality of death. (Please don't misunderstand me! I am not arguing here for the nonreality of death; I am merely trying to pinpoint the ideas suggested by these incidents without trying to defend them.) That the Bankei incident suggests this is of course immediate. Bankei said that *he* had never been born. Now, Bankei knew as well as you or I that his body emerged from his mother's womb at a definite time and place, that his *body* had been born. Yet he believed that *he* had never been born. This means that he did not identify himself with his body. So, his body had been born, but he had not. Now, I understand this feeling perfectly! I often feel that I am somehow outside of time despite the obvious fact that I am experiencing time. (It's as if I were observing the flow of time from a vantage point located outside of time.) So I understand how Bankei feels. (I should have said *felt*, but I shall leave this error uncorrected because it is rather revealing!) That the second Zen incident should have the same psychological effect is perhaps more puzzling. The second Zen-Master evidently identified himself completely with his body. When asked where *he* would be, he simply stated where he thought his body would most likely be. Why, then, does this also suggest the nonreality of death? I can only hazard some guesses.

In the first place, is not this answer a bit of a shock? I think suprisingly few people would give such an answer—even those with no belief in a soul or afterlife or anything like that. Most likely, such people would answer something like:

"Where will I be after I die? I will no longer exist!" or "There won't be any more me" or "I will get annihilated". (Incidentally, isn't this word *annihilated* a bit on the gruesome side? I don't even know what it means for a soul to get "annihilated", but whatever it does mean, it certainly sounds a bit ominous!)

To diverge a bit from my main point, I should like to make some remarks concerning this usual trigger response. I find it strange that a self-called "materialist" who claims not to believe in the so called "soul" would say "After I die, I will no longer exist". Does this imply that he exists now but will cease to exist after his bodily death? What is this *he* which exists now, but which will not exist after his body dies? This *he* is certainly not his body; his body will indeed continue to exist for a while as a dead body—perhaps lying on the ground with its four limbs pointing up at the sky. When this self-styled "materialist" is asked, "What is this *you* which exists now but which will cease to exist in the future?" he will probably answer, "My consciousness. My consciousness is something purely physical which exists now but which will cease to exist upon my bodily death". Indeed, I know one "materialist" who thought of consciousness as nothing but a relation between bits of matter. He likened the consciousness of an individual to the motion of a motor. He said, "It makes no more sense to ask where one's consciousness goes after death than to ask where the motion of a motor goes after the motor is turned off. The motion does not *go anywhere;* it just ceases".

I do not know whether the analogy of consciousness with the motion of a motor is a good one. To me, consciousness seems something very, very different from the motion of a motor! Also, I cannot think of consciousness as some sort of a "relation"; relations are something abstract, whereas consciousness is the most concrete thing in the world. Nevertheless, I think the idea that consciousness does not go anywhere

is a good one. One might ask: "If consciousness does not go anywhere, does that mean that it remains where it is?" To which I would answer: "Hardly! Going somewhere or remaining do not seem like categories which can be at all applied to consciousness".

When you stop to think about it, a pure thoroughgoing materialism (which unfortunately is not the philosophy of many who call themselves materialists) is also suprisingly suggestive of the nonreality of death. For, since there is no soul, what is there to die? I am, of course, not speaking of biological death, but of psychic death—if there is such a thing. When I say "if there is such a thing", I have in mind several different philosophies which believe there is no such thing—but each for different reasons. On the one hand, some forms of Christianity—for example Catholicism—definitely believe in the existence of the "soul" or "psyche" and that it does in fact survive one's bodily death. Then, of course, there are those Eastern religions that believe in reincarnation; for them, death is also unreal. But perhaps most remarkable of all are those who believe in the nonreality of psychic death, not because of their belief that the soul somehow outlasts the body, but simply because there is no soul or psyche to begin with! Curiously enough, both pure materialists and some philosophical Buddhists fall into this class. The essence of one form of Buddhism is the denial of the *I* or ego or what Western religions call the individual "soul". This attitude was also shared by David Hume[1]

I have still not solved the problem which plagues me—why the second Zen-Master's reply so strongly suggests the nonreality of death. The answer I have suggested—that the Zen-Master completely identified himself with his body and did not believe in any such thing as a "soul" which could perish —strikes me as too superficial to be really satisfying. And besides, this is not really the feeling I get from the story! When the Master said, "When I die, I will probably be lying

on the ground with my four limbs pointing at the sky", the feeling I get is that the body is indeed lying there, but the master is somehow around observing the body lying there. I get this feeling far more strongly than the feeling that he identified himself with his body. In a way, I almost get the feeling that he identified himself with the entire universe or perhaps even with some sort of Cosmic Consciousness which observed the entire universe. But this may all be projection on my part; it is perhaps more likely that he, being a Zen-Master, didn't identify himself with anything! (Identification involves the duality of a subject, which does the identifying, and the object with which the subject identifies.) Perhaps the Zen-Master meant his answer as a plain statement of fact, without any metaphysical connotations at all! Still more likely yet, the Zen-Master did not *mean* anything at all; his response spontaneously came forth from the question just like the sound of a bell comes forth when you strike it (without the bell "meaning" anything by the sound). Yes, I think this is the most likely of all. In this case, then, I may be reading far too much into the whole incident. Still, the answer suggests to me the nonreality of death. Why is this?

40.

TWO VERSIONS OF A STORY ABOUT BANKEI

I know two versions of a very illuminating story about Bankei the Zen master. These two versions are superficially close, but I think they illustrate two completely different points.

1. The Master Bankei's talks were attended not only by Zen students but by persons of all ranks and sects. He never quoted sutras or indulged in scholastic discussions. Instead, his words were spoken directly from his heart to the hearts of his listeners.

His large audiences angered a priest of the Nichiren sect because the adherents had left to hear about Zen. The self-centered Nichiren priest came to the temple, determined to debate with Bankei.

"Hey, Zen teacher!" he called out. "Wait a minute. Whoever respects you will obey what you say, but a man like myself does not respect you. Can you make me obey you?"

"Come up beside me and I will show you", said Bankei.

Proudly the priest pushed his way through the crowd to the teacher.

Bankei smiled. "Come over to my left side."

The priest obeyed.

"No", said Bankei "we may talk better if you are on the right side. Step over here."

The priest proudly stepped over to the right.

"You see," observed Bankei, "you are obeying me and I

think you are a very gentle person. Now sit down and listen".

The key issue in this version seems to be the question of obedience. The story reminds me of a cute joke or trick which someone once played on me: He said, "I bet I can make you open your fist". I said "okay", and I made a fist. He said, "No, no, thumb inside!" I naïvely opened my fist, put my thumb inside and reclosed my fist. He said "There, you have opened it!" This trick really works; I have tried it on dozens and have not failed yet! Try it sometime!*

The story is also somewhat reminiscent of the lovely Aesop fable of the Sun and the Wind disputing who was more powerful. They agreed to a match. The test case was a traveler on the road. The question was whether the Sun or the Wind could make the traveler remove his cloak The Wind tried first. He raised a violent storm and blew and blew and blew, trying to blow off the cloak. But the more the Wind blew, the more tightly the man wrapped the cloak about himself. Finally the Wind was exhausted and defeated. Then came the Sun's turn. The Sun warmed up everything, dispelled the storm, and shone warmer and warmer. Finally the man perspired and took off his cloak.

When the priest told Bankei that he could not make him obey him, he of course meant "against my will". But Bankei never specified that he would get the priest to obey him against his will; Bankei merely claimed he would get the priest to obey him, which of course he did. The kind of obedience Bankei got was exactly like the Sun in Aesop's fable, who curiously enough forced the traveler to "voluntarily" remove his cloak.

It is this type of obedience which is so thoroughly Taoistic in nature! The whole idea of Taoistic politics is that the Sage-Ruler influences the people to *voluntarily* do that which is good for them. As Laotse said: "When the true sage rules,

*If you do, you will be obeying me!

good things are accomplished, and the people all say, "We did it ourselves" ". This, incidentally, is an illustration of Wu-Wei in politics (in which Laotse, more than Chuangtse, was interested).

This Wu-Wei method for obtaining voluntary obedience (which is also somewhat reminiscent of B.F. Skinner) is really the methodless method of the Tao itself (though the Tao is not consciously aware of this). The Tao acts spontaneously, rather than purposively, but this is nevertheless the way it acts. The following could well have been said by Laotse:

> The Tao never commands,
> And for this reason, is
> voluntarily obeyed.

By contrast, we might remark that the Judeo-Christian God does command, and for this reason is sometimes disobeyed.

2. In the second version of the story, the whole point seems different. The issue is not obedience but understanding. In this version, the Nichiren priest was not innately hostile or argumentative, he simply kept saying to Bankei, "I cannot understand you". Bankei said, "You cannot understand me? Come up on the platform and perhaps I can get you to understand me." The priest went up on the platform and Bankei asked him to move to the left, then to the right, which the priest did. Bankei said, "See, you understand me perfectly! Now be a good fellow, and sit down and listen to what I have to say".

This second version strikes me as more subtle, though in a way more profound, than the first and also a little disquieting. A logician may well be irritated with this story and say, "Well now, just because the priest understands Bankei's request to come up and move about does not negate the fact that he did not understand what Bankei was saying while he was delivering his sermon. Indeed, when Bankei said, "See,

you understand me perfectly", the priest's logical answer would have been, "Of course I understand the things you are saying now, but I did not understand the things you were saying before, and you still have not gotten me to understand those things."

Well, this is a typical logical analysis, and as logical analyses go, it is not a bad one. But I don't think it goes far enough; there is more to the picture. But unfortunately the *more* of the picture is extremely difficult, if not impossible, to explain by purely rational methods—at least for me it is. Could one perhaps say that part of Bankei's real message was that the type of understanding displayed by the priest in coming up to the platform is more basic and important than the type of understanding required to follow the thoughts of a sermon? One might add an even more subtle point. The response of the priest when he said, "I don't understand you" was a live, spontaneous reaction, and as such represented an important kind of understanding similar to the direct and un-premeditated response of the priest when he walked onto the platform. It is this immediate type of understanding—the type which comes direct from ones true "unborn nature"— which is the important one. There is, I think, even more to the picture than that, but at this point, words simply fail me.

41.

AN IMAGINARY ZEN STORY

ZEN MASTER: I have here a staff, and yet I don't have a staff. How would you explain *that?*

JEWISH NOVICE: I wouldn't!

MASTER: Now, don't be impertinent! It is encumbent on you—if you really wish to attain enlightenment as you claim —to make every possible effort to answer this.

NOVICE: All right, I guess that looked at one way you have a staff; looked at another way you don't.

MASTER: No, that is not what I mean at all! I mean that looked at exactly the *same* way, I have a staff and I don't have a staff. Now, how do you explain that?

NOVICE: I give up!

MASTER: But you *shouldn't* give up! You should strain every ounce of your being to unravel this.

NOVICE: I won't argue with you as to whether I should give up. The existential fact simply is that I do give up.

MASTER: But don't you wish to attain enlightenment?

NOVICE: If attaining enlightenment means considering such damn-fool questions, then to hell with it! I am sorry to disappoint you, but goodbye!

Twelve Years Later

NOVICE: And so I return to you, O Master, in a state of absolute contrition. For twelve years now I have been wandering about feeling terrible for my cowardice and impa-

tience. I now realize that I can't keep running away from life. Sooner or later I have to face the ultimate problems of the universe. So now I am ready to steel myself and try to work in earnest on the problem you gave me.

MASTER: What problem was that?

NOVICE: You said that you have a staff and yet you don't have a staff. How do I explain that?

MASTER: Is that what I really said? Why how silly of me!

42.

WHY DO WE SOMETIMES
MISUNDERSTAND?

Zen writers often tell us that we sometimes fail to understand a given passage because our approach is too intellectual and rationalistic. We try to reason it out rather than approach it intuitively. This is certainly often the case, but I wish to point out that in many cases the fault is really not our own but is rather due to incredible stupidity on the part of translators. Let me cite some examples.

One Chinese translator of Laotse translates the first line of the Book of Tao thus:

> The Tao that can be Taoed
> is not the true Tao

Now, how on earth can any English-speaking person be expected to understand that? The fact of the matter is that the Chinese ideograph for the Tao has many other meanings as well, one of which is "speech". Thus a correct (and perfectly understandable) translation would be "The Tao that can be spoken of" or "The Tao that can be named" or perhaps "The Tao that can be described" is not the true (or eternal) Tao. But "The Tao that can be Taoed" is hardly comprehensible!

Another cause for our lack of understanding is that the translator sometimes fails to include certain relevant facts which are absolutely crucial. There is, for example, the well-known story of the Zen-Master who when asked,

"What is Buddha?" replied, "Three pounds of flax".

Now, any reader who thinks he can understand that story (in the above version) is only kidding himself! He may give some far out interpretation, but he will totally miss the point and would have done far better to have ignored the story altogether. This is what I did until I recently came across the following version which makes complete sense. In this version, the Zen-Master was spinning flax at the time he was asked the question, and answered something like: "What is the Buddha? Why it is nothing more than these three pounds of flax". (In other words, the Tao is your everyday mind, and God is everywhere, and the Buddha is everything and anything, like these three pounds of flax, for example.) Does not this make sense?

There is another reason for our misunderstanding of many Zen incidents which is indeed our own fault: We assume that when the Zen-master speaks, he always means something by what he says. And to make matters worse, we assume that he means something profound and important (and thus we have missed something profound and important!). So, the Zen-Master always *means* something, eh? Tell me, when you strike a gong and the gong responds with a sound, does the gong always mean something by its response? This analogy will strike most readers as terrible, but fortunatly it will not necessarily strike the gong that way!

For those who don't like analogies between humans and gongs but prefer analogies between humans and humans, consider the joke about two psychiatrists who pass each other on the street, one says, "hello" and the other thinks, "Hm, I wonder what he meant by that!" Well, I think many of us are as bad as the psychiatrists in always trying to impute meaning to all things said. The Zen-Master can only be properly understood if we don't always try to find some "deep spiritual meaning" behind these responses, but simply understand them as arising just as naturally in their contexts as the sound

of a gong from its being struck. I am not saying that the Zen-Master's response does not *have* a deep spiritual meaning, but only that the meaning is not necessarily that of the Zen-Master himself, nor does he necessarily know what this meaning is. It is the same with the gong! Its sound has a deeply spiritual meaning indeed, but it is not known that the gong can tell us what it is.

I can think of no more fitting conclusion to this chapter than to cite the following fairly well-known story: Someone asked a Zen-Master, "What is the ultimate nature of reality?" The Master replied: "Ask the post over there". The man responded: "Master, I don't understand!" The Master said, "Neither do I".

43.

MONDO ON IMMORTALITY

ZEN STUDENT: So Master, is the soul immortal or not? Do we survive our bodily death or do we get annihilated? Do we really reincarnate? Does our soul split up into component parts which get recycled, or do we as a single unit enter the body of a biological organism? And do we retain our memories or not? Or is the doctrine of reincarnation false? Is perhaps the Christian notion of survival more correct? And if so, do we get bodily resurrected, or does our soul enter a purely Platonic spiritual realm?

MASTER: Your breakfast is getting cold.

44.

DO YOU SEE THE POINT?

A beautiful Zenrin poem begins:

> Sitting quietly doing nothing,
> Spring comes, and the grass
> grows by itself.[1]

I would like to interrupt at this point, and add

> Standing wildly, doing something!
> Spring comes, and the grass
> doesn't grow anyhow!

But I shouldn't spoil this marvellous poem! It continues:

> The wild geese do not intend
> to reflect their images
> The water has no mind to receive them.

In spirit, that verse reminds me of the following profound thought:

> Though not conciously trying to
> guard the rice field against intruders,
> The Scarecrow is, after all, not
> standing to no purpose.[2]

The Zenrin poem then continues:

> An old pine preaches wisdom.
> A wild bird is crying the truth.

I find the line "A wild bird is crying the truth" almost shattering in its realism. That line seems to be crying the truth!

There is the well known incident about a Confucian scholar seeking enlightenment from a Zen-Master. The student constantly complained that the Master's account was somehow incomplete, that the Master was withholding some vital clue. The Master assured him that he was withholding nothing from him. The student insisted that there was something the Master was withholding from him. The Master insisted that he was not withholding *anything* from him. Later on, the two went for a walk along the mountain path. Suddenly the Master said "Do you smell the mountain laurels?" The student said "Yes!" The Master said, "See! I am not withholding anything from you!"

I told this story once to an intelligent mathematician. He said he could not see the point. In my clumsy Western manner, I bumbled something like the following: The reality which the student sought is nothing more than that which comes directly through the senses. The Tao is your everyday mind. The transcendental which the student thought the Master was withholding from him is nothing more than the imminent, which the Master could not possibly withhold from him. Yes, if the Master had blinded or deafened him or had in some other way prevented information from normally filtering through his senses, then the Master would have been withholding something from him—something most valuable indeed! But the Master did none of these things, so what could the Master have been withholding from him?

My friend sort of saw the point. I then said that essentially the same message lay in the following Zen poem (which incidentally has struck me as the most enlightening poem I have ever read):

> When the wild bird cries its
> melody from the treetops,
> Its voice carries the message
> of the Patriarch.
> When the mountain flowers are in bloom,
> Their full meaning comes with their scent.[3]

My friend excitedly responded "If you had read me this poem first, I would have fully understood the other! Now I get the point!"

Postscript. I once read this to a friend who said: "I thing that *seeing* the point is the wrong approach". There is much in what he says. Therefore I might add:

> To see the point
> Is to miss it completely!

45.

ENLIGHTENMENT

A (possibly) fundamental notion of Eastern religions and mystical or philosophical thought is this thing called *enlightenment*–or *samahdi* or *Satori* (in Japanese). There is the (possibly) corresponding notion of *salvation* in Christianity. One possible virtue of the Christian notion of salvation is that conceptually it is extremely clear. According to Christianity —at least some versions of old-fashioned Christianity—there is a personal God whose creations we are. This God punishes or rewards us in the afterlife for our behavior in this life. If we have been sufficiently "good", we attain "salvation"—we are "saved" and our souls go to heaven where we enjoy total bliss for all eternity. Now, regardless of whether we believe this or not, I cannot see anything the least bit unclear about what it is that is being asserted. According to some more modern approaches to Christianity (e.g., C. S. Lewis) our salvation or damnation is not so much a "reward" or "punishment" of God, but is something we in a sense choose for ourselves. That is, it comes about as an inevitable consequence of our own acts (in this respect, it comes remarkably close to the Indian doctrine of *karma*). Now, the Eastern notions of enlightenment—at least some of them—do not seem to have this same conceptual clarity—except perhaps to those already enlightened or at least partially enlightened. I do not speak so much of those Eastern religions which literally believe in reincarnation. According to them, enlightenment or *nirvana* is a pretty clear cut thing. After having

led sufficiently good lives for sufficiently many life-cycles, one accummulates sufficient good karma to "escape the wheel of life and death" (or the "wheel of Samsara") and thus not have to be born again in a world of evil and suffering like this one. Now again, this idea—regardless of whether it happens to be true or false—strikes me as perfectly clear as to its meaning. But I am mainly interested in those Eastern notions of enlightenment (or the equivalent) which are—at least from the more literal Western rational or scientific point of view—less clear in their (so-called) *meaning*. I am thinking more specifically of the Taoist notion of "being in harmony with the Tao" and the Zen notion of "Satori". Just what does it mean to be in harmony with the Tao, and just what is Satori? Well now, if you asked an ancient Taoist what it means to be in harmony with the Tao, he might well just smile at you, sweetly but sadly. Recall the following wonderful two lines of the poet Li Tai Po:

> You ask me why I live in
> these blue hills.
> I smile, but do not answer.

If you asked a Zen-Master just what is Satori, he might smile or scowl at you, or give an answer like "the stream flows on". Or he might simply give you a couple of good blows with his stick.

I guess from the Western rationalistic, scientific point of view, those answers are not too good, are they? How do they actually tell you what enlightenment really is? (As a matter of fact, in their own strange way, they do, but I am not prepared to argue the point here) For that matter, can any words tell you what this kind of enlightenment is? What about words like "seeing into your true unborn nature"? What about words like "show me your real face before you were born"? Do these words help? Do any words help? There seems to be a difference of opinion here amongst the

so-called *experts.* * Some say that the notion of enlighten-
ment is absolutely ineffible, and so no words can help; they
are only comprehensible to one who is already enlightened.
Other's say words can help—if only as a suggestive pointing
of the way.

Although nobody has asked my opinion of the matter, I
wish to give it anyway. Here is how I see it: Of course, words
can help! But they can help only those who are not already
hostile to the idea. The amount of hostility I have encoun-
tered is fantastic! Why are people so unbelievably uneasy and
disturbed about this? Is it simply *jealousy* toward those who
are enlightened, coupled with a fear of somehow being left
out or being incapable of this marvelous thing called "en-
lightenment"? I really don't know; all I know is that this
painful hostility exists plentifully and often manifests itself as
a flat denial that there is any meaning or important signifi-
cance in the whole idea of enlightenment. Indeed, the angry
skeptic will say, "if the word *enlightenment* or *Satori* really
has any meaning, as you claim, why can't you plainly tell me
what it means?" But, as I have said, it can only be successfully
told in an atmosphere free of hostility. So we have here a
strange deadlock! I believe I can easily (though not quickly)
convey the Eastern notion of enlightenment to anybody who
is sympathetic to it. But in a hundred million kalpas, no words
of mine can convey it to one who is not. For any such words
I can find, he can find more clever words to show that what
I am saying is as empty as the babbling of a stream. The
curious thing, though, is that the babbling of a stream is itself
something so remarkably close to enlightenment!

*Isn't the idea of an expert on enlightenment a bit ludicrous?

46.

THE EVENING COOL

> The evening cool
> Not knowing the bell
> Is tolling our life away.[1]

This is a verse of the great Haiku poet Issa. Another of his verses goes:

> The evening cool
> Knowing the bell
> Is tolling our life away.[1]

Of these two verses, Blyth says:

> These two verses express the difference between the ordinary man and the enlightened man. Both know, if they think of it, that the evening bell from the temple sounds the passing of one more day of their life. But the enlightened man *knows,* as part of his hearing the bell, as part of every breath he draws, as part of the coolness, that all is fleeting and evanescent. Only the enlightened man enjoys this whole truth of the temporary nature of the coolness. For the unenlightened man, the coolness, the sense has for its enemy the *thought* of the transitoriness of everything.[1]

I agree with the last sentence of this commentary, but I radically disagree with the rest! To me, the first poem, not the second, represents the state of the enlightened

man. In the first place, it is not even true that the bell is tolling our lives away, and to associate the tolling of the bell with the gradual expiration of our lives is indicative of a profound state of unenlightenment. Let me say more.

As I see it, the completely unenlightened man believes there is such a thing as death and that death is tragic. The slightly more enlightened man believes there is an afterlife. The still more enlightened man believes there is no afterlife, but that death is not tragic. The man more enlightened yet does not believe in death at all (except, of course, in the trivial biological sense), nor does he necessarily believe in an afterlife. The next stage of enlightenment is to realize that life and death are both purely illusory; they may have existence in the phenomenal but not in the numenal world. At a still higher stage, one realizes that all talk of life and death totally misses the truth. For example, Buddha when asked "Is there an afterlife?" replied: "To say there is an afterlife is to miss the mark. To say there isn't is to miss the mark. To say either there is or there isn't is to miss the mark. To say that there both is and isn't is to miss the mark. All these have no bearing on the real problem, which is salvation".

Thus, as I have said, at a certain high stage of enlightenment, one realizes that all thoughts of life and death are futile. Finally, the completely enlightened man even transcends the above realization, and simply ceases to think about life and death at all! Therefore I say that the truly enlightened man hearing the tolling of a bell would simply enjoy the experience for what it is, and would have no such foolish and "arty" thoughts about its connection with life and death. In this respect he is like my dogs who, upon hearing a bell, would not in a million years have any such ridiculous idea as that it is "tolling their lives away".

My attitude is very much like that of the poet Basho when he wrote:

> Admirable is he, who when he
> sees lightning, does not say
> "Life goes by like a flash".

47.

WHEN THE TIME IS RIPE—

There are some philosophers—as well as people—who seriously wonder or worry about such questions as How did I *really* come into existence? How did the universe come into existence? Am I caused by something outside me? How come there is any world at all? How come the world produced me rather than someone else? Where would I be now if my mother's egg had been fertilized by a different sperm cell than the one which actually fertilized it? And what really am *I* anyhow? Am I a mind? Or a body? Or both? Or neither? Did I have a beginning? Will I have an end? Did I, perhaps, cause this universe, or did the universe cause me, or are the universe and I so related that neither could possibly exist without the other? Is my existence necessary or only contingent? What really is everything all about anyway?

Let us now imagine such a metaphysical inquirer expressing these perplexities to a group and some of the reactions which might ensue.

MORALIST: The main thing that strikes me—apart from the pomposity of such questions—is the man's incredible egocentricity! Almost all the questions use the word *I*. How did *I* come into existence; did *I* create the universe. I like the man's nerve!—did *he* create the universe! Perhaps if he thought a little more about other people, he would not be so involved in all this nonsense!

PRACTICAL MAN: I agree with the Moralist. But apart from the moral angle, I should like to express my distress at seeing

a man of such talent waste so much time on such utterly hopeless speculations! Doesn't he have anything better to do with his time than to fritter it away on questions the whole human race has been asking for thousands of years and which no one has even remotely answered? I am not saying that he should never think about such matters; everybody thinks about them occasionally. Even I, when I have nothing better to do, sometimes have such thoughts, but I quickly dismiss them because I realize they are an utter waste of time. There is much useful work to be done in this world, and I feel it is a great shame for anyone with the capacity for honest work to lose himself in a morass of speculations which are useful to nobody.

LOGICAL POSITIVIST: These questions are not merely useless but actually quite meaningless. The fact that they have never been answered is not something accidental. It is not that nobody so far has been sufficiently intelligent to find the answers; rather it is that there are no answers since these are not real questions. They have a syntactical form which somewhat resembles real questions, and it is this superficial resemblance which is so misleading. But a closer and more formalistic analysis reveals that they are not questions at all. Therefore, this metaphysician is not, like genuine scientists, a seeker of truth—though I grant he may believe he is. Rather he is striving to express certain poetic and artistic emotions, but unfortunately metaphysics is a very poor medium for such expression. As the philosopher Rudolph Carnap so aptly expressed it, "Metaphysicians are musicians without musical ability."

DISSENTER: I couldn't fail to disagree with you less!* To me, the metaphysicians questions are perfectly clear and meaningful. I don't care how many formalized languages you

*I did not invent this gorgeous phrase! I just could not resist using it in this context.

positivists set up, and how many empirical criteria of "meaning" you may care to consider, or how many "proofs" you offer for the meaninglessness of metaphysics, I know as well as I know anything that metaphysical questions are as meaningful as any other questions, at least according to my meaning of the word "meaning". And don't ask me for *my* definition of "meaning", because it won't do you any good! It is just as untranslatable into terms which you are capable of understanding as are many of the metaphysical terms which you reject. If you should ask me why you as a rational being should accept the meaningfulness of the metaphysicians questions, I would reply that there is absolutely no rational reason why you should. Either you see the meaning or you don't. And if you don't, then no rational analysis of *meaning* nor any setting up of formalized languages or framing of "criteria" of meaning will help you in the least.

I totally disagree that metaphysicians are musicians without musical ability. Of course metaphysics is neither logic nor science—everybody knows that. Even the metaphysicians themselves will be the first to acknowledge this obvious fact. But just because metaphysics is totally different from science and mathematics, it does not follow that it must be art, poetry or music. Anyone who has the least feeling for metaphysics knows that the metaphysical sense is as different from the aesthetic sense as either is from the rational sense. Metaphysics is not inferior art, it is not art at all; it is something completely different.

Sometimes I cannot but wonder what is the real psychological basis of the positivists' attack on metaphysics. I can think of two possibilities. One is that positivists are simply lacking in metaphysical sensitivity just as some people are lacking in any aesthetic sense or as some lack any sense of humor. The positivists therefore are simply jealous, envious of the metaphysician and hence take the sour-grape attitude "metaphysics is just a lot of nonsense." Another possible explanation is

that positivists are *very* sensitive to metaphysics, far too sensitive for their own comfort! Indeed, metaphysical questions come so dangerously close to their real problems that the positivists hold them at arm's length by the simple device of declaring them "meaningless". But why should I be talking about these psychological questions when we have a professional psychologist in our midst? I think we should hear his views on the psychology of philosophy.

PSYCHOLOGIST: Surely all of you here must have sufficient psychological sophistication to realize the real questions the metaphysician is asking. Just consider some of them: "Where did I come from? What is my ultimate origin?" Is it not obvious that the metaphysician is simply concerned with his unfulfilled incestuous longings, coupled with his desire to return to the womb? Consider his final question which is logically the most vague but psychologically the most expressive: "What is everything all about anyhow?" What is this "everything" which he wants to know all about? Is it not clear that what he really wants to know is what it would really be like had he fulfilled his Oedipal wishes! The logical positivist, on the other hand, is frightened of his Oedipal attachments—he indeed wants to keep his mother at "arm's length" and tries to annihilate his incestuous longings by declaring them "meaningless". Thus, I would say, the metaphysician is the man who is still longing for his mother; the positivist is the man who is trying to break away from his mother.

DISSENTER: I'm afraid that I cannot but fail not to disagree with you even less yet! (Either that, or I mean the opposite of what I have just said.) This Freudian type explanation, though not totally unrelated to the truth, is too simplistic.

PSYCHOLOGIST *(agitated):* Of course you call it simplistic! Everything that comes too close to the unwelcome truth, anything which comes dangerously close to shattering one's defenses, is usually rejected as being "too simplistic".

DISSENTER: My dear sir, you can save this coercive type of argument for your parishioners or "patients". You are now dealing with *me*, and I am a little too tough to be easily scared off by this type of argument ad hominum. As I was saying, before I was interrupted, this Freudian type analysis is too simplistic. I do not deny that there may be a close relationship between metaphysical curiousity and sexual curiousity. But it is a mistake blithely to assume that the former is necessarily a sublimation of the latter. If anything, I would say the latter is a sublimation of the former. Metaphysical curiousity, it seems to me, is really concerned with the question, What will really happen to me after I die? Will I get annihilated like the materialists tell me? Or will I somehow survive? And I believe survival is more basic to an individual than reproduction. But I would like to hear what our friend here the Mystic —who has been so strangely silent this whole conversation— has to say about the true nature of metaphysical inquiry. Tell me, why have you been so silent? Why have you not had anything to say?

MYSTIC: What is there to say?

DISSENTER: Whatever you like! Don't you have anything you'd like to say?

MYSTIC: Yes.

DISSENTER: Very well then, say it.

MYSTIC: Say what?

DISSENTER: Say whatever it is you want to say.

MYSTIC: And what is that?

DISSENTER: What is what?

MYSTIC: What is it that I want to say?

DISSENTER: How should I know what you want to say? If anybody knows, it should be you.

MYSTIC: Why?

DISSENTER: Why? I don't know why! Don't you know what you want to say?

MYSTIC: Yes.

DISSENTER: Then why don't you say it?

MYSTIC: Why don't I say what?

DISSENTER: Oh, for heaven's sakes, there we go in a circle again! Talking to these mystics is like pulling teeth. Why can I never get a straightforward answer to a perfectly simple question!

PSYCHOLOGIST: Perhaps your approach is wrong. I think your original question, Why have you not had anything to say, sounded a little too supercilious and patronizing and tended to put the mystic into a not too cooperative mood. Let me try! All right then. Tell us, what do *you* think of metaphysics?

MYSTIC: Oh, shut up!

PSYCHOLOGIST: Hm, the dissenter was right; these mystics are sometimes a little on the touchy side.

METAPHYSICIAN (to the mystic): Do you really agree with these people here that my questions have no meaning? I am not talking about cognitive meaning, or emotional meaning, or artistic meaning, or symbolic meaning, or sexual meaning, or psychoanalytic meaning; I am talking about *real* meaning. Am I making no sense at all?

MYSTIC: Of course you are making sense! To me, you are making more sense than anyone else here. Who in his right mind could for one minute doubt that your questions are not only meaningful but are obviously the questions which are of most concern to mankind?

PRACTICAL MAN: Many of us here have doubted it.

MYSTIC: That does not contradict what I have said.

PSYCHOLOGIST: How can you, a mystic, accept the significance of metaphysics? Did not Buddha explicitly reject metaphysical questions as irrelevant to the problem of salvation or enlightenment?

MYSTIC: So because Buddha didn't like metaphysics, it follows that I don't? Just because you label me a *mystic*, you think I can't think for myself?

No, to me, the problem of enlightenment and the solution

of metaphysical problems are one and the same thing. There is no question in my mind that the questions asked by the metaphysician are very real and of the utmost importance. Now, what the practical man said is quite true: Metaphysicians have been about their business for thousands of years, yet have not proved one single fact about philosophy. Their speculations have indeed not directly contributed anything to any knowledge of the answers. But I totally disagree with the logical positivist that this state of affairs is indicative of the fact that no answers are to be found. The ironic part of the whole situation is that the answers are already known. Known not by the metaphysicians more than anyone else, but the answers are known by everybody.

DISSENTER *(in genuine astonishment):* You say the answers are known by everybody?

MYSTIC: Yes. But unfortunately only on an unconscious level. The main struggle of mankind is to bring these memories to the conscious foreground.

PSYCHOLOGIST: You really believe the matter is analagous to capturing past memories?

MYSTIC: Yes, extremely analogous. That's why the methods of philosophy fail. They are trying to use objective methods for finding out something which can only be known by a process which is more like a direct recollection. If I may use an analogy, imagine two individuals trying to ascertain some past event. The one man—the type like the "objective" philosopher—tries to find out by gathering external information. He interviews people, searches out correspondence, looks for external "clues", etc. The other type—analogous to the so-called "mystic"—simply wracks his brains until he directly remembers what has happened. Again, a person under hypnosis can well remember events of his earliest childhood that he could probably never discover by external or objective investigation. The introspective methods of the mystic are very much like hypnosis and are no less reliable in unearth-

ing valuable data. Thus, I say, the metaphysician is like the objective inquirer who simply does not have enough available external data to provide answers to his question, whereas the mystic is like the one who directly remembers.

METAPHYSICIAN (sadly): Then you really mean that all the metaphysical speculations of the human race have been completely futile?

MYSTIC: Oh, not at all! It is sometimes absolutely necessary to bat one's head against a stone wall trying to use objective methods which cannot possibly work before one sees for oneself the necessity of direct introspective methods. Metaphysics is essentially one giant koan, not for an individual, but for the human race as a whole—a koan whose purpose is to force the realization of the impossibility of metaphysical methods being pushed any further. Stated otherwise, metaphysics is the necessary ripening process of the human race to prepare it for mysticism. So do not think that metaphysical inquiry serves no purpose; it serves a most important one.

DISSENTER: All this is very well, all this talk about introspective methods, direct memories and hypnosis. But what assurance do we have that all these methods are reliable? Memories unsubstantiated by objective confirmation are notoriously fallible. And certainly not enough is known about hypnosis that we should trust childhood memories incurred in such a state.

PSYCHOLOGIST: I must disagree with you on this.

DISSENTER: Well, maybe you know enough to trust them, but I do not. I never could see why memories—especially under hypnosis—may not be fantasies or false memories rather than true ones.

PSYCHOLOGIST: We do have a great deal of confirming evidence on this point.

DISSENTER: Well all right, perhaps I shouldn't argue with you on the subject of hypnotism, but on the subject of so called "mystical insight", do you not share my skepticism?

PSYCHOLOGIST: Yes, I do.

DISSENTER *(to mystic):* And how can you blame us for being skeptical? Why should we accept the validity of mystic claims?

MYSTIC: No reason whatsoever! Your very skepticism is a most essential part in ripening you to the point where you will see these things directly for yourself.

DISSENTER: Oh, come on now! Do you really expect me to swallow all this stuff?

MYSTIC: No, I do not. Fortunately or unfortunately as the case may be, I feel strongly compelled to state what I know to be the truth even when I know that the truth will be totally rejected. But I now know enough to realize that sometimes a violent rejection of the truth is an absolute prerequisite for the ultimate realization of the truth.

Please do not think that skeptical arguments are in any way new to me! I understand exactly how you feel since I long ago have felt just as you feel now—perhaps even more strongly. For twenty years I studied philosophy as assiduously as has anyone, and I used to write impassioned articles in defense of the purely objective methods of inquiry as opposed to the so-called "subjective". And only as a result of this intense preoccupation with objectivity did I mature to the stage where I realized the absolute necessity of a more subjective approach. It's not that I *objectively* came to the conclusion that subjectivity is valuable, but rather the change came over me, as it were, by a process I no more can explain than the growth of a tree. I hope you understand what I am saying. It could conceivably happen that a person might start out taking a purely objective approach, and then objectively come to the conclusion that a subjective approach is better. But this is not what happened to me. I started out in life as a scientist and philosopher and was totally distrustful of subjectivity. Then the day came when I realized, not objectively but purely subjectively the value of subjectivity—or rather of direct insight.

DISSENTER: I say all this is fine. I am not doubting that you do as a matter of fact believe all this. The only question I am asking is why should I?

MYSTIC: And I am trying to tell you that there is absolutely no reason whatsoever why you should. In the last analysis, it is not a question of whether you should or whether you shouldn't but whether in fact you do or you don't.

I hope you don't think I'm so unrealistic as to expect that the whole human race is ready to embark on the way of mysticism! I have absolutely no doubt that one day it will but not before the time is ripe. And don't believe any self-styled "mystic" who argues with you that you "should"—he is really trying to convince himself rather than you. To argue with someone that he *should* follow the way of the mystics is as silly as to argue with an unripe apple that it is time that it should fall from the tree. When the apple is ready, it will not need to be told that it should fall; it will do so quite of its own accord.

NOTES

Chapter 2. The Tao.

1. This is a composite of several translations of several verses of the Book of Tao.

Chapter 5. The Tao Is Vague.

1. Composite translation.

Chapter 6. The Tao Is Formless.

1. See Chang Chung-yuan, *Creativity and Taoism* (Harper & Row, 1970), p. 113 and p. 187.

Chapter 7. The Tao Is a Mysterious Female.

1. *The Way And Its Power,* (Grove Press, 1958), p. 171.

Chapter 12. The Tao Is Everywhere.

1. Herrlee G. Creel, *What Is Taoism?* (Chicago: University of Chicago Press, 1970, p. 31.)

Chapter 13. The Tao Does Not Command.

1. *The Way of Zen,* (Vintage Books, 1957), p. 18.

Chapter 14. The Tao Is Not Arrogant.

1. Composite Translation.
2. Lionel Giles, *Taoist Teachings,* (John Murray, London, 1959), p. 68.
3. For Confucious, some of this is remarkably Taoistic. For example,

"He makes no reforms, yet right conduct is spontaneous and universal." Several have wondered just who is this "Sage in the West." The early Jesuit missionaries saw an allusion to Jesus. Others have conjectured that it was Buddha, which is more credible in light of the fact that he and Confucious were more or less contemporaneous.

Chapter 15. Worship of the Buddha.

1. According to R.H. Blyth, this great statue of Buddha would be the one at Nara, or at Kamakura. See *Haiku,* (Hokuseido Press, 1950), Vol. 2, p. 216.
2. Ibid, p. 258.

Chapter 17. The Tao Is Ever Spontaneous.

1. D. Suzuki *Zen and Japanese Culture,* p. 100 (Bollingen Series LXIV. Pantheon Books, 1959).
2. Hokuseido Press, Vol. 7, 1962, p. 174.
3. I cannot recall the source.
4. Richard Maurice Bucke, *Cosmic Consciousness,* 4th ed. rev. (New York: E.P. Dutton & Co., 1923), p. 186.

Chapter 19. Whichever the Way.

1. See Alan Watts, *The Way of Zen* (Vintage Books, 1957), p. 134.

Chapter 21. Taoism Versus Morality.

1. (The Ronald Press Company. New York, 1955), p. 41.

Chapter 22. Is God a Taoist?

1. Alan W. Watts, *The Way of Zen* (Vintage Books, New York, 1957), p. 115.
2. See Arthur Waley, *Three Ways of Thought in Ancient China* (George Allen & Unwin Ltd, London, 1953), pp. 30, 31.

Chapter 23. The Tao Is Good but Not Moral.

1. See Ch. 22, n. 1.
2. Thomas Merton, *The Way of Chuang Tzu* (New Directions Paperbook NOP 276, 1969), p. 76.

Chapter 25. On Dogs.

1. R. H. Blyth, *Haiku* (Hokuseido Press, 1952), Vol. 4, p. 26
2. R. H. Blyth, *Haiku* (Hokuseido, 1952) v. 4, p. 13, 14
3. Ibid.
4. D. T. Suzuki, *Zen and Parapsychology* (Philosophy and Culture/East and West, Charles A. Moore/Editor, University of Hawaii Press/Honolulu/1962—p. 740)

Chapter 26. On the Art of Management.

1. Lin Yutang, trans. and ed., *The Wisdom of Laotse* (New York: Modern Library, 1948), pp. 161–62.

Chapter 28. Selfishness and Altruism.

1. Welsch Holmes, *The Creed of Buddha* (London: John Lane Company, 1908), pp. 211–12.

Chapter 29. On Egotism.

1. Donald Keene, ed., *Anthology of Japanese Literature* (Grove Press, New York, 1955), pp. 434–35.
2. Save for the last line, I have followed Alan Watts' modification of Ch'u Ta-Kao's translation—see Alan Watts, The Way of Zen, (Vintage Books, 1957), p. 20.
3. Fung Yu-lan, *A History of Chinese Philosophy*, tr. Derk Bodde (Princeton University Press, 1952), V. 1, p. 173–74.

Chapter 30. Egotism and Cosmic Consciousness.

1. Richard Maurice Bucke, *Cosmic Consciousness,* 4th ed. rev. (New York: E. P. Dutton & Co., 1923), pp. 174–75.

Chapter 31. On Trusting One's Own Nature.

1. Arthur Waley, *Translations From The Chinese,* (New York: Alfred A. Knopf, 1941), pp. 251–54).
2. Indianapolis, The Bobbs-Merrill Company, 1915, p. 28.

Chapter 34. On Making an Effort.

1. Kōjirō Yoshikawa, *An Introduction to Sung Poetry,* translated by Burton Watson, (Harvard University Press, 1969), p. 102.
2. Ibid, pp. 121–22.

3. Lin Yutang, trans., *The Chinese Theory of Art* (New York, G. P. Putnam's Sons), p. 206.
4. Chang Chung-Yuan, *Original Teachings of Ch'an Buddhism* (Pantheon Books, 1969), p 144.

Chapter 35. Crazy Philosophy and Sensible Philosophy.

1. With minor modifications I have followed the translation in Osvald Siren, *The Chinese on The Art of Painting*, (Schocken Books, New York, 1971), p. 184, n.

Chapter 39. Two Zen Incidents.

1. Cf. *Improvement of the Understanding*—Section VI.

Chapter 44. Do You See the Point?

1. See Ch. 19, n. 1.
2. See Ch. 17, n. 1.
3. See Ch. 6, n. 2.

Chapter 46. The Evening Cool.

1. R. H. Blyth, *Haiku*, Vol. 3 (Hokuseido Press), pp. 124–25.

SUGGESTED READINGS

The annotated select bibliography which follows is informal, rambling, and highly personal. I cite only those books I have loved most. I list them roughly in the order I suggest they be read.

I. *Taoism and Zen*

[1] Chang Chung-yuan, *Creativity and Taoism, A Study in Chinese Philosophy, Art, and Poetry.* Harper Colophon Books/CN 228. New York: Harper & Row, 1970.

This is as wonderful a book as any on this list, and is an excellent one to start with. It gives a completely unified picture of Taoistic philosophy, poetry, and painting (which to the classical Chinese mind were all one and the same thing).

[2] *Three Ways of Thought in Ancient China,* by Arthur Waley (London: George Allen and Unwin, 1953) is an excellent comparative study of Taoism, Confucianism, and Legalism.

[3] *The Wisdom of Laotse* by Lin Yutang (New York: The Modern Library, 1948) is a fine introduction to the thoughts of both Laotse and Chuangtse. Each verse of Laotse is followed by relevant passages of Chuangtse. The reader thus gets an excellent integrated account of the ideas of both thinkers.

I highly recommend Lin Yutang in general. His following
books can be nicely interspersed from time to time with the
othor roadings on this list.

(a) *The Importance of Living.* New York: The John Day Com-
pany, 1940.

(b) *From Pagan to Christian.* Cleveland and New York: The
World Publishing Company, 1959.

(c) *My Country and My People.* New York: Reynal and Hitch-
cock, 1936.

(d) *The Wisdom of America.* New York: The John Day Com-
pany, 1950.

(e) *The Gay Genius—The Life and Times of Su Tungpo.* New
York: The John Day Company, 1947.

[4] My favorite translator of Chuangtse is Thomas Merton.
His book *The Way of Chuang Tzu* (New Directions,
1965) is a literary masterpiece. I wish Merton had tran-
slated *all* of Chuangtse! The book also contains a mag-
nificent introductory essay.

En passant, the following are two other superb books of
Thomas Merton:

(a) *Zen and the Birds of Appetite.* A New Directions Book,
1968.

(b) *Mystics and Zen Masters.* New York: Dell Publishing Com-
pany, 1967.

[5] The best translation I know of the complete works of
Chuangtse is the Burton Watson: *The Complete Works
of Chuang Tzu.* New York and London: Columbia Uni-
versity Press, 1971.

[6] It is good to have several translations of Laotse and
Chuangtse. The reader really should possess the follow-
ing two companion volumes written jointly by Gia-Fu
and Jane English:

(a) *Lao Tzu, Tao Te Ching.* New York: Vintage Books, A Divi-
sion of Random House, 1972.

(b) *Chuang Tzu, Inner Chapters.* New York: Vintage Books, A
Division of Random House, 1974.

I particularly love the text of the Chuangtse. The photography by Jane English, the calligraphy by Gia-Fu Feng, and the general format of both volumes are superb.

[7] *The Taoist Teachings from the Book of Lieh Tzu* translated by Lionel Giles (London: John Murray, 1959) may be out of print. If you can get a copy, you will find it an utter delight from beginning to end.

[8] Speaking of delightful books, do try and get hold of a copy of Oscar Mandel's *Chi Po and the Sorcerer* (Rutland, Vermont and Tokyo, Japan: Charles E. Tuttle Co.). One thing that attracted me was the subtitle "A Chinese Tale for Children and Philosophers." I felt qualified on both counts. This book is as thoroughly delightful for children as adults.

[9] *The Way of Zen* by Alan Watts (New York: Vintage Books, Random House, 1957) is as good an introduction to Taoism and Zen as I know. As I have said to all my friends to whom I have recommended it, "If you like the first chapter on the philosophy of the Tao, you will like the rest of the book as well. If you don't like the first chapter, then the entire subject is simply not for you."

I am an Alan Watts fan. I believe this book and his autobiography are his best works. I recommend:

(a) *In My Own Way—An Autobiography.* New York: Pantheon Books—a Division of Random House, 1972.
(b) *This Is It—and Other Essays.* New York: Collier Books, 1969.
(c) *The Book—On the Taboo Against Knowing Who You Are.* New York: Pantheon Books, 1966. Also New York: Collier Books, 1970.
(d) *Psychotherapy East and West.* New York: Ballantine Books, 1969.

(e) *The Wisdom of Insecurity.* New York: Vintage Books, a Division of Random House, 1951.

(f) *Tao—The Watercourse Way.* New York: Pantheon Books, 1975.

The chapter in (c) which interested me the most is Chapter III, "How To Be a Genuine Fake." This contains an excellent account of Gregory Bateson's theory of the Double Bind as being a leading cause of schizophrenia. This theory may well be the greatest contribution yet made to psychiatry.

[10] Daisetz Suzuki is probably the best-known expositor of Zen in the West. I particularly recommend:

(a) *Zen and Japanese Culture.* Bollingen Series LXIV. New York: Pantheon Books, 1959.

(b) *Manual of Zen Buddhism.* New York: Grove Press, 1960.

(c) *Living by Zen.* New York: Samuel Weiser, Inc., 1972.

(d) *The Zen Doctrine of No Mind.* New York: Samuel Weiser, Inc., 1972.

(e) *Essays in Zen Buddhism.* 3 vols. London: Luzac, 1927, 1933, 1934. Repr., London: Rider, 1949, 1950, 1951. Also available in paperback, New York: Samuel Weiser, Inc., 1971.

I recommend (a) the most, and it is certainly the best Suzuki to start with. It is common to start with (e), but I think this is a mistake. These essays will be much more comprehensible to those who have first read a good deal of Suzuki's other works.

I also recommend *Zen Buddhism and Psychoanalysis* by Erich Fromm, D.T. Suzuki and Richard De Martino (New York: Harper & Row, 1960).

[11] *Zen in the Art of Archery* by Eugen Herrigel (New York: Pantheon, 1968) is one of the best-known works in English. This was the first book on Zen I ever read, but I did not appreciate its true significance until I reread it after having read many of the other works on Zen. It

is an extremely important book, and is highly praised by many of the Japanese Zen-Masters.

[12] I believe the best work of all (available to the English reader) on Zen is *The Zen Teachings of Huang Po,* translated by John Blofield (New York: Grove Press, 1958). I have left this to the last because it may be completely bewildering to the beginner.

[13] For Chinese Philosophy in general, the reader should consult:
 (a) Fung Yu-Lan, *A History of Chinese Philosophy,* 2 vols. Princeton: Princeton University Press, 1952, 1953.
 (b) Wing-Tsit Chan, *A Source Book in Chinese Philosophy.* Princeton: Princeton University Press, 1963.

II. *Poetry and Painting*

[14] Kenneth Rexroth: (a) *One Hundred Poems from the Chinese;* (b) *Love and the Turning Year.* Both are available in New Directions Paperbooks, 1970 and 1971. There are no translations I have loved more than these.

[15] Another of my favorites is John C.H. Wu, *The Four Seasons of T'ang Poetry.* Rutland, Vt. and Tokyo, Japan: Charles E. Tuttle Company, 1972.

[16] I equally recommend:
 (a) *An Introduction to Sung Poetry* by Kōjirō Yoshikowa, tr. Burton Watson. Cambridge: Harvard University Press, 1969.
 (b) *Chinese Lyricism* by Burton Watson. New York and London: Columbia University Press, 1971.
 Both these works are philosophically profound.

[17] "It's cold on this mountain! Not just this year, but every year!" Thus writes Han-Shan, who with his poet-companion Shih-Te constitute just about the most delightful pair of characters I have ever come across! If you can

imagine an eighth-century Chinese hippie poet, you will
have some idea of Han-Shan. The translations of both
Burton Watson and Gary Snyder should be read and
compared.

(a) Burton Watson, *Cold Mountain*. New York: Grove Press,
1962. Reissued by Columbia University Press, New York
and London, 1970.

(b) Cyril Birch, ed., *Anthology of Chinese Literature*. New
York: Grove Press, 1967. See pp. 194–202 for the Snyder
translation.

Some of Han-Shan's verses have also been translated by
Arthur Waley. An extremely interesting and valuable com-
parison between the three translations can be found in an
article, *Three English Versions of Han-Shan's Cold Moun-
tain Poems* by Herbert V. Fackler. This article was published
in *Literature East and West*, Vol. XV No. 2. Austin and New
York: Jenkins Publishing Company.

Han-Shan and Shih-te have been painted over and over
again by the Japanese for centuries! A particularly marvelous
reproduction can be found in Suzuki's *Zen and Japanese
Culture*.

It is most unfortunate that only about one-third of the Cold
Mountain poems have been translated into English. It is high
time that someone should undertake a really comprehensive
book on Han-Shan, containing translations of *all* his poems,
plus all known existing translations, and illustrated with a
host of reproductions of the many Japanese paintings.

[18] In a very different way, I equally love the poet Wang
Wei. He is the poet of quietude *par excellence*. Some
beautifully apt remarks comparing Wang Wei with
Han-Shan can be found in [16-b]—pp. 176–78. Transla-
tions of some of Wang Wei appear in [1], in [15], and in
[17-b]. For more comprehensive treatments, I strongly
recommend:

(a) Chang Yun-nan and Lewis Walmsey, *Poems of Wang Wei.* Rutland, Vt. and Tokyo, Japan: Charles E. Tuttle Co., 1969.
(b) Lewis Calvin Walmsey and Dorothy Brush Walmsey, *Wang Wei, Painter-Poet.* Charles E. Tuttle Company, 1968.

Wang Wei was, in fact, one of China's greatest painters as well as one of China's greatest poets. [18-b] is beautifully illustrated and has an excellent format.

[19] It is almost axiomatic that Zen without Haiku is like bread without butter (or perhaps more like butter without bread). The one obviously indispensable English work is R.H. Blyth, *Haiku,* 4 vols. Hokuseido Press, 1950, 1952. By the same author, *Zen in English Literature.* Hokuseido Press, 1942.

[20] One marvelous thing about Chinese aesthetic criticism is that it has the very same beauty as the works of art it talks about! Reading the Chinese philosophy of painting produces virtually the same aesthetic experience as looking at the paintings themselves. You should certainly read:
(a) Lin Yutang, *The Chinese Theory of Art.* New York: G.P. Putnam & Sons, 1967.
(b) Osvald Siren, *The Chinese on the Art of Painting.* New York: Schocken Books, 1971.

In (a) be sure not to miss the fantastic chapter on Shih T'ao! I never liked Shih T'ao's paintings all that much, but his views on art are the most remarkable ones I have ever come across. Concerning one section of the chapter, Lin Yutang in a footnote says: "This is the strangest discourse I have ever translated. In this whole section, the artist identifies himself with the universe and its various manifestations."

[21] A large collection of Chinese art books can be costly, so let me stick to only a few essentials. I particularly recommend:

(a) George Rowley, *Principles of Chinese Painting.* Princeton: Princeton University Press, 1947; Second Edition, 1959; Paperback, 1970.

The text is superb. The reproductions in the first edition are particularly beautiful.

(b) Ernest Fenellosa, *Epochs of Chinese and Japanese Art.* London: William Heinemann, Ltd.; New York: Frederick A. Stokes Company. First published 1912; reprinted 1913, 1917, 1921. Also Dover Paperback, New York.

(c) Lawrence Binyon: (1) *The Flight of the Dragon* (The Wisdom of the East Series, New York: Grove Press, 1961); (2) *Painting in the Far East* (London: Edward Arnold, 1908. Also Dover Paperback, New York, 1957); (3) *The Spirit of Asian Art* (Harvard University Press, 1936. Also Dover Paperback, 1965).

[22] If you are ever lucky enough to come across the following gem, grab it!

Richard Barnhart, *Wintry Forests, Old Trees.* New York: China House Gallery, China Institute in America.

This is a catalogue of the superb exhibition given at the China Institute October 26, 1972 through January 28, 1973. It then cost three dollars. You might find a copy in a used bookstore specializing in Oriental art.